A horse is a thing of such beauty…

none will tire of looking at him as long as he

displays himself in his splendor.

XENOPHON

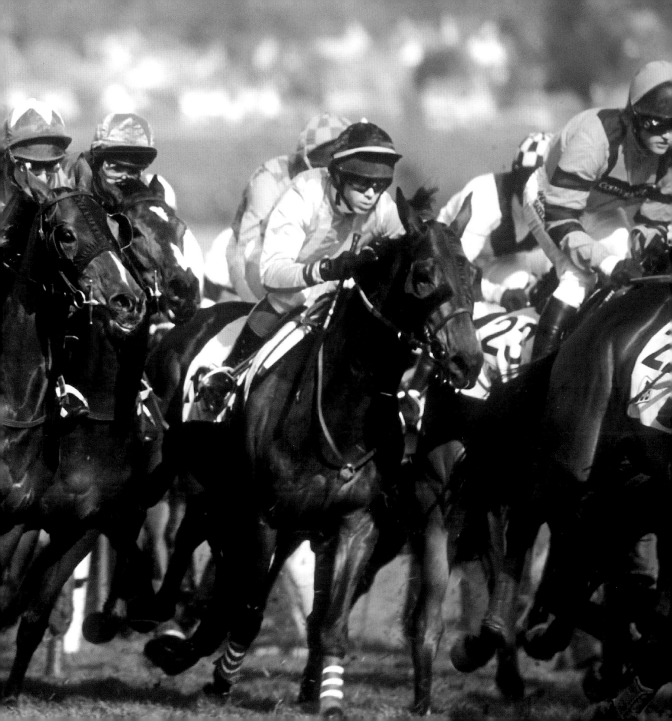

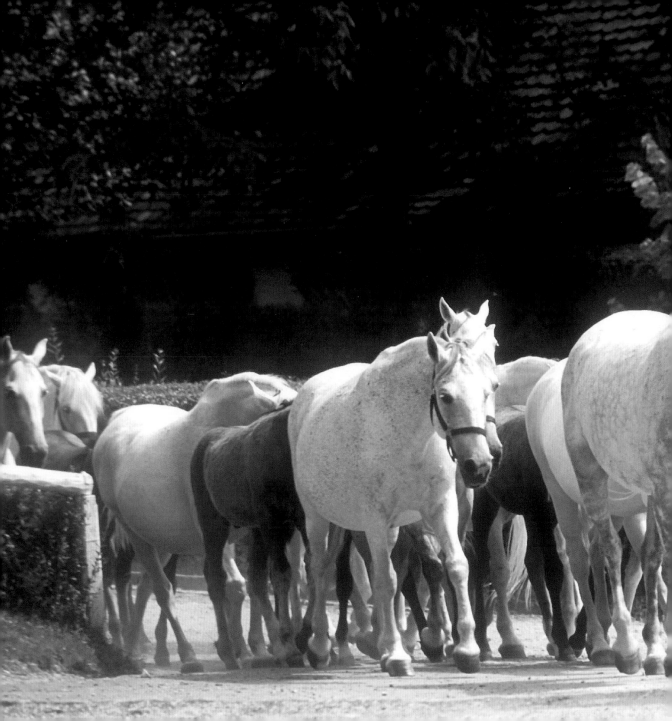

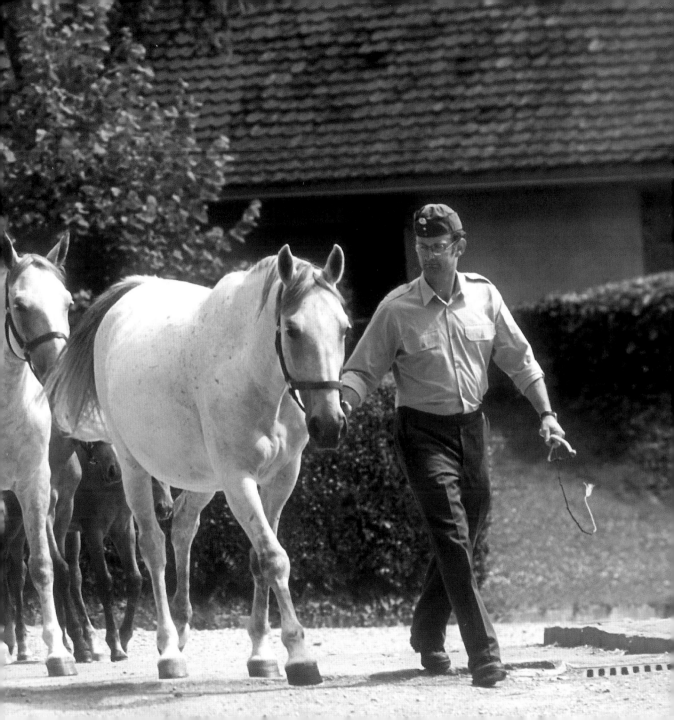

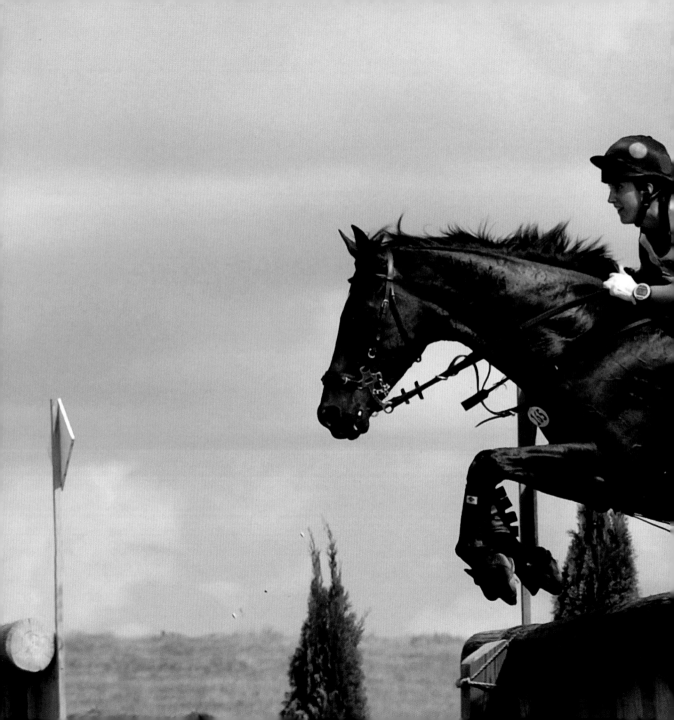

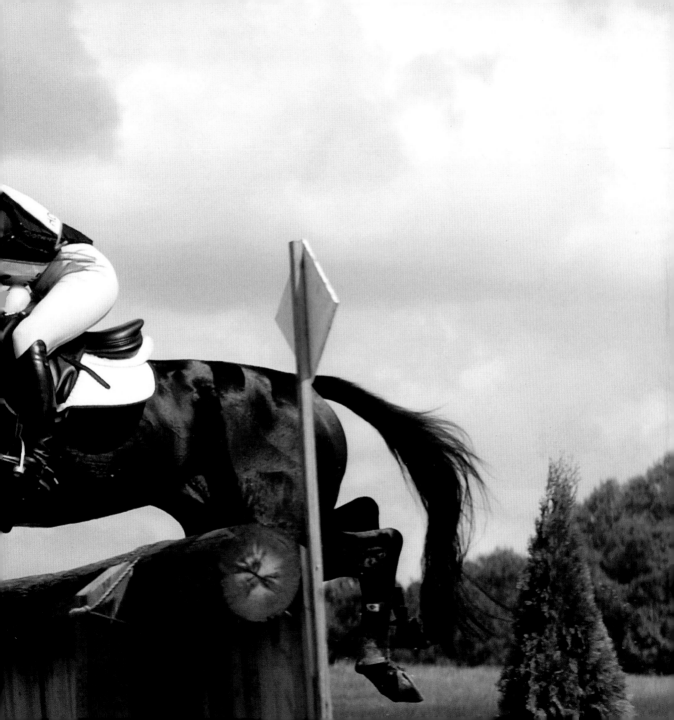

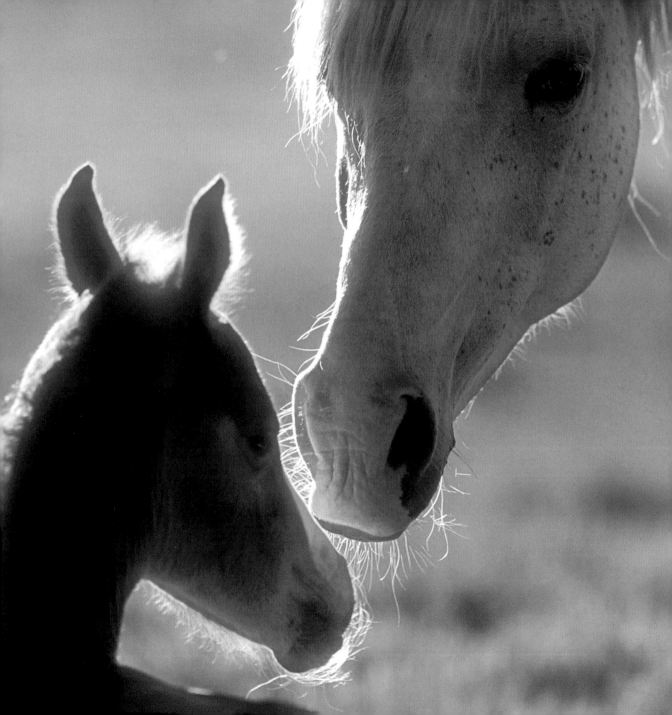

THE BIG BOOK OF

HORSES

EDITED BY J.C. SUARÈS

welcome
BOOKS

NEW YORK • SAN FRANCISCO

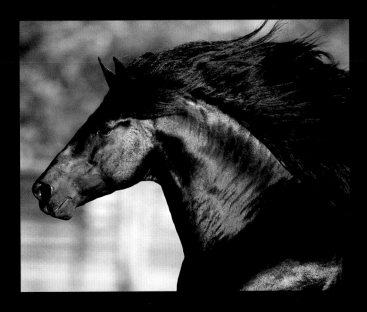

The essential joy of being with horses

is that it brings us in contact with the rare elements

of grace, beauty, spirit, and fire.

SHARON RALLS LEMON

Herradura, a Purebred Spanish Andalusian stallion, resides in Texas.
The Andalusian breed originated from Andalusia, a Spanish province.

FOREWORD

MY FATHER CLAIMED to have entire conversations with horses. As horse whisperers go, he was an unlikely candidate. He was a gambler first and a horse breeder by necessity. His whole life revolved around gambling. His daily routine was a gambler's life: up at four in the morning to go watch the horses train, a three-hour poker game starting at 11 A.M., back to the racetrack in the afternoon, blackjack at the casino every evening, and sometimes an after-hours bridge game.

But underneath the tough Damon Runyon façade was a deep love for horses. He could not tolerate any mistreatment of horses and forbade the use of crops unless absolutely necessary. In the 23 years that I knew him, I only saw him get into a single knock-down fight. We were driving in the country and he saw a man beating a young horse. He stopped the car, jumped out, and without ever saying a word, punched the man. He then threw down a wad of money and ordered his chauffeur to walk the horse back to our barn about a mile away. The horse was a two-year-old mare named Esmeralda—not a good racehorse name, but my father was superstitious about horse names and never changed it. I think she won a race or two.

Sometimes, when we found ourselves at various racetracks, he would dispense with the statistics, facts, and figures about a horse's past performance and announce that before he plunked down any money on a horse, he would have to go talk to it first. He would then claim that a favorite could not possibly win because the horse was having a bad day or that an unlikely candidate was his choice because the horse told him he felt like running that day. He was never wrong. He was so sure of himself that he would buy the winning ticket and announce that he had bet on a different horse. He would then surprise

F O R E W O R D

everyone by pulling the winning ticket from his pocket after we'd thought he had finally lost his touch.

I first talked to horses a few years ago when I was confined to a shed in the middle of a sudden and violent rainstorm with a couple of Argentinian polo ponies. They were the kind of horses people seldom bond with, part of a large string with a number branded on their rump, bred to win polo games and seldom rewarded (most polo ponies have to be taught about carrots—they've never seen one before and won't open their mouths). As I stood under the shed roof waiting for the rain to end, I don't even know why I opened a conversation with them. "You're such nice horses, you really should have names instead of numbers. If you were my horses, I'd give you names and carrots." The horses were so curious at the tone of my voice that their anxiety over the weather and being kept in a strange shed disappeared. They spent the rest of the time trying to get closer and closer until they blew warm air on my face.

Although they don't talk back to me as they did to my father, I've been talking to horses ever since. I say hello to them, I talk to them when I mount them, I thank them as I get off. I once stopped a runaway horse by talking to him in a loving way.

It's clear that all horses like to be talked to. Maybe we are all horse whisperers. Maybe some of us are even lucky enough to be talked back to. Try it the next time you meet a horse.

—J.C. Suarès

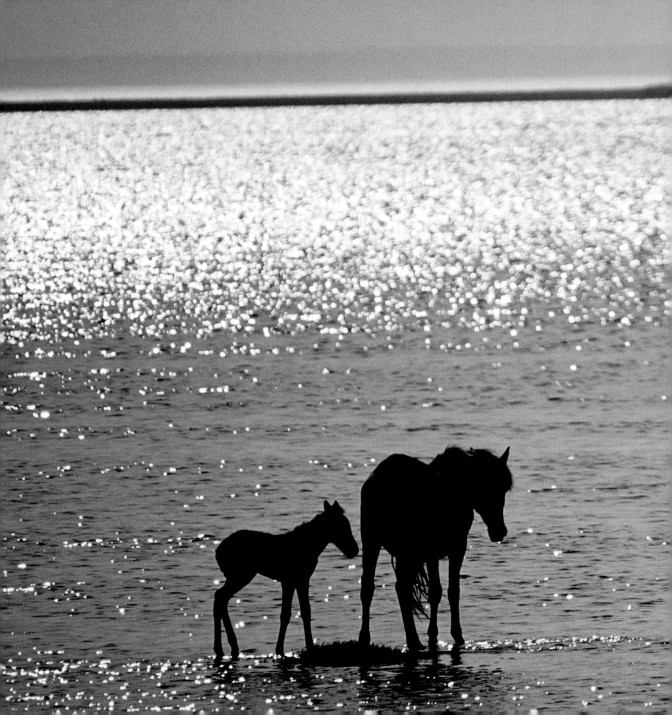

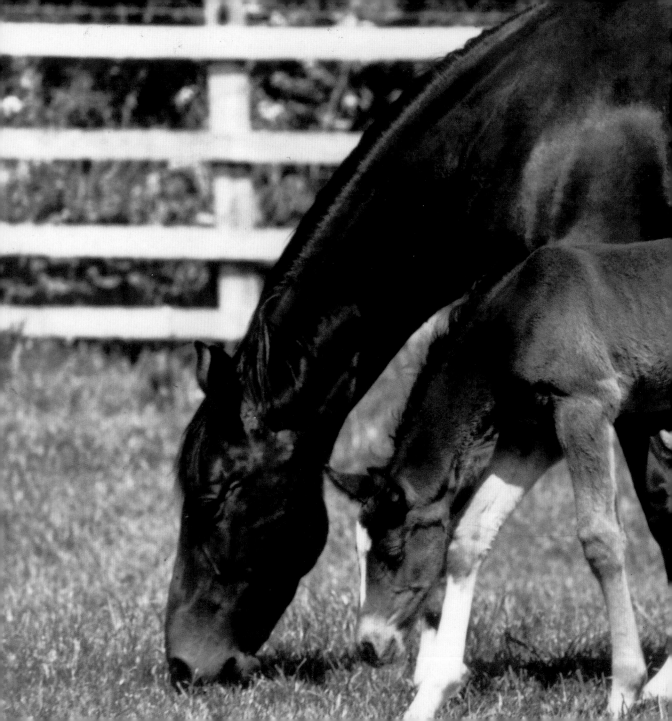

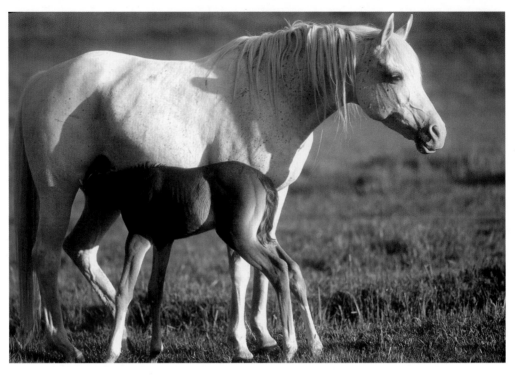

A mother and foal Chincoteague pony stand along the shore of the Chincoteague National Wildlife Refuge, Virginia. The Chincoteague pony, a registered breed, is a feral horse that lives on the island of Assateague.

A Warmblood mare and foal. Warmblood is a type of horse. Other types of horses include "cold bloods," such as draft horses and "hot bloods," such as Arabians and Thoroughbreds.

A young Arabian foal enjoys some nourishment from its loving mom at Bitterroot Ranch in Dubois, Wyoming. Arabians have a very characteristic look with a delicate head; large, prominent eyes; a statuesque arched neck; and a naturally high tail carriage.

A young chestnut foal at Bitterroot Ranch in Dubois, Wyoming. Chestnut (also called "sorrel") horses are reddish brown in color.

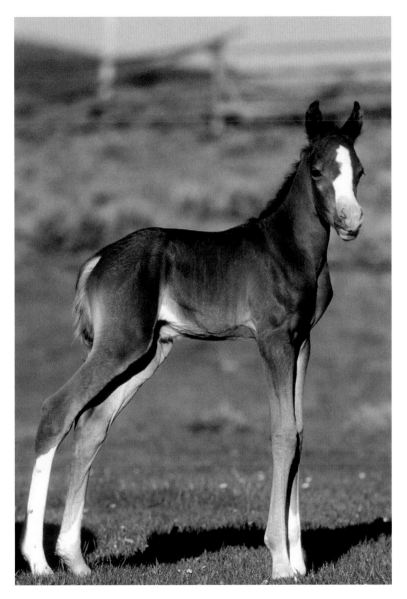

MRS. B

I worked at a therapeutic riding center and was always amazed at the bond that developed between the riders and horses. Every horse had a rider who saw it as his or her "favorite," but there was one horse in particular who had more fans than I could count. Her name was Mrs. Butterworth ("Mrs. B" for short). Her résumé included being one of the first therapeutic riding horses in the country and working in the industry for more than 20 years. She taught several children to walk; she helped others learn how to speak; and she made a lot of children smile—because what greater gift could a child have than to ride the most beautiful horse in the world?

You see, to children or to people who perceive the world from a child's perspective, beauty, grace and value take on a different meaning than they do for adults. What is beautiful is what makes them smile and laugh, and what is valuable are the things that make them feel loved. We sometimes lose that as adults, when we judge things with our eyes instead of our hearts. Fortunately for those who rode her, Mrs. B had the quality that most horses have. She did not judge her riders by how they looked, walked, or even if they walked. She took her riders at face value, for who they were and how they treated her. And as different as those many riders were on her back, whether uncomfortable for her or not, she was always willing to give them the best ride she could.

Here a strawberry roan Shire foal is lying down resting in England. Roan horses come in many colors. The main color is interspersed with many single white hairs. Although the roan gene can be matched with any color, the most commonly seen are the red or strawberry, blue, and bay roans.

JON PADGHAM, TEXAS

NUTRITION SPECIALIST, D&L FARM AND HOME

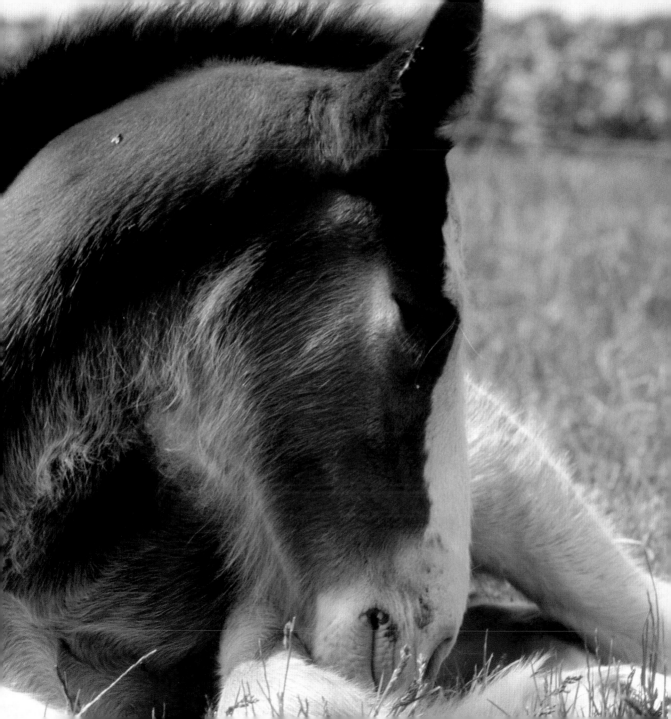

Having seen horses all his life, Jody had never looked at them very closely before. But now he noticed the moving ears which gave expression and even inflection of expression to the face. The pony talked with his ears. You could tell exactly how he felt about everything by the way his ears pointed. Sometimes they were stiff and upright and sometimes lax and sagging. They went back when he was angry or fearful, and forward when he was anxious and curious and pleased; and their exact position indicated which emotion he had.

JOHN STEINBECK, *THE RED PONY*

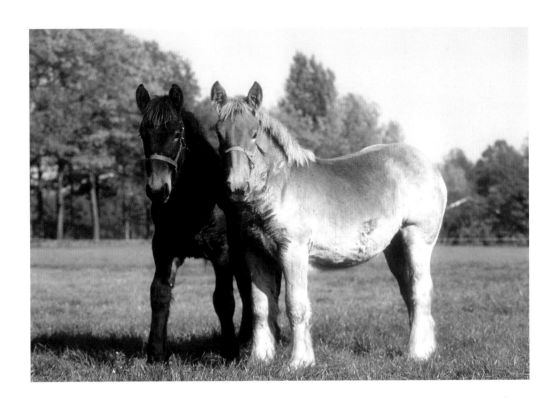

These Dutchbred heavy draft foals are enjoying an afternoon of relaxation at their home in the Netherlands. The draft breed of horses is larger and heavier than many of the other breeds.

T ake most people, they're crazy about cars. They worry if they get a little scratch on them, and they're always talking about how many miles they get to a gallon, and if they get a brand-new car already they start thinking about trading it in for one that's even newer. I don't even like old cars. I'd rather have a goddamn horse. A horse is at least human, for God's sake.

J.D. SALINGER, *CATCHER IN THE RYE*

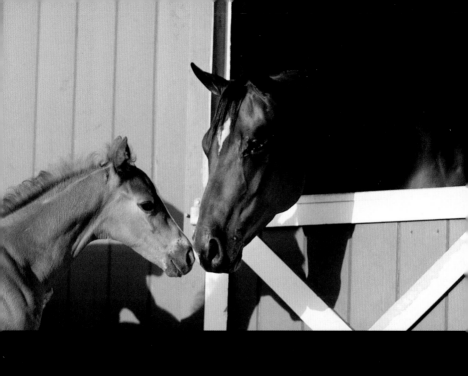

*A touching moment as this Quarter Horse mare and foal connect by nuzzling.
Horses have their own way of communication and touch is important to them.*

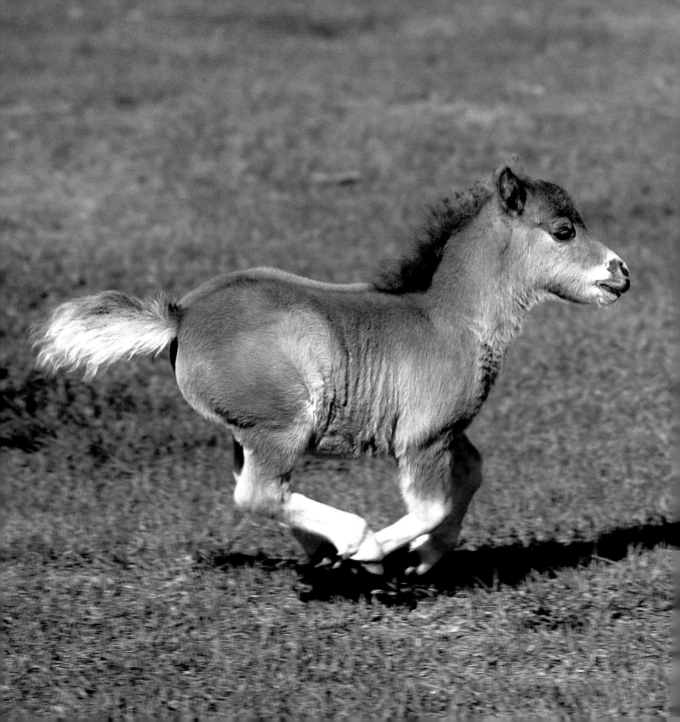

This Warmblood foal is enjoying a relaxed canter in the grass at his United Kingdom home. The canter is one of the three gaits: walk, trot, and canter. It is a three-beat gait and, as the foal grows and matures, his gaits will get smoother and more defined.

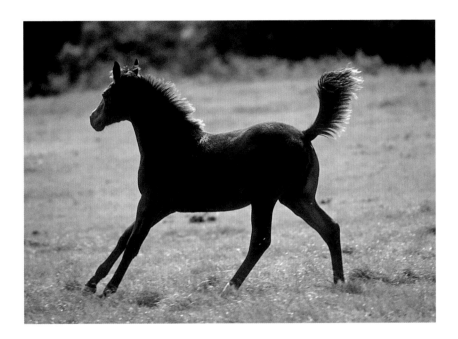

OPPOSITE:
Miniature foal at Conder Farm in Ocala, Florida. Miniature horses are generally recognized in two classifications based on height: A for horses 34 inches (82 cm) and under and B for horses between 34 and 38 inches (82–91 cm) in height. Miniatures have their own competitions throughout the world in a variety of divisions. They also make great pets.

Somewhere . . . Somewhere in time's Own Space

There must be some sweet pastured place

Where creeks sing on and tall trees grow

Some Paradise where horses go,

For by the love that guides my pen

I know great horses live again.

STANLEY HARRISON

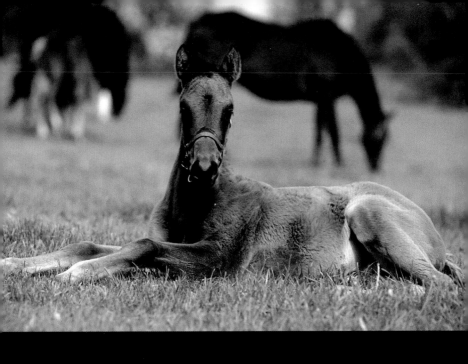

This bay Thoroughbred foal relaxes at a stud farm in Lexington, Kentucky, one of the cities known for its concentration of horses and horse organizations, including the United States Equestrian Federation, the organization that provides leadership for equestrian sport in the United States.

Mother and Daughter Share a Passion

Horses have always played an important role in my life. When I was two years old, I owned a retired Arabian mare named Susie. Every Sunday, my father would tack her up and lead me around our small farm. When Susie passed on, we purchased Thursday, a Welsh pony mare that was broken to drive. We had a harness made to fit her very round body and purchased an Amish courting buggy. On Sundays we would hook Thursday to the buggy and pick up our neighbors for an afternoon drive. After my "horse-less" college years and starting my family, my oldest daughter announced that she wanted riding lessons for her fifth birthday. Remembering how important horses were in structuring my own early years, I was glad for her interest. The weekly riding lessons soon led to purchasing a pony and going to the barn at least five times a week. Now a teenager, my daughter devotes many hours to caring for, riding, and competing her horse.

I spend my Sundays with my daughter and relive my formative years. Her horse experiences are a bit different from mine, but as I watch her I often think back to the joy I felt growing up with Susie and Thursday. I'm glad that horses are a big part of her life, as they were in mine. In today's world, as a parent, it is good to know where your daughter is spending most of her time. And my hope is that someday, she too will be able to watch and share her children's appreciation for whatever horse endeavor they choose.

SUSIE WEBB, MARYLAND
EXECUTIVE DIRECTOR, WASHINGTON INTERNATIONAL HORSE SHOW

A playful foal bites his buddy on the neck. Play and grooming among horses is important for their social development.

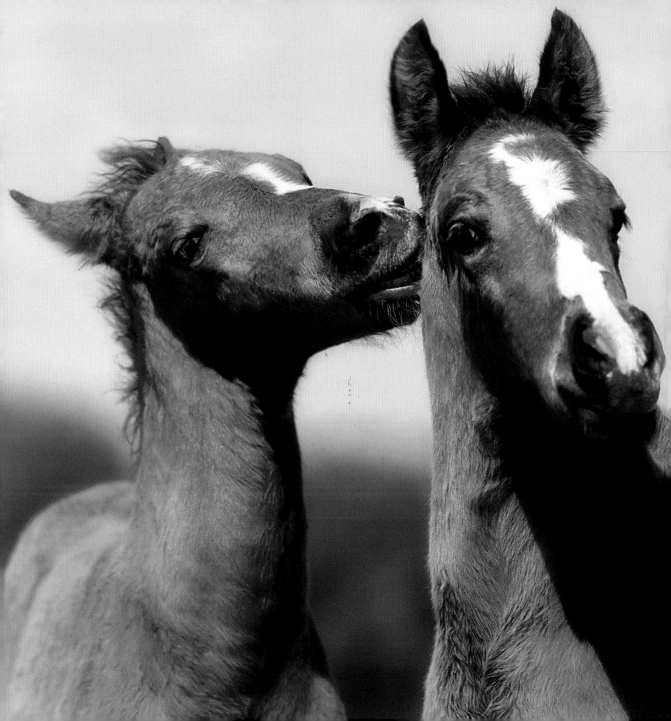

A curious Arabian foal stretches out to sniff a cat.

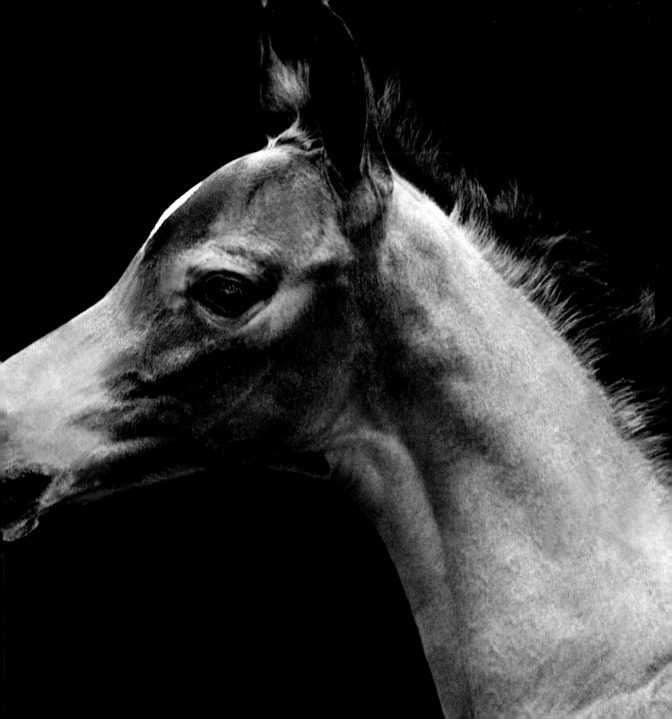

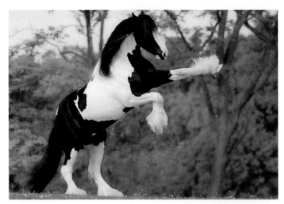

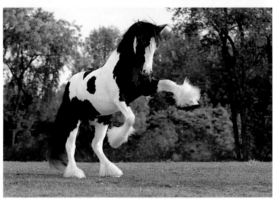

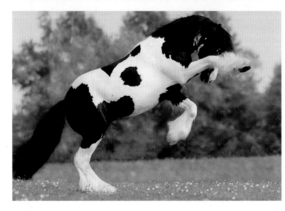

Gypsy Vanner colt "Turly" leaps, rears, and plays with enthusiasm.

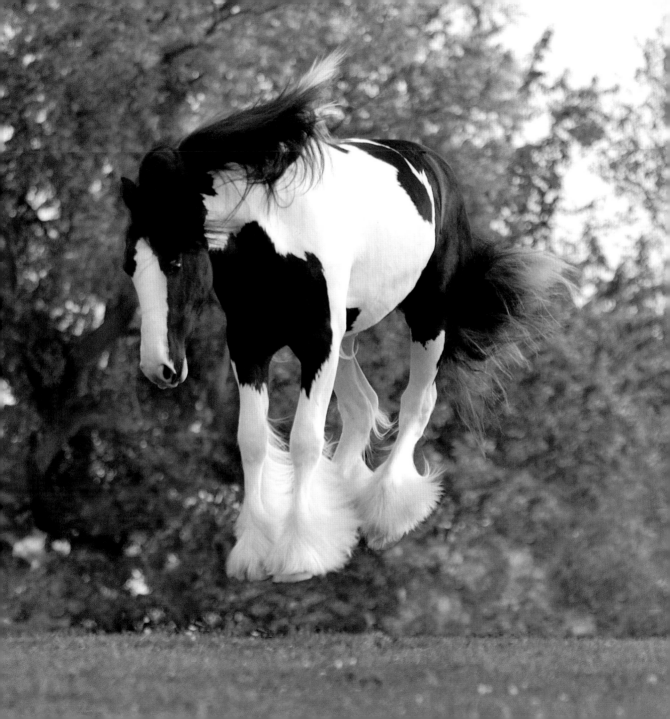

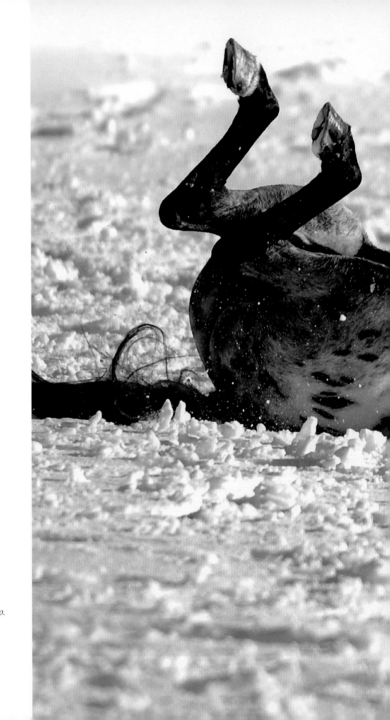

An Appaloosa gelding pony rolling in the snow in Columbus, Ohio.
He is scratching his back after the recent removal of his saddle.

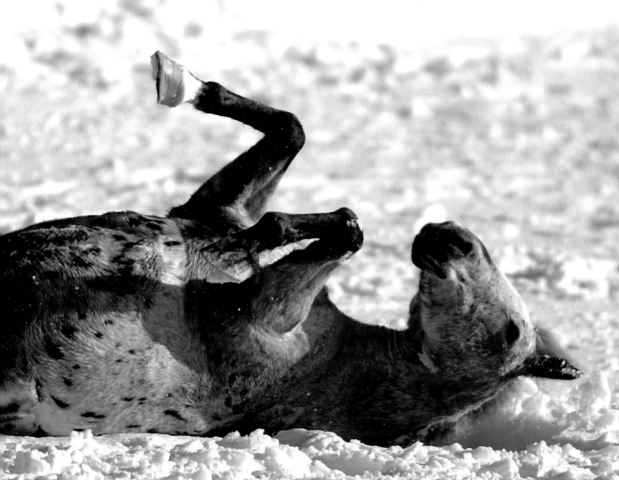

I love the horse from hoof

to head from head to hoof and

tail to mane I love the horse

as I have said from head to hoof

and back again.

JAMES WHITCOMB RILEY

A Thoroughbred turned out in a paddock and taking advantage of
that freedom by going for a nice run at its Lexington, Kentucky home.
The horse has equipment on its legs to protect it from hurting itself
while running and playing.

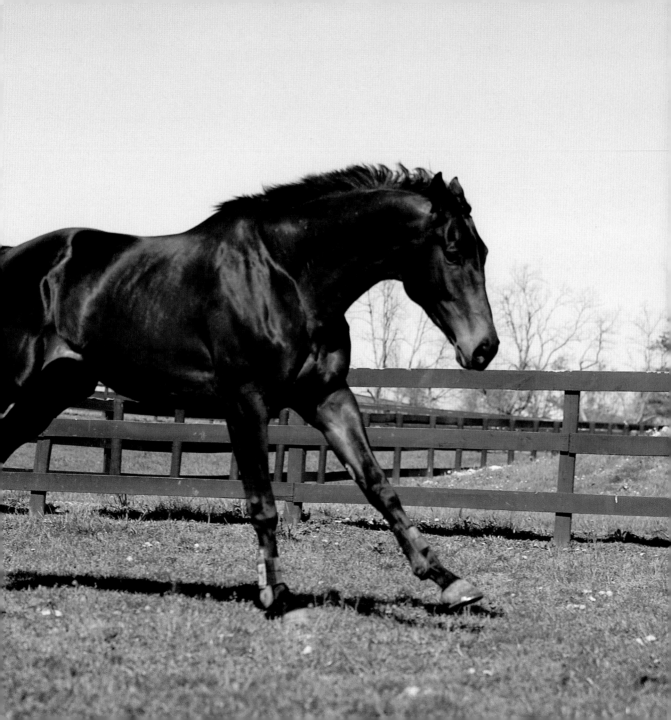

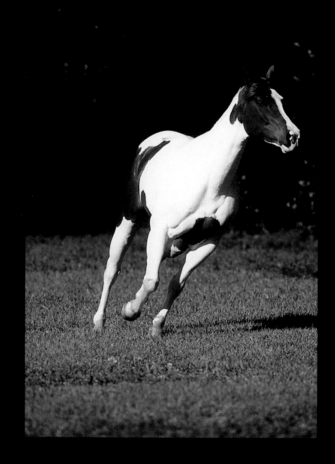

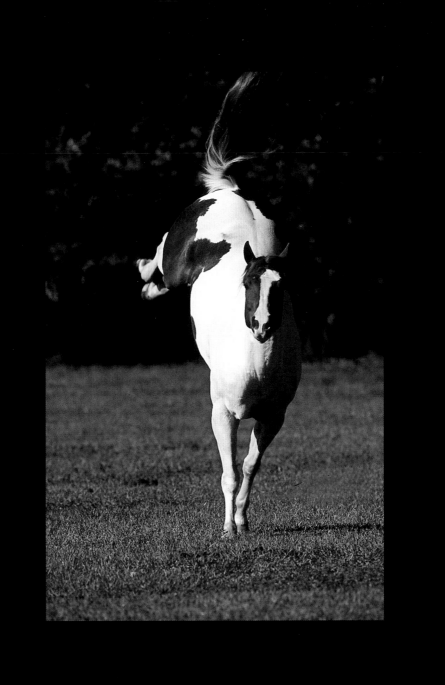

An instinct sympathy—which makes the horse

and master one heart, one pulse, one understanding

love—is never made, but born.

GEORGE AGNEW CHAMBERLAIN

These Appaloosas call Lynn's Appaloosas breeding farm in Florida their home. Everything produced at this ranch is a son, daughter, grandson, or granddaughter to "Kings Heir", a breeder of champion horses.

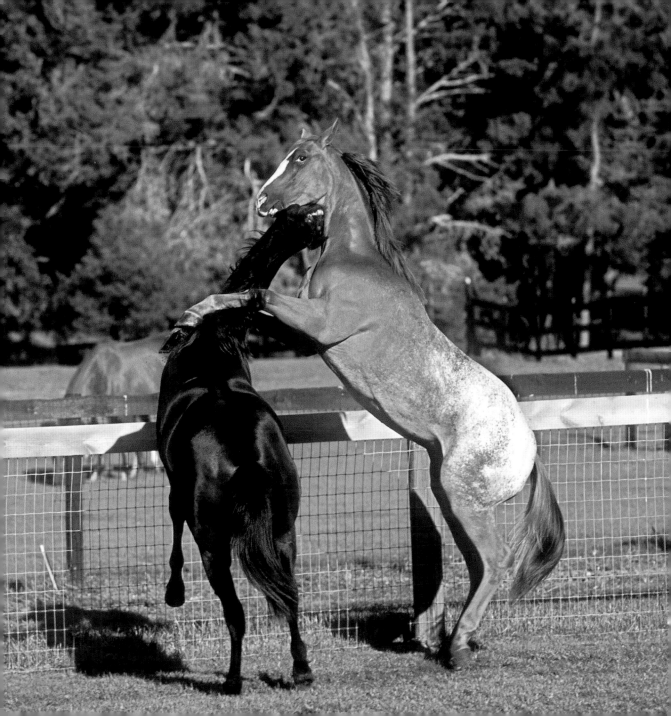

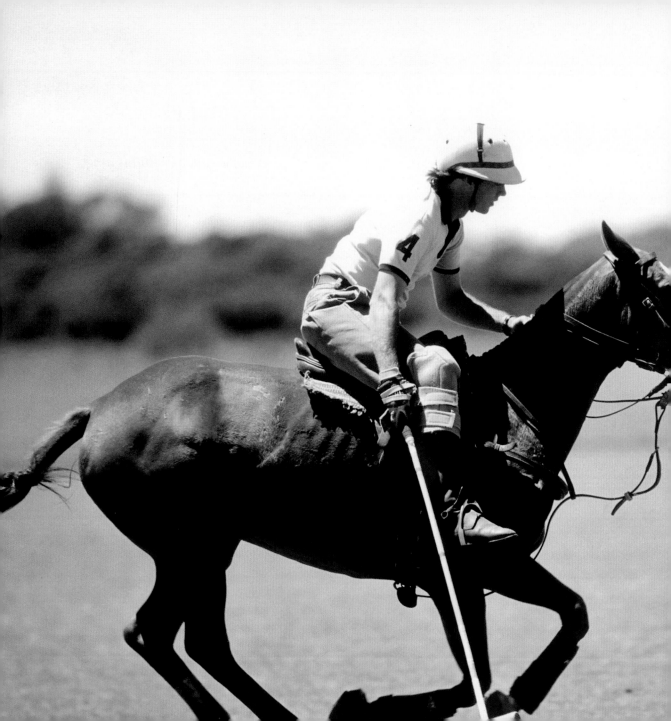

A horse gallops with his lungs,

perseveres with his heart,

and wins with his character.

TESIO

Polo, whether in practice as here at Estancia Escondida Polo School in La Pampa, Argentina, or in competition, is fast paced and exciting. This sport played on horseback involves two teams each doing its best to get the ball into the opposing team's goal using mallets. It can in some ways be compared to hockey.

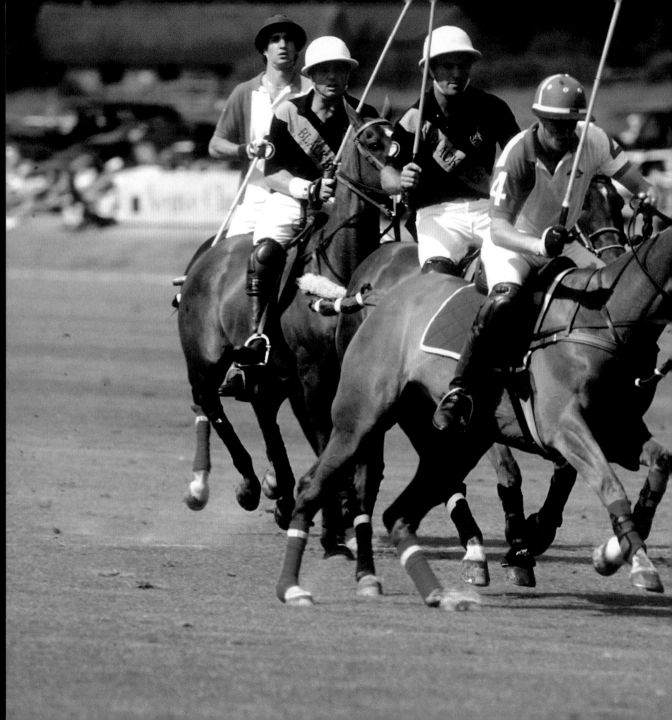

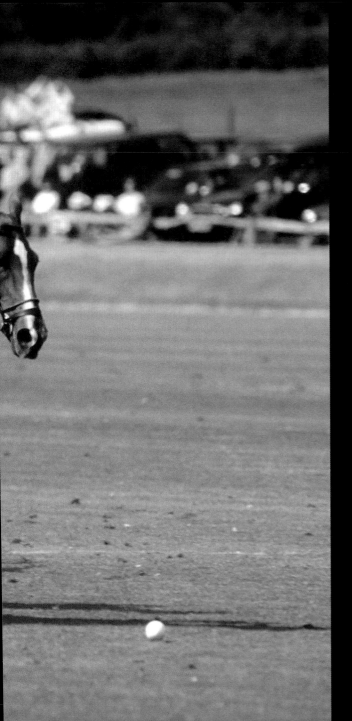

A good rider on a good horse

is as much above himself and others as

the world can make him.

LORD HERBERT

An action-packed polo match taking place in the Veuve Clicquot Gold Cup at Cowdray Park in England. Polo is most often played in Argentina (the country that dominates the sport), England, Pakistan, India, and the United States. It was an Olympic sport from 1900 to 1939.

L et's see," said a soft, golden-colored Arab, who had been playing very badly the day before, to The Maltese Cat, "didn't we meet in Abdul Rahman's stable at Bombay, four seasons ago? I won the Paikpattan Cup next season, you may remember."

"Not me," said The Maltese Cat, politely. "I was at Malta then, pulling a vegetable cart. I don't race. I play the game."

"O-oh!" said the Arab, cocking his tail and swaggering off.

"Keep yourselves to yourselves," said The Maltese Cat to his companions. "We don't want to rub noses with all the goose-rumped half-breeds of Upper India. When we've won the cup, they'll give their shoes to know us."

"We shan't win the cup," said the Shiraz. "How do you feel?"

"Stale as last night's feed when a muskrat has run over it," said Polaris, a rather heavy-shouldered gray, and the rest of the team agreed with him.

"The sooner you forget that the better," said The Maltese Cat, cheerfully. "They've finished tiffin in the big tent. We shall be wanted now. If your saddles are not comfy, kick. If your bits aren't easy, rear; and let the saises know whether your boots are tight."

<div align="right">

RUDYARD KIPLING,

CONVERSATION BETWEEN TWO POLO PONIES, THE MALTESE CAT

</div>

Polo is thought to have originated in China and Persia around 2,000 years ago. Here, British men play the sport that was brought from India to England in 1872.

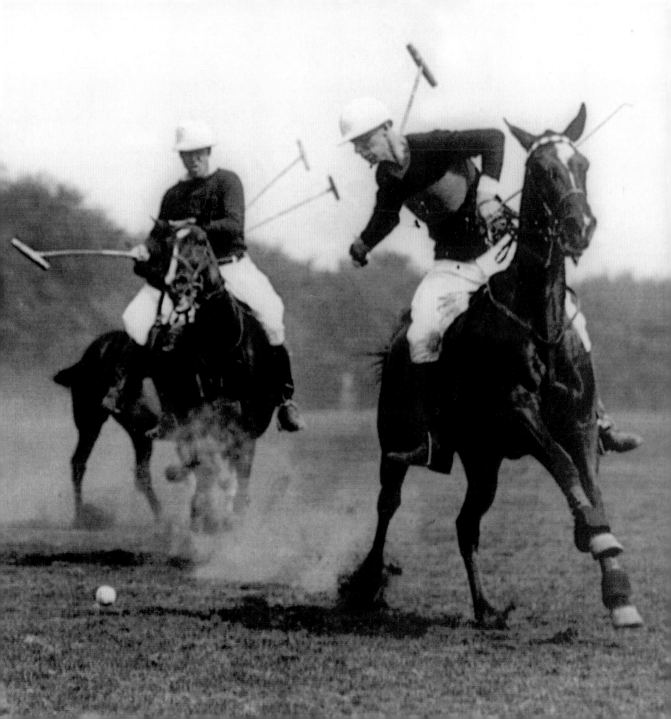

ROCKY THE BITTER CAR HATER

I spent the better part of my early years desperately wanting my own horse . . . I'm talking from age two on. When I turned seven, my father presented me with a fine looking dappled gray—a good 17 hands for sure. There were no questions asked. I was just thrilled to have him. Well, perhaps someone should have asked why this particular large beast was available for free!!! Turns out that he, Rocky the Horse, loathed automobiles of any shape or make—no exceptions. I believe he actually stalked them. At the end of a rough year, there was not a single car in the neighborhood that didn't sport deep, hoof-shaped dents. A petition was taken up amongst the bitter townsfolk and Rocky went off to while away the remainder of his days in a big, vehicle-free field.

JEAN LINDGREN, NEW YORK

FORMER CO-EXECUTIVE DIRECTOR, HAMPTON CLASSIC HORSE SHOW

RIGHT:
A Standardbred harnessed to a small sulkie, circa early 1900's.

PAGES 48-49:
Polo is thought to have originated in China and Persia around two thousand years ago. Here, British men play the sport that was brought from India to England in 1872.

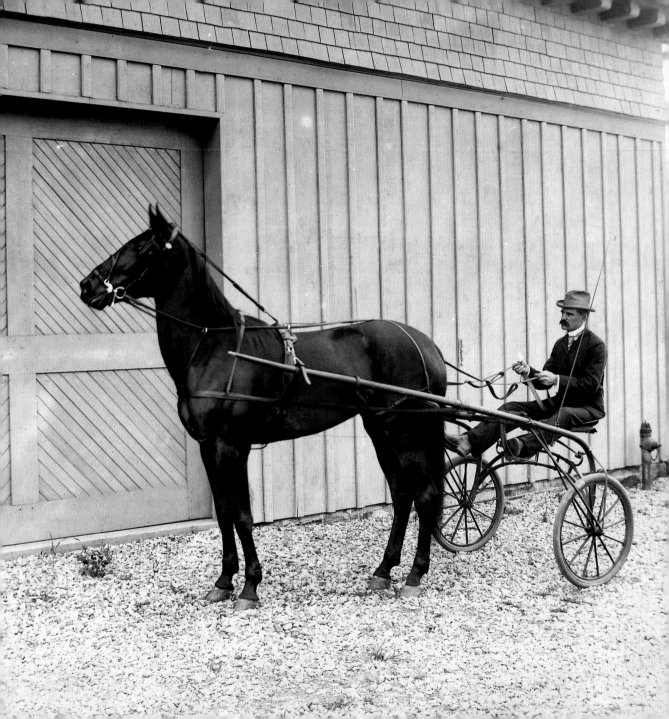

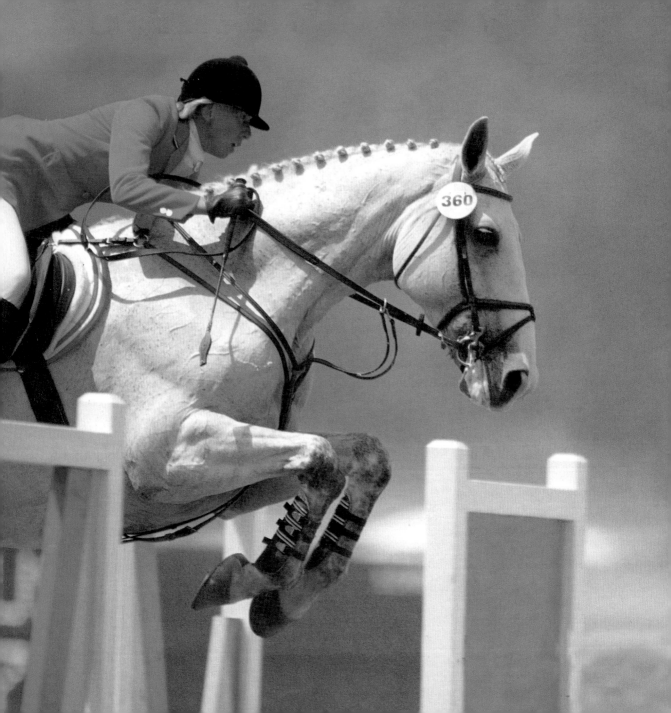

The 1984 Olympic silver medalist in the three-day event, Karen Stives of the USA takes Ben Arthur over a jump.

My sister Debbie had a great equitation horse. His name was "Three A.M." Our cousin Susan had gotten him from the track and trained him for hunter classes. When our parents bought him from Susan, Debbie discovered why Three hadn't made it at the track. He was one slow Thoroughbred. Any slower, he'd be going backwards, we joked. But he went where Debbie pointed him—and she did well with him, especially in equitation.

The ultimate was the day Debbie outrode Rodney Jenkins. Yes, THAT Rodney Jenkins, whose bio says he was a "master in the hunter ring . . . in the 1960s." We mostly showed at small shows in Virginia around Manassas, Warrenton, and Culpeper, so we'd heard of Rodney, who's from Orange, Virginia. Our paths didn't cross much: Rodney rode at "A" shows and, usually, our riding wasn't exactly A-circuit material. Sometimes, though, he showed where we showed. We had almost no formal training, other than the riding lessons drilled into us by our cousin. That day, with Three A.M.'s slow-but-steady stride, Debbie got it just right. In that one class, on that one glorious day in the 1960s, at a hunter show in Haymarket, Virginia, my little sister outrode the man who, more than 30 years later, would be inducted into the Show Jumping Hall of Fame.

JEAN FARMER, VIRGINIA

FULL-TIME WRITER/EDITOR, PART-TIME RIDER

In 2002, the western sport of reining made a huge leap when it became part of the World Equestrian Games. Seeing riders in cowboy hats was a big change for these audiences. We were thrilled but concerned, because you don't always know how a new sport is going to be received. Before our first competition in Jerez, Spain, Don Treadway, AQHA Senior Executive Director of Marketing; Michael Stone, FEI Development Director; and I discussed the attendance. It was well known that the Spanish are notorious for being late risers. They love those evening parties, but they take their time heading out in the morning. Stone forewarned us that attendance at our 11:00 A.M. event would be slight, probably around 500 people in an arena that could seat 5500, but that more people would probably show up for the finals.

We were disappointed but hopeful. By 10:30 we were headed for the nearly empty arena. By 11:00 only about 500 seats were filled. I thought, What a bust this is going to be for our WEG debut. Then suddenly the doors opened up and a steady stream of people started to flow in. Much to our amazement, the line continued, and by the time the competition was half over we were playing to a full house. Better yet, they were eagerly cheering and enjoying the skills of reining horses from around the world as they performed their rollbacks, slide stops, and more. Many in that audience had never seen a reining horse in action, and their enthusiasm was heartwarming. For the finals the arena overflowed, and the reiners performed to a standing-room-only audience that included the Queen of Spain. Since then it's been a constant uphill ride for reining, with our ultimate goal to one day be a featured sport at the Olympics. I've been part of that climb, and it's very gratifying for me to see the sport I know and love being so well received around the world.

FRANK COSTANTINI, OHIO

FEI REINING COMMITTEE CHAIRMAN AND FORMER PRESIDENT, NRHA

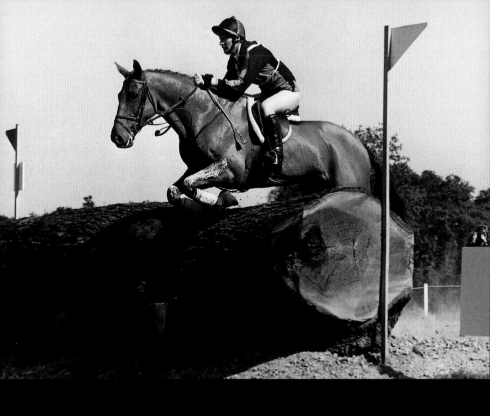

Mary Thompson and King Max in the first Copper Horse Section which took place in Windsor, England in 1989. Mary King (née Thompson) has represented Britain in numerous Olympic Games, starting with the 1992 Olympics in Barcelona, Spain.

KEEPING UP THE JUMPS (OR NOT!)

In the early 1970s, I was competing in the American Gold Cup (a very prestigious show jumping competition), which took place at the Rose Bowl in Pasadena, California. At that time I was Jimmy Williams' assistant trainer. George Morris was in town for the grand prix. George suggested we go to Hollywood Saturday night. We went, raised hell, and got back at 5 A.M. I was supposed to have an early-morning school session. I overslept, however, making it just in time to trailer the horses. Physically and mentally, I was not at my best. I was terrified at the size of the jumps.
Jimmy was so pissed at me that he made me school myself. Graciously, Champ Hough set fences for me. I went in the grand prix, had time faults and two refusals, and there probably wasn't a jump standing when I was done. I can laugh at it now, but it wasn't funny at the time. Needless to say, that never happened again.

Moral of the story: If you are going to play with the big boys, you'd better act like one.

MASON PHELPS, FLORIDA AND ONTARIO, CANADA

ALTERNATE OLYMPIAN, *1968,* MEXICO

RIGHT:
Alan Paul and Apollo, in North Suelton in 1990, fully extended over the wall as a packed house watches them meet the challenge.

OVERLEAF:
Olympic veteran Laura Kraut (USA) and Liberty competing in show jumping. Their third place finish in the Olympic selection trials earned them a berth on the 2000 Olympic team in Sydney, Australia. Kraut's love of horses began when she was quite young. She was riding at the age of three.

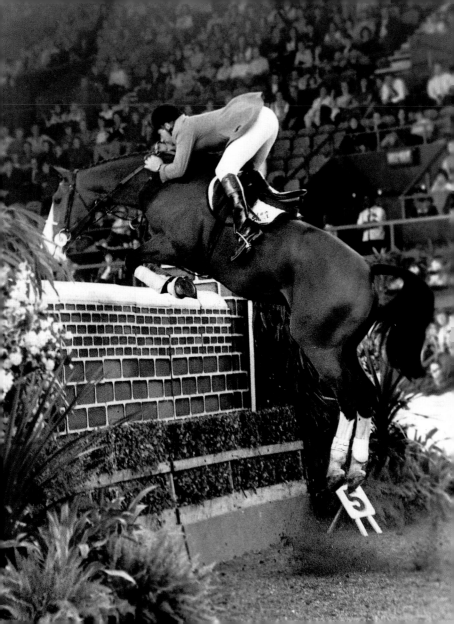

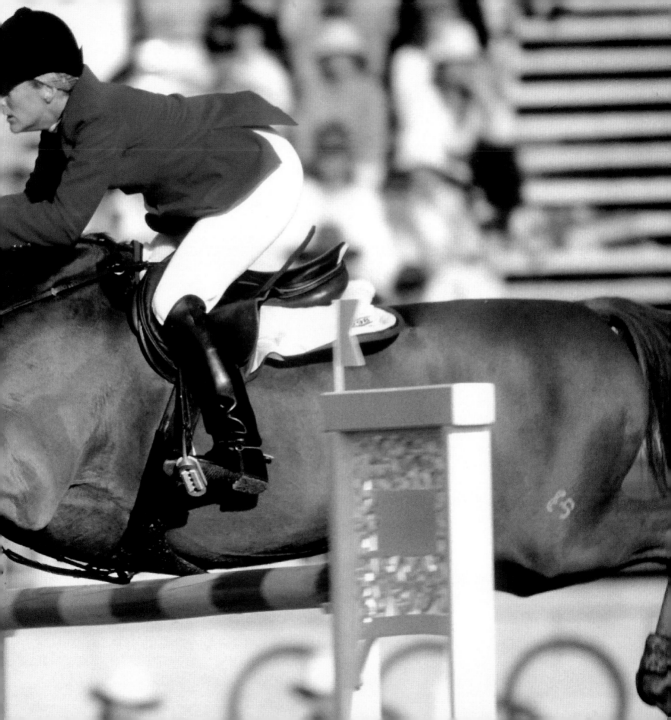

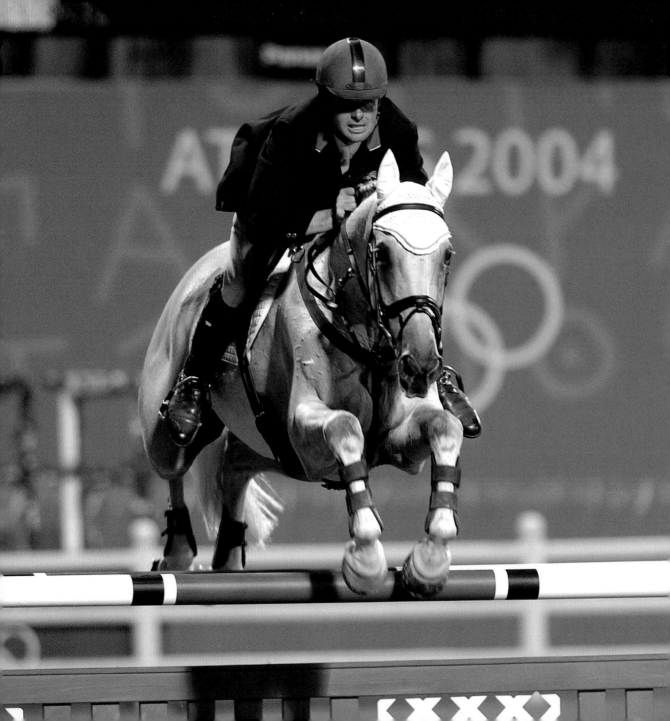

There is no way to tell non-horsey people that the companionship of a horse is not like that of a dog, or a cat, or a person. Perhaps the closest two consciousnesses can ever come is the wordless simultaneity of horse and rider focusing together on a jump or a finish line or a canter pirouette, and then executing what they have intended together. What two bodies are in such continuous, prolonged closeness as those of a horse and rider completing a hundred-mile endurance ride or a three-day event? I have a friend who characterizes riding as "one nervous system taking over another." I often wonder—which is doing the taking over, and which is being taken over?

JANE SMILEY, *PRACTICAL HORSEMAN*

Leslie Law (GBR) and Shear L'eau competing in the stadium jumping phase of the three-day event during the 2004 Olympic Games in Athens, Greece.

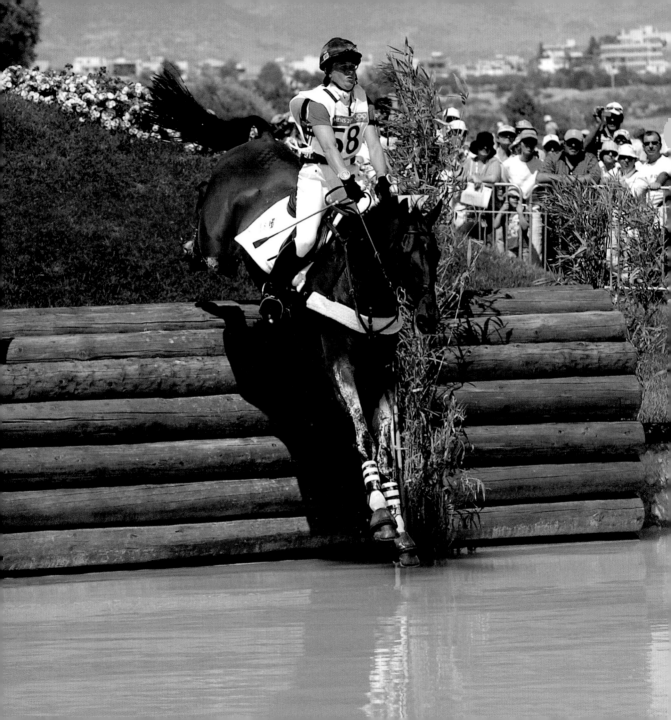

For horses can educate through first hand, subjective, personal experiences, unlike human tutors, teachers, and professors can ever do. Horses can build character, not merely urge one to improve on it. Horses forge the mind, the character, the emotions and inner lives of humans. People can talk to one another about all these things and remain distanced and lonesome. In partnership with a horse, one is seldom lacking for thought, emotion and inspiration. One is always attended by a great companion.

CHARLES DE KUNFFY

Pippa Funnell (GBR) and Primmore's Pride competing in the three-day event during the 2004 Olympic Games in Athens, Greece. A three-day event takes place over three days. The first phase is dressage, the second is cross country, and the final phase is stadium jumping.

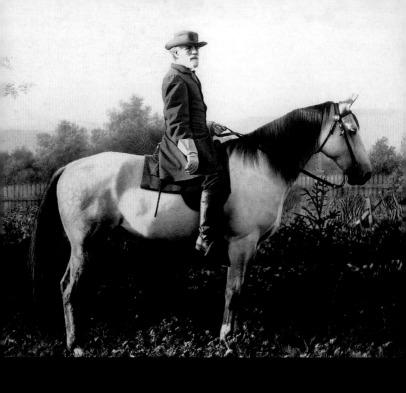

Robert E. Lee atop Traveller. Lee purchased his iron-gray horse in 1861 for $200 and rode him for most of the Civil War. Lee described his favorite horse as a "Confederate grey". After the war, Traveller lost much of his tail hair to admirers.

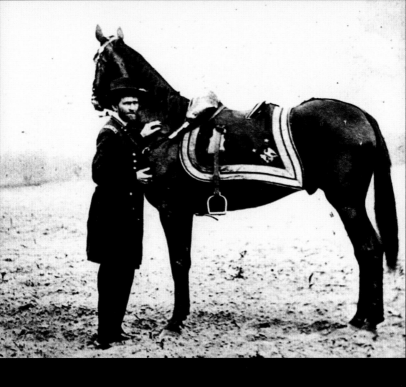

Union general and future president Ulysses S. Grant with one of his many mounts during the Civil War. Grant graduated low in his West Point class but gave a memorable jumping exhibition at the graduation ceremony.

I f you desire to handle a good war-horse so as to make his action the more magnificent and striking, you must refrain from pulling at his mouth with the bit as well as from spurring and whipping him. [...] but if you teach your horse to go with a light hand on the bit, and yet to hold his head well up and to arch his neck, you will be making him do just what the animal himself glories and delights in.

XENOPHON, *THE ART OF HORSEMANSHIP*

The famous Canadian Mounties performing their Musical Ride at the 2000 Royal Windsor Horse Show. In the early 1900s, the Canadian Mounties protected the Canadian Province. Nowadays we see them performing their Musical Ride all over the world.

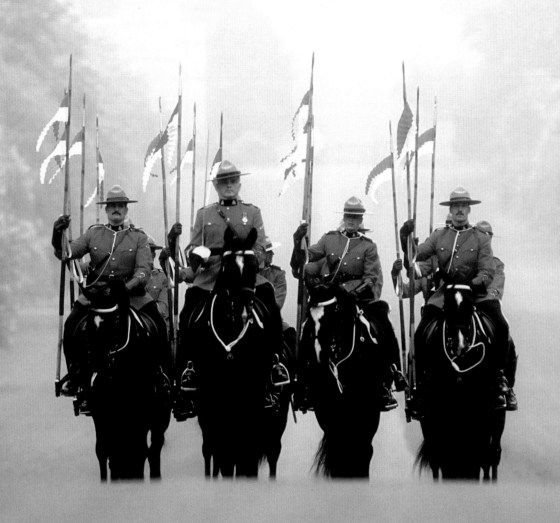

*These U.S. Cavalry horses seen in California in 1917 represent the many
military mounted troops that were trained to fight on horseback.*

A scene from "Wagon Train", a popular television show about a wagon train traveling across the unsettled American West in the late 1800's.

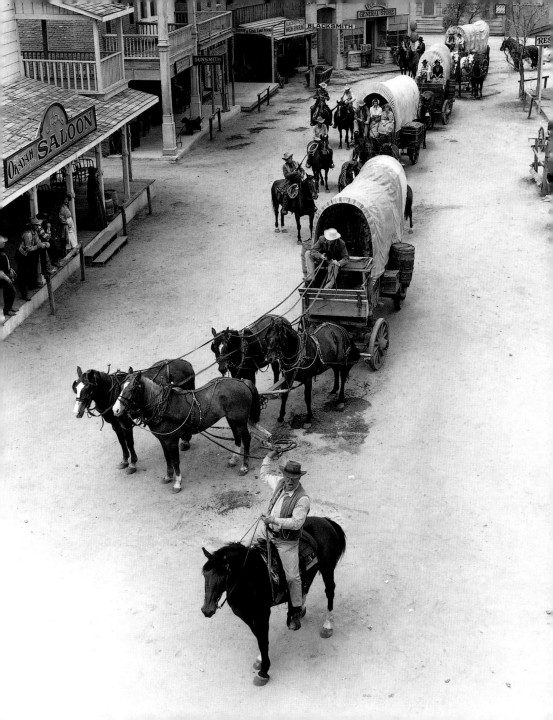

President Theodore Roosevelt was an avid horseman. He was a lieutenant colonel of the Rough Rider regiment during the Spanish-American War. The Rough Riders were the first U.S. voluntary cavalry organized by Theodore Roosevelt and Leonard Wood, M.D.

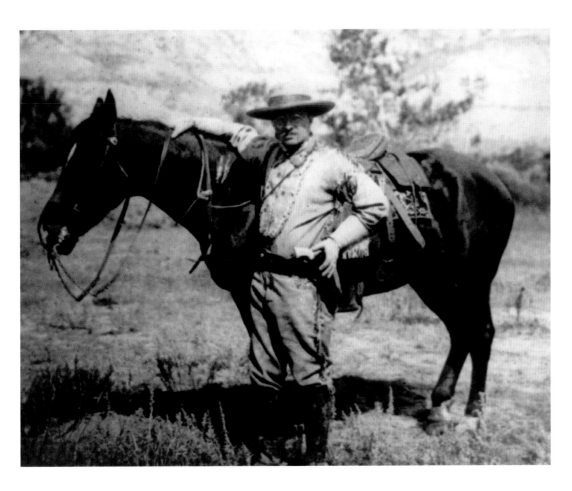

A naturalist and horse-lover, President Theodore Roosevelt takes a moment to relax with a horse. Riding was one of his favorite pastimes. Eventually a national park with more than 70,000 acres of areas for riders to roam was named after him in North Dakota.

Old fellow, your journeys are over. Here in the ocean you must rest. Would that I could take you back and lay you down beneath the billows of that prairie you and I have loved so well and roamed so freely; but it cannot be. How often at break of day, the glorious sun rising on the horizon has found us far from human habitation! Yet, obedient to my call, gladly you bore your burden on, little heeding what the day might bring, so that you and I but shared its sorrows and pleasures alike. You have never failed me. Ah, Charlie, old fellow, I have had many friends, but few of whom I could say that. Rest entombed in the deep bosom of the ocean! I'll never forget you. I loved you as you loved me, my dear old Charlie. Men tell me you have no soul but if there be a heaven, and scouts can enter there, I'll wait at the gate for you, old friend.

BUFFALO BILL CODY

SPEAKING TO THE BODY OF OLD CHARLIE

JUST PRIOR TO HIS BURIAL AT SEA ON MAY 17TH, 1887

Buffalo Bill Cody poses in his Wild West Show regalia, 1890. Although much has been said about Buffalo Bill, part from legend and part from fabrication, he did serve during the Civil War. As a young boy, after his father's death, he worked for a wagon-freight company as a mounted messenger.

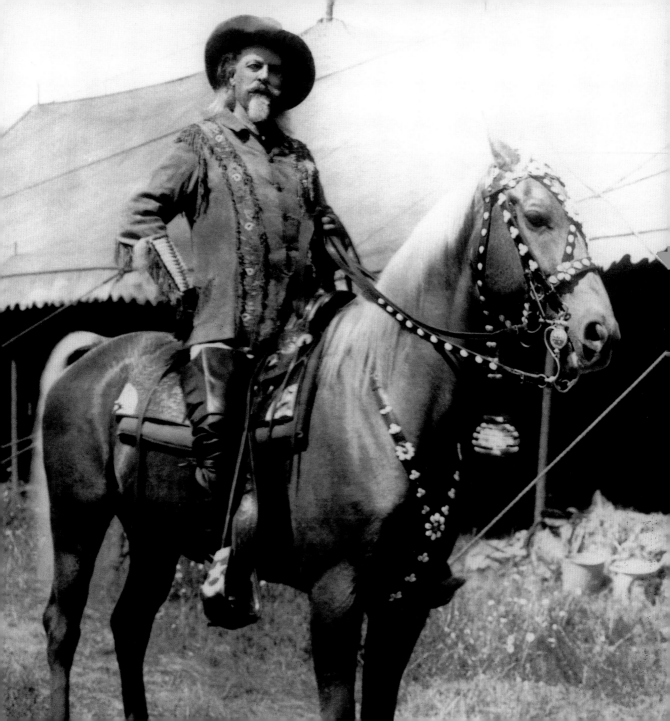

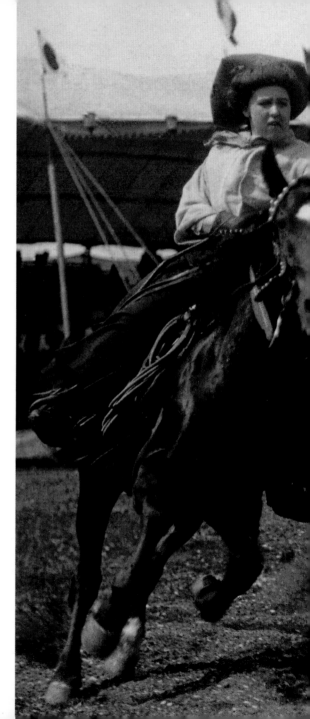

Steeds, steeds, what steeds!

Has the whirlwind

a home in your manes?

NIKOLAI GOGOL

Buffalo Bill's cowgirls race around the ring of his Wild West Show, 1905. It was from his hunting of buffalo in 1867 that he earned the nickname of Buffalo Bill. It is said that he killed 4,280 buffalo in 17 months.

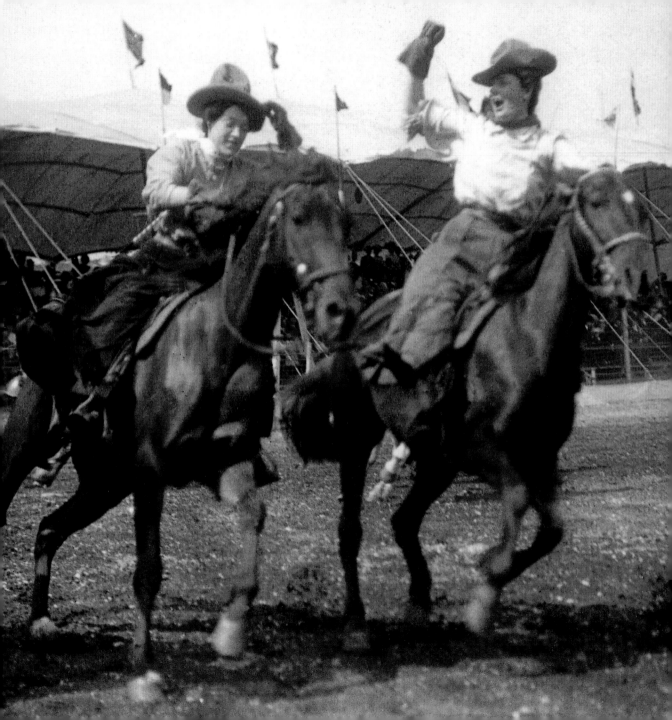

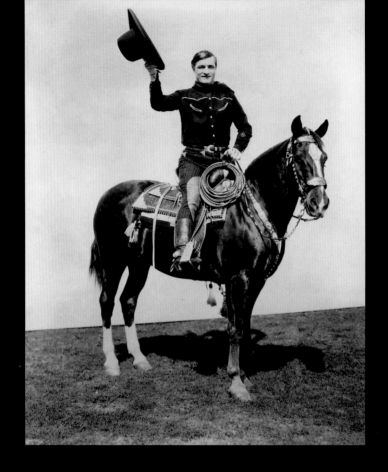

ABOVE:

Tom Mix, who was born near Mix Run, Pennsylvania, is known as the silent movie cowboy star. Here he is with his horse, Tony, who he acquired after his famous horse, Blue, died. He and Tony worked together for many years and a strong bond grew between them.

OPPOSITE:

Rand Brooks, Hollywood stuntman and actor, who was often seen in westerns, made his first film appearance in 1938. He also had a small cameo appearance in "Gone With the Wind," as Scarlett O'Hara's first husband. He is best known for his parts in the Hopalong Cassidy series as Lucky Jenkins and in "The Adventures of Rin Tin Tin" (1956–1958).

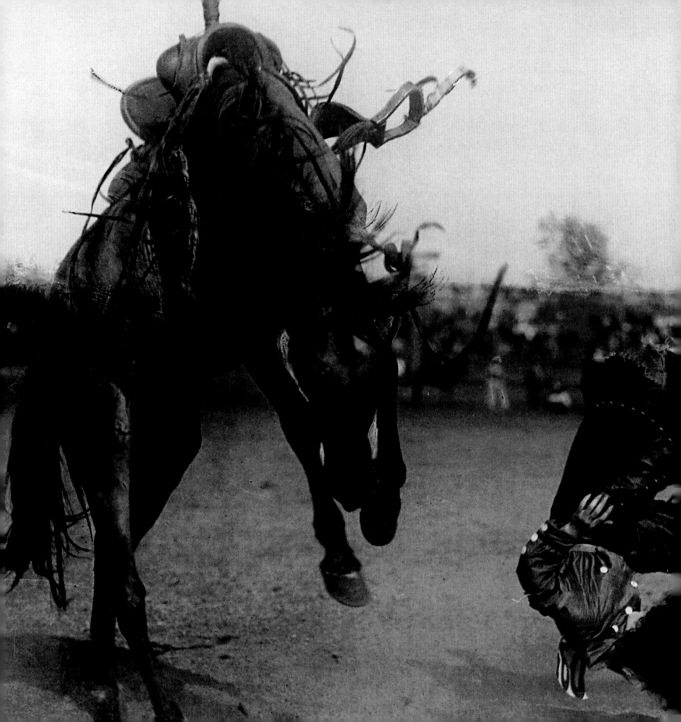

There is just as much

horse sense as ever, but the

horses have most of it.

ANONYMOUS

Circa 1900, Wild West Show rider Bonnie McCarroll is thrown from Silver. This cowgirl bronc rider from Idaho lost her life in 1929 when she was thrown and trampled while competing in the Pendleton Roundup Rodeo. After her death, the Roundup dropped cowgirls from competing at their rodeo.

Narrator: The Lone Ranger!

[gunshots are fired]

The Lone Ranger: Hi-Yo, Silver!

Narrator: A fiery horse with the speed of light, a cloud of dust and a hearty "Hi-Yo Silver"—the Lone Ranger!

The Lone Ranger: Hi-Yo, Silver, away!

Narrator: With his faithful Indian companion, Tonto, the daring and resourceful masked rider of the plains led the fight for law and order in the early West. Return with us now to those thrilling days of yesteryear. The Lone Ranger rides again!

FAMOUS OPENING LINES FROM "THE LONE RANGER"
TELEVISION SERIES, WHICH AIRED FROM 1949 TO 1957.

Who doesn't know the legendary Lone Ranger (Clayton Moore) and his trusty mount Silver, stars of both radio and television. That powerful phrase "Hi-Yo, Silver, away!" was all part of their fight for law and order for the masked man and his white horse.

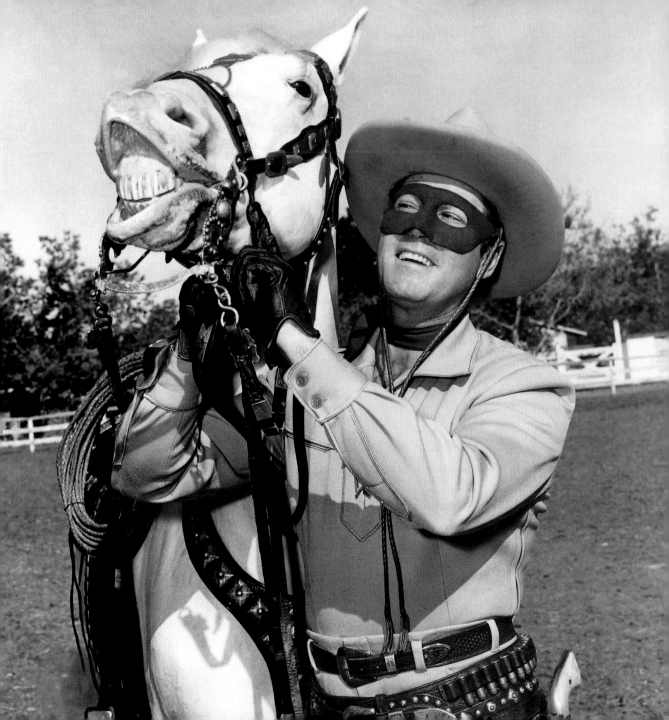

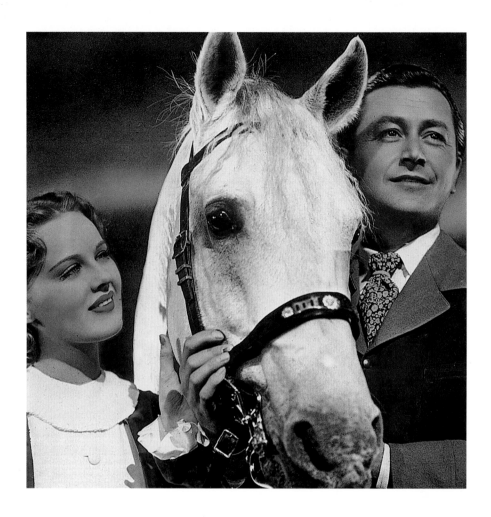

Helen Gilbert and Robert Young with "Florian" in the 1940 MGM film with the same name.
Young, who was in film from 1931 to 1952, appeared in some one hundred movies. This movie
focuses on how Young is brought together with Gilbert through their love of horses.

Florian strode as those horses strode who, centuries ago, triumphantly and conscious of their triumphant occasion, bore Caesars and conquerors into vanquished cities or in homecoming processions. The rigid curved neck, such as the ancient sculptors modeled; the heavy short body that seemed to rock on the springs of his legs, the interplay of muscle and joint, together constituted a stately performance, one that amazed the more as it gradually compelled the recognition of its rising out of the will to perfect performance. Every single movement of Florian's revealed nobility, grace, significance and distinction all in one; and in each of his poses he was the ideal model for a sculptor, the composite of all the equestrian statues of history.

FELIX SALTEN, *FLORIAN, THE EMPEROR'S STALLION*

He turns his old belly right up toward the sun,
He sure is uh sun-fishin' son-of-uh-gun,
He is the worst bucker I seen on the range,
He kin turn on uh nickle an' give yuh some change.

While he's uh-buckin' he squeals like uh shoat,
I tell yuh, that pony has sure got muh goat.
I claim that, no foolin', that bronk could sure step,
I'm still in muh saddle, uh-buildin' uh rep.

He hits on all fours, an' suns up his side,
I don't see how he keeps from sheddin' his hide.
I loses muh stirrups an' also muh hat,
I'm grabbin' the leather an' blind as uh bat.

With uh phenomenal jump he goes up on high
An' I'm settin' on nothin', way up in the sky,
An' then I turns over, I comes back tuh earth
An' lights in tuh cussin' the day of his birth.

Then I knows that the hosses I ain't able tuh ride
Is some of them livin'—they haven't all died.
But I bets all muh money they ain't no man alive
Kin stay with that bronk when he makes that high dive.

FROM *THE STRAWBERRY ROAN* BY CURLEY FLETCHER

Action-paced steer wrestling, which is based on speed, strength, timing, and balance, taking place in the United States. The bulldogger, or steer wrestler, works with both strength and technique to wrestle the steer, which is often twice his weight. Steer wrestling starts on horseback, but once the wrestler reaches the steer the action begins.

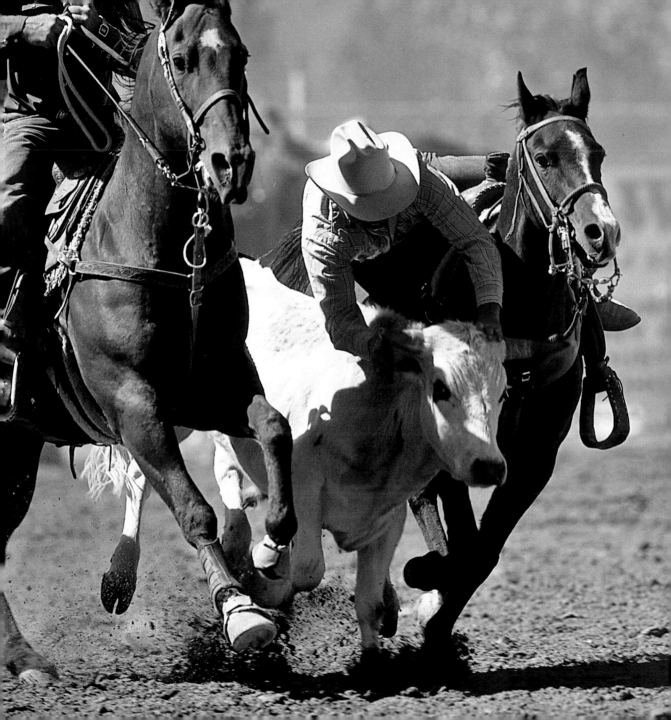

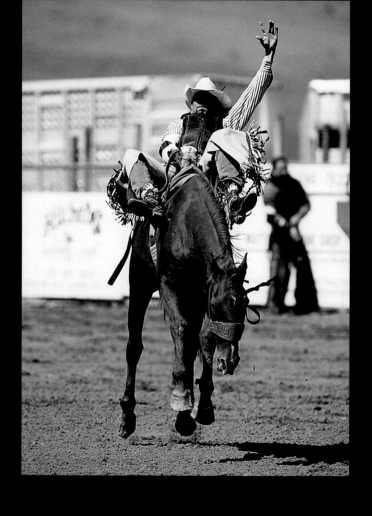

Two cowboys compete in bronco riding in the United States. Saddle bronc riding, a rodeo event, stems back to an earlier time in the Old West when "bronco men" went into town to compete against each other. The ultimate goal was to see who was the best at staying on the bucking horse.

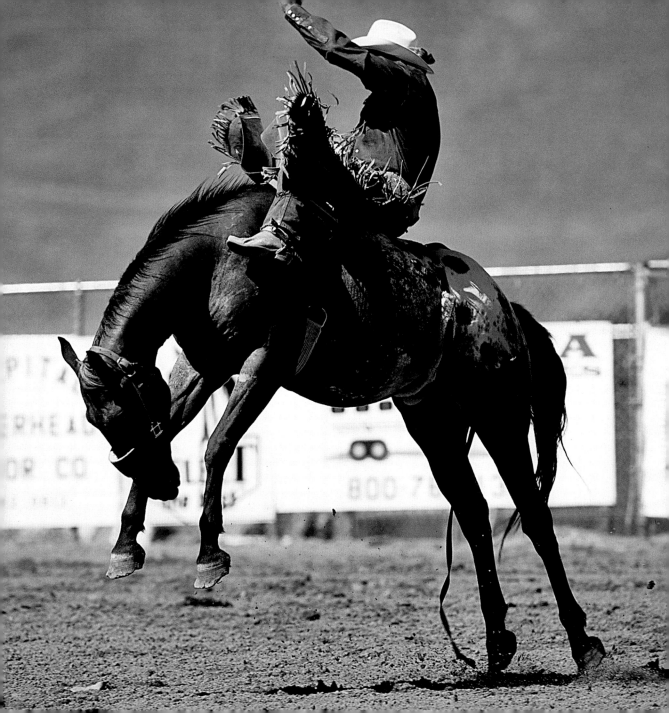

Of all the bad horses that I ever rode,
None was like him, for he seemed to explode.
He busted me up and I'm still stiff and lamed—
That Ridge Runnin' Outlaw will never be tamed.

The last time I saw him, he was crossin' a bridge,
He was high-tailin' back to his favorite ridge.
I've borrowed an outfit as I've none of my own—
My riggin' ran off on the Ridge Runnin' Roan.

FROM *THE RIDGE RUNNING ROAN* BY CURLEY FLETCHER

A cowboy in Colorado and his companions survey the land. The early
meaning of cowboy was a boy who took care of cows or cattle. Eventually that
evolved to include the performance of many duties on horseback.
Today cowboys work on ranches, ride in rodeos, and more.

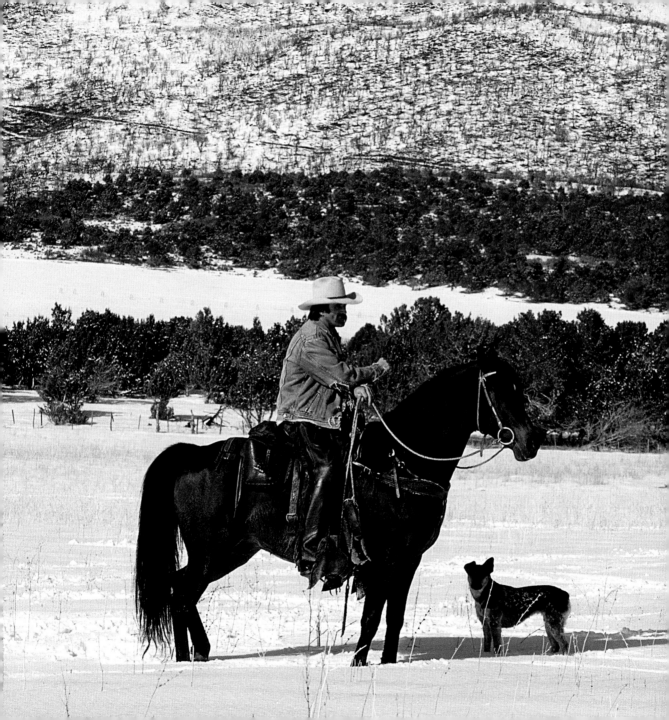

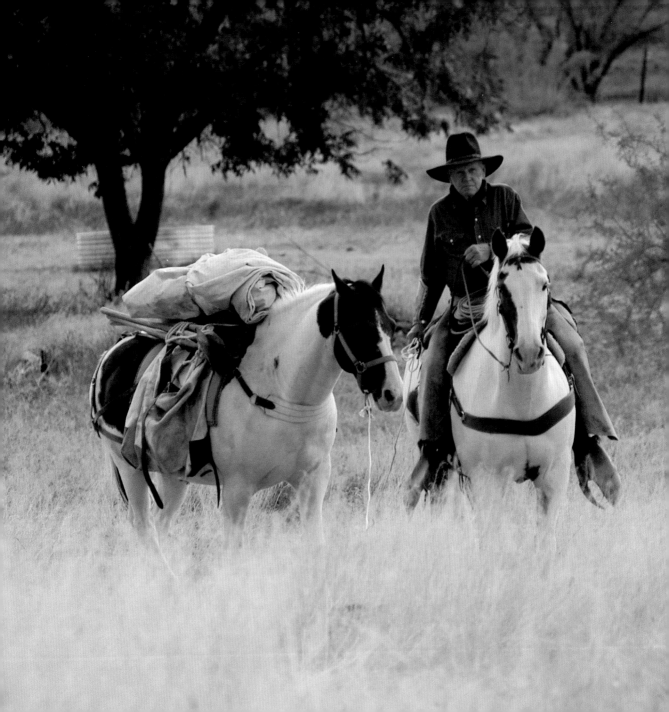

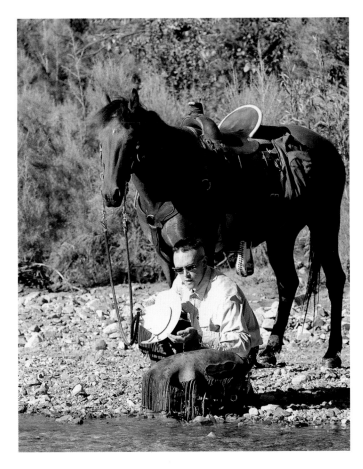

Cowboy Stephen White at the Gold Bar Ranch in Walnut, Arizona in 2005. A ranch or farm is generally considered a place to raise livestock, and when we think of a cowboy, we envision someone working with cattle. Although many cowboys do spend much of their time on the ranch they're also seen at rodeos or competing in a variety of western events.

Cowboy James Stocker with his Paint horses at the Lazy J Dude Ranch in Wickenburg, Arizona in 2003. Paint horses come in three patterns: tobiano, overo, and tovero. The differences are based on how the color is distributed over the horse's body.

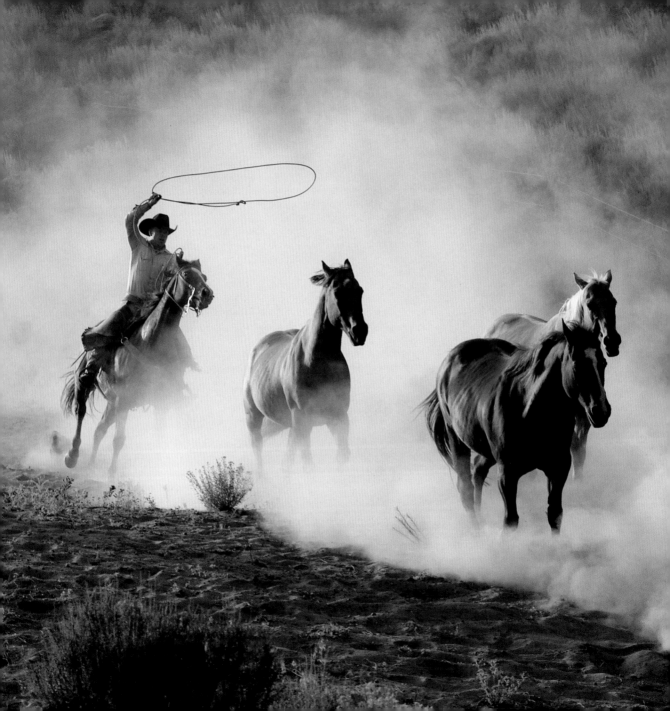

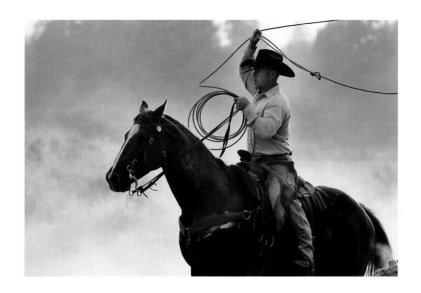

Spending that many hours in the saddle gave a

man plenty of time to think. That's why so many cowboys

fancied themselves philosophers.

C. M. RUSSEL

ABOVE:

Cowboy Hud Crites roping on his Quarter Horse at Rock Springs Guest Ranch in Bend, Oregon in 2005. Roping involves two cowboys. The first roper (the header) throws a rope (loop) around the steer's horns or neck. The second roper (the heeler) rides up to the steer in tow and throws a loop around the steer's hind legs.

OPPOSITE:

Cowboy Hud Crites roping on his Quarter Horse at Rock Springs Guest Ranch in Bend, Oregon in 2005. Team Roping is the classic American sport that is based on the working cowboy gathering cattle. The sport is a timed event that involves two mounted riders (ropers) who catch a steer with their ropes.

That night as he lay in his cot he could hear music from the house and as he was drifting to sleep his thoughts were of horses and of the open country and of horses. Horses still wild on the mesa who'd never seen a man afoot and who knew nothing of him or his life yet in whose souls he would come to reside forever.

CORMAC MCCARTHY, *ALL THE PRETTY HORSES*

RIGHT:
A herd of mustangs.

PAGES 98-99:
These Quarter Horse geldings are enjoying their time together at this Montana ranch. Horses tend to stay together in herds and work through their own hierarchy based on the dominating characteristics of the horses in the herd.

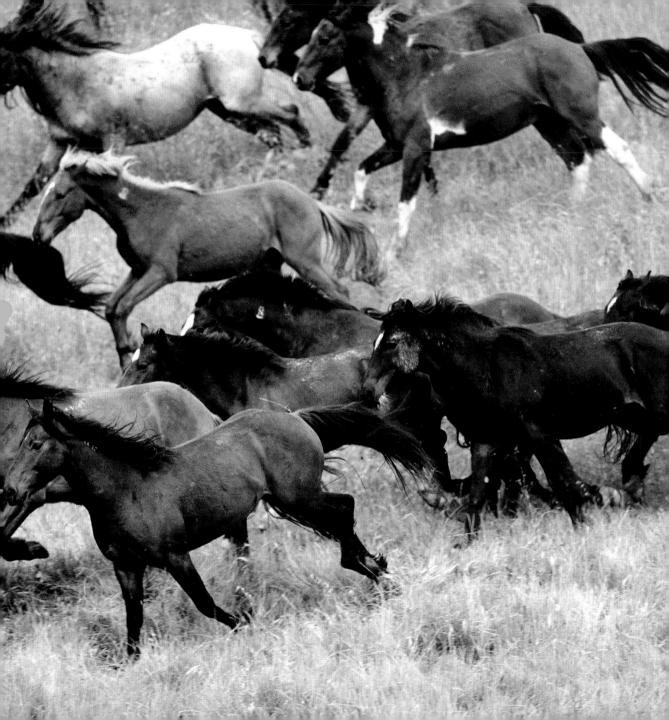

Hast thou given the horse strength? Hast thou clothed his neck with thunder? Canst thou make him afraid as a grasshopper? The glory of his nostrils is terrible. He paweth in the valley, and rejoiceth in his strength: he goeth on to meet the armed men. He mocketh at fear, and is not affrighted; neither turneth he back from the sword. The quiver rattleth against him, the glittering spear and the shield. He swalloweth the ground with fierceness and rage: neither believeth he that it is the sound of the trumpet. He saith among the trumpets, Ha ha; and he smelleth the battle afar off, the thunder of the captains, and the shouting.

THE BOOK OF JOB **39:19-25**

Time for these Camargue ponies to relax as they meander through tall grass in a field in France. Ponies come in three sizes: small (12.2 hands high and under), medium (12.3 to 13.2) and large (13.3 to 14.2).

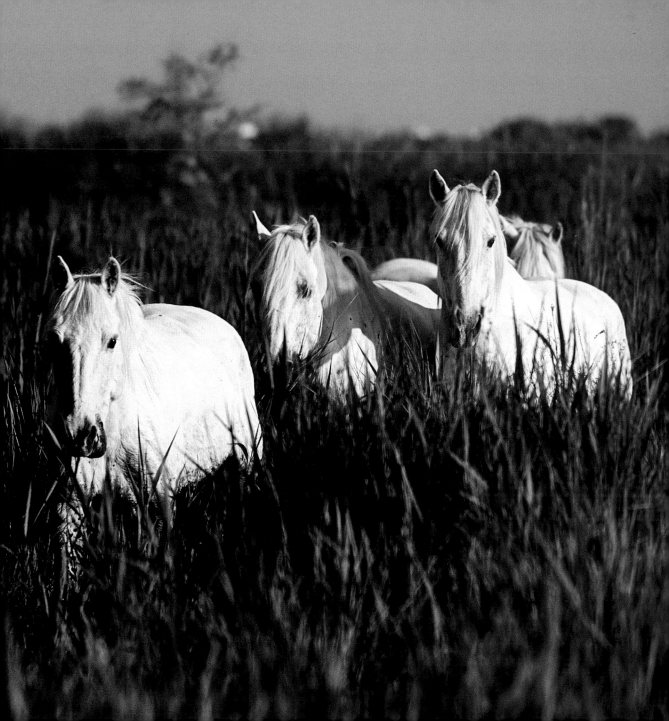

When God created the horse he said to the magnificent creature:

I have made thee as no other. All the treasures of the earth

lie between thy eyes. Thou shalt carry my friends upon thy back.

Thy saddle shall be the seat of prayers to me. And thou fly

without wings, and conquer without any sword. Oh, horse.

THE KORAN

OPPOSITE:
A Camargue pony in France. Camargue ponies are generally referred to as horses but because of their small size they are really ponies. These ponies are muscular with a stocky build. Most Camargue ponies are born black, dark grey, or brown, with a white blaze.

PAGES 104-105:
A Camargue pony peers through the grass at a farm in France. The Camargue generally lives in watery or marshy areas in the southeastern part of France. The region is known for its cold winters and hot summers, to which the hardy Camargue pony has adapted.

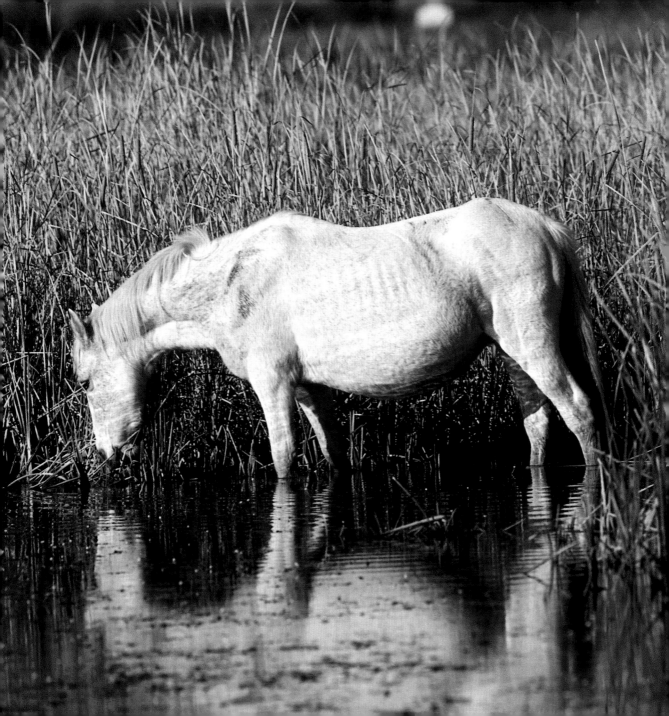

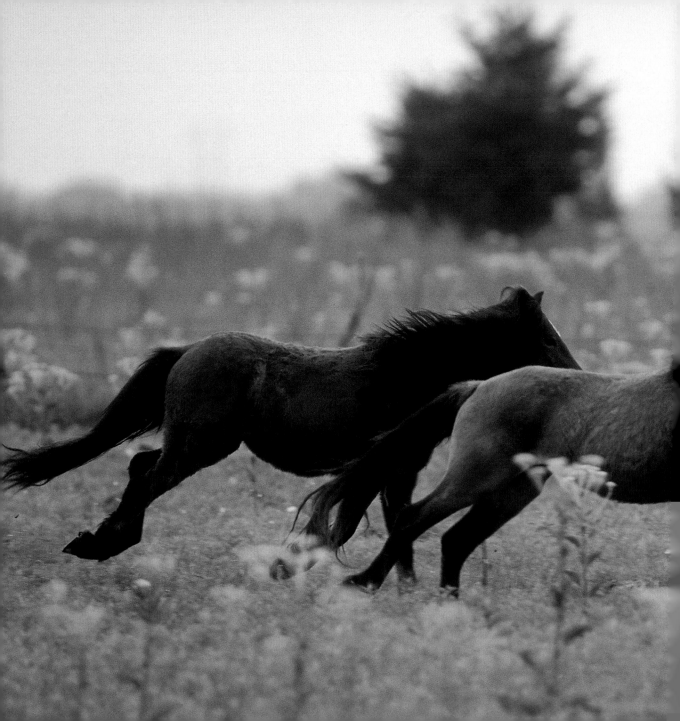

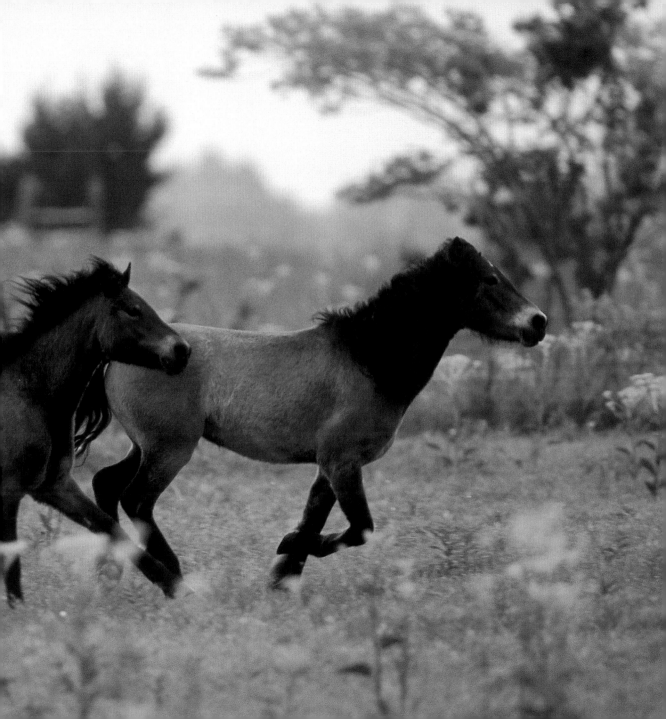

God forbid that I should

go to any heaven

in which there are no horses.

R. B. CUNNINGHAME GRAHAM

PAGES 106-107:
Dartmoor ponies in England. The Dartmoor pony is often used when teaching children to ride because of their calm disposition. They also are good for pulling carriages.

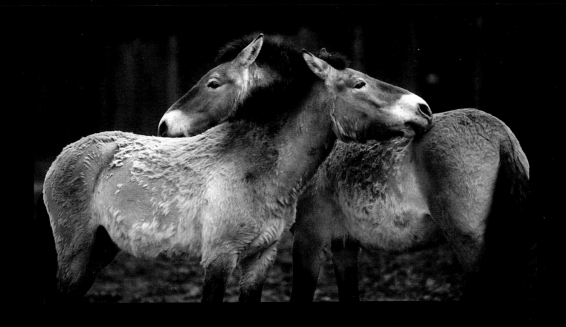

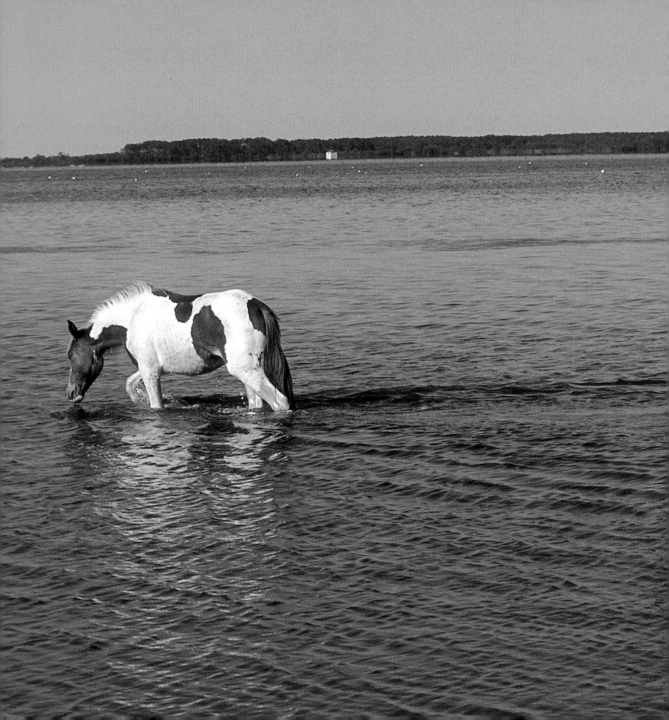

HORSES PROVIDE FREEDOM

I have never considered myself to be very much of a horse expert. In fact, all of my participation in athletics has, over the years, been from the sidelines. You see, as a result of an accident in 1990, I have been paralyzed from my neck down and confined to a wheelchair. As a child growing up, though, I defined my life by the physical activities I was engaged in, and to this day I have a deep appreciation of athleticism.

My first experience with the horse-riding community took place at the 2005 Hampton Classic. On a sun-drenched summer day, my family and I drove out to Long Island's east end, where we had the privilege to watch some of the sport's finest. Watching the riders perform in front of the crowds seemed to be the very essence of freedom and exhilaration. Both the horses themselves and the riders on their backs were so graceful and so beautiful. Although I wasn't taking part in the sport directly, my ability to watch the talent and share the day restored for me all the excitement and freedom I have valued in life.

BROOKE ELLISON (27), LONG ISLAND, NY

VENTILATOR-DEPENDENT QUADRIPLEGIC

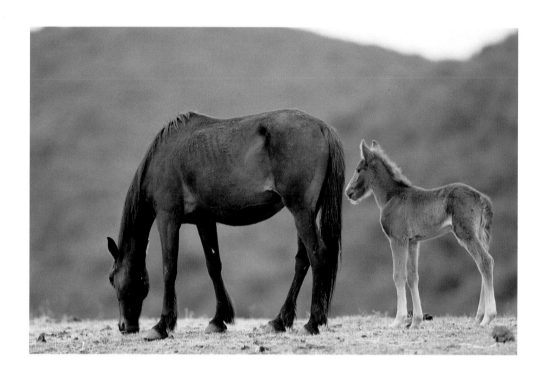

Mustang mare and foal at Gardner Ranch in California. The mustang is a feral or wild horse found in the western United States. The mustang is considered to be a descendant of the Spanish horse.

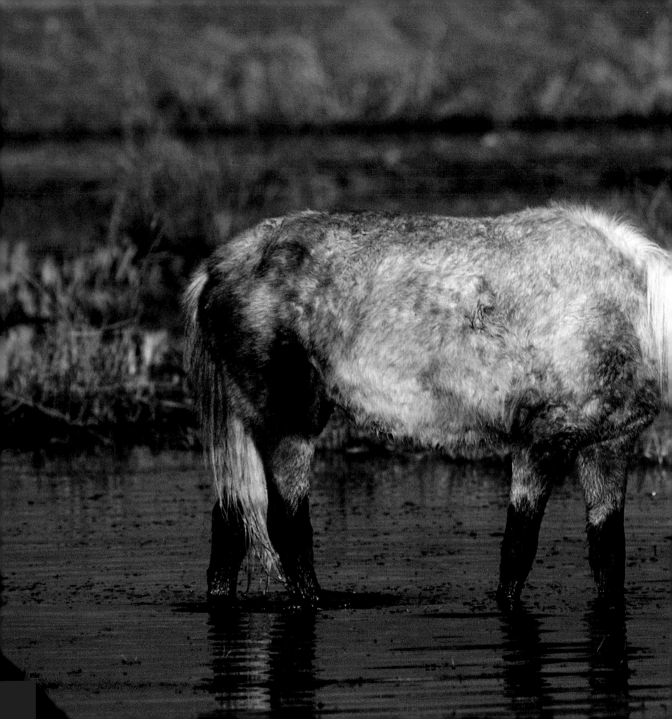

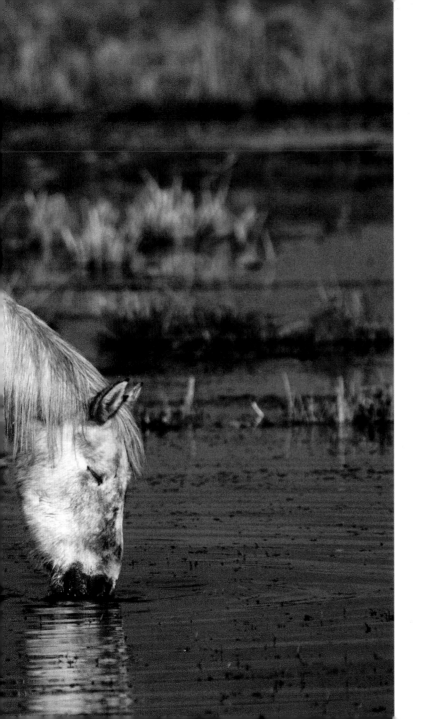

No philosophers

so thoroughly comprehend us

as horses.

HERMAN MELVILLE

Camargue ponies—one of the oldest breeds in the world—are sometimes referred to as the "horse of the sea," because they tend to run wild in marsh-lands. They often can be found in a somewhat isolated environment and are a protected breed.

The wind of heaven is that which

blows between a horse's ears.

ARABIAN PROVERB

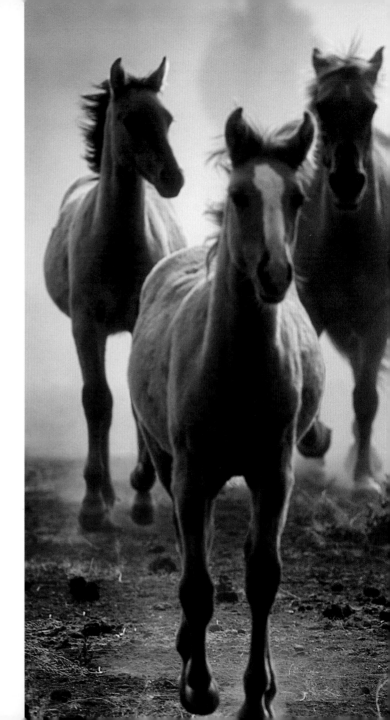

Kiger mustangs in Oregon. Their origins stem back more than 500 years when Spanish conquistadors arrived on the shores of North America. Kigers are a particular breed of mustang and are limited in number.

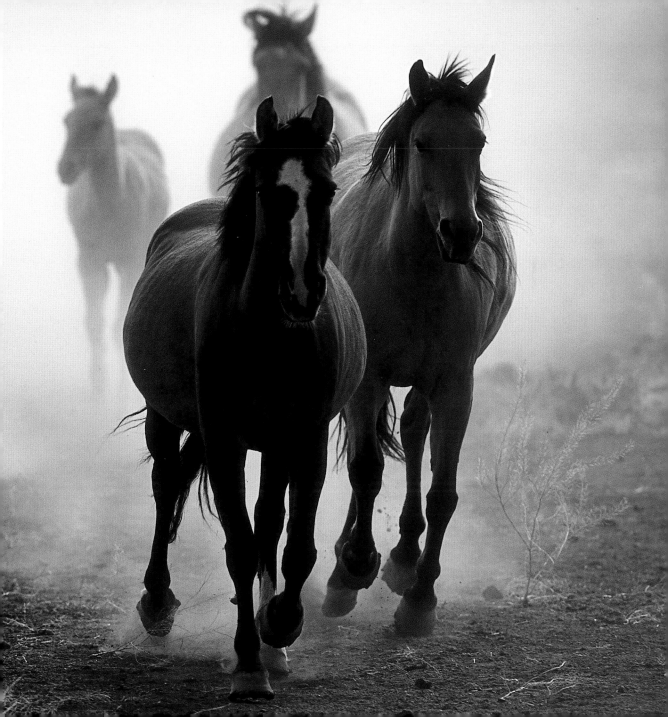

As a horse, stabled and fed, breaks loose and gallops gloriously over the plain to the place where he is wont to bathe in the fair-flowing river—he holds his head high, and his mane streams upon his shoulders as he exults in his strength and flies like the wind to the haunts and feeding ground of the mares—even so went forth Paris from high Pergamus, gleaming like sunlight in his armour, and he laughed aloud as he sped swiftly on his way.

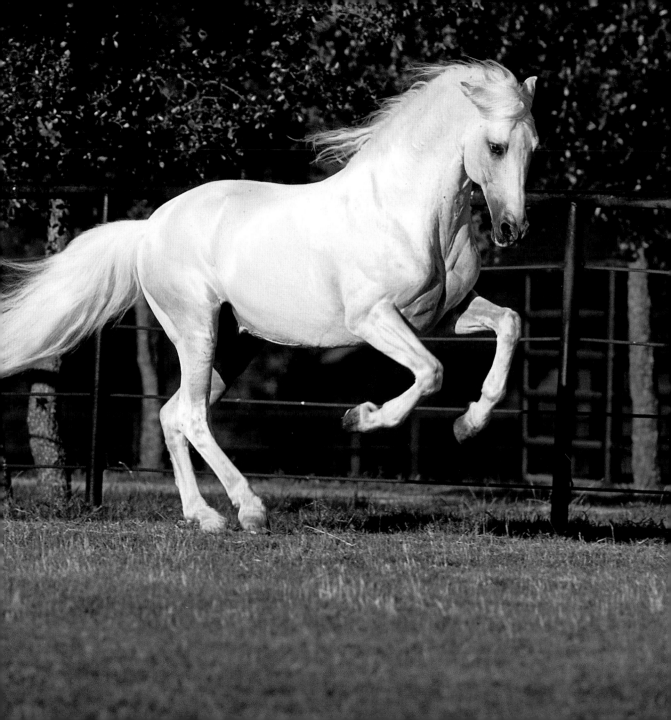

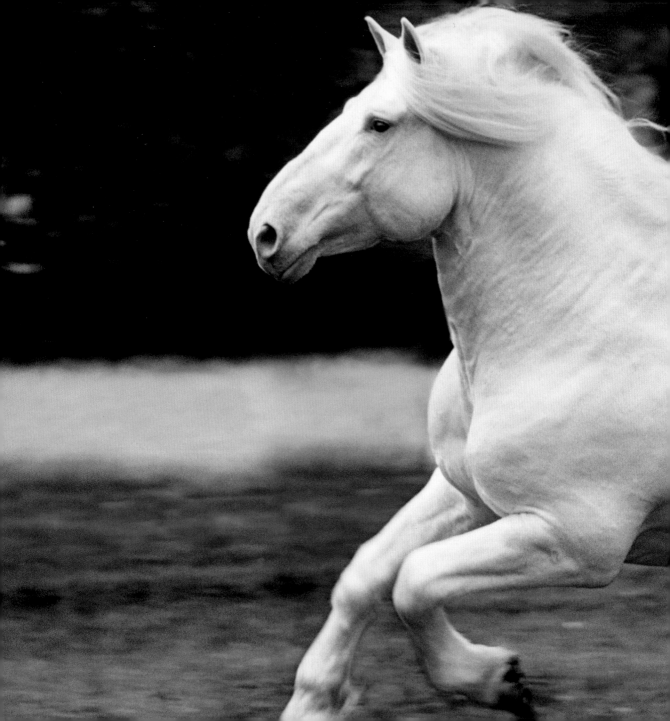

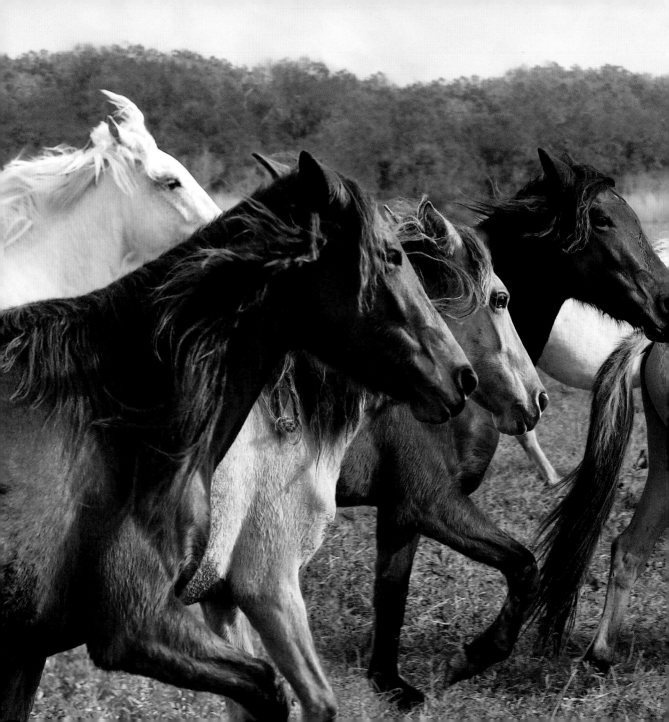

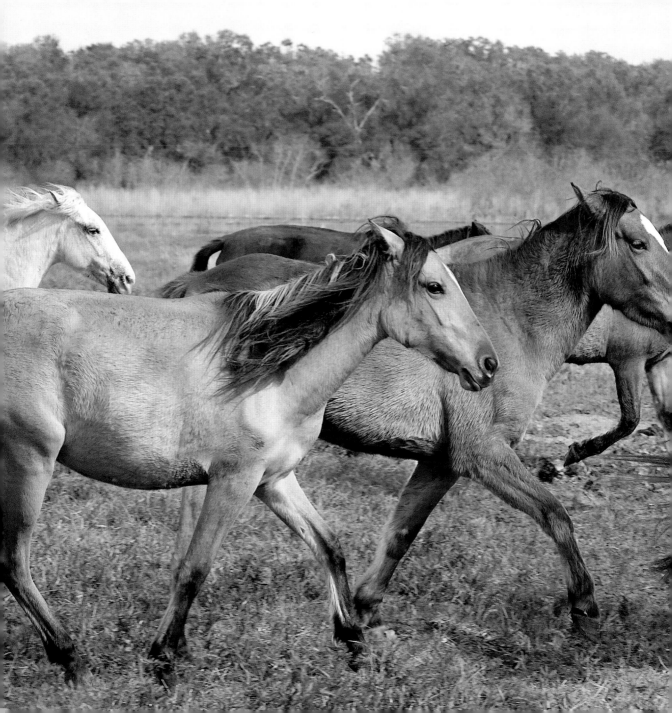

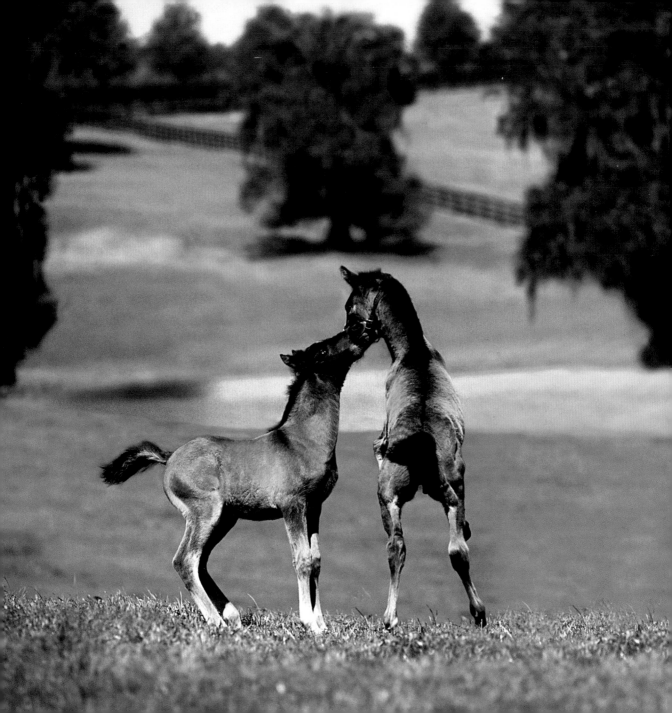

For what the horse does under compulsion, as

Simon also observes, is done without understanding;

and there is no beauty in it either, any more than

if one should whip and spur a dancer.

XENOPHON, *THE ART OF HORSEMANSHIP*

PAGES 122-123:
*A herd of Spanish mustang horses gallop across the Florida prairie scrub. The
name "mustang" derives from the word mesteth, meaning "band or herd of horses."*

LEFT:
*Two Arabian foals play on this rise overlooking a pond. There are different strains
of Arabians, but the presence and stature of this horse cannot be mistaken,
especially the high carriage of both the arching neck and tail.*

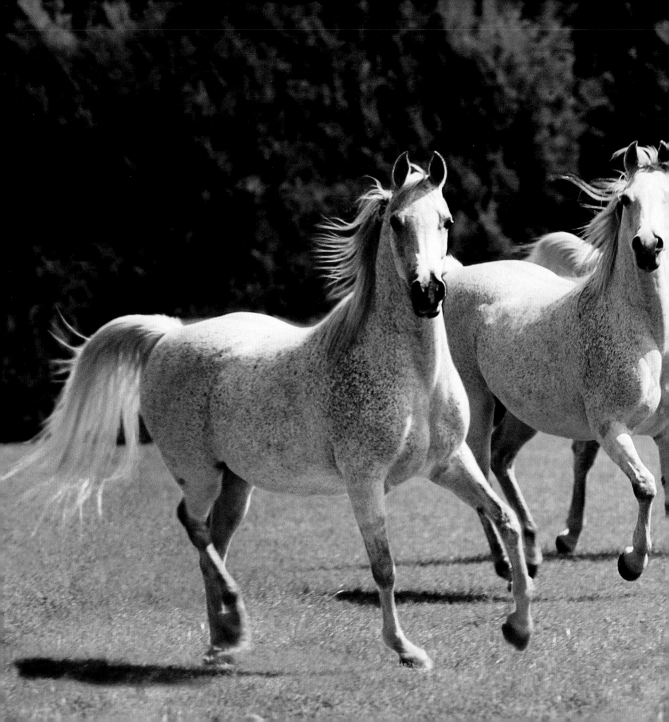

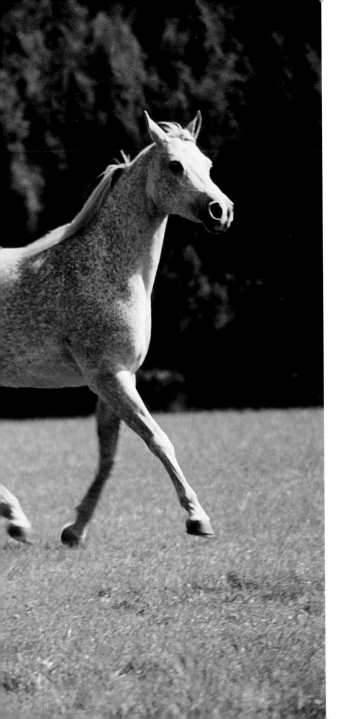

To know the Arabian horse is to love him.

ANONYMOUS

LEFT:

Three grey Arabian mares trot fancifully across an open paddock. Religious belief and superstition are said to have influenced the Arabian breed. Some believe the bulging forehead held the blessings of Allah.

OVERLEAF:

These two statuesque Arabian mares share some special nuzzling moments in an Ocala, Florida paddock. Great emphasis has always been put on keeping the breed pure. Originally, the Arabian horse was used for war, and for capturing herds of sheep, camels, and goats. Their speed and endurance were needed to successfully escape with their bounty.

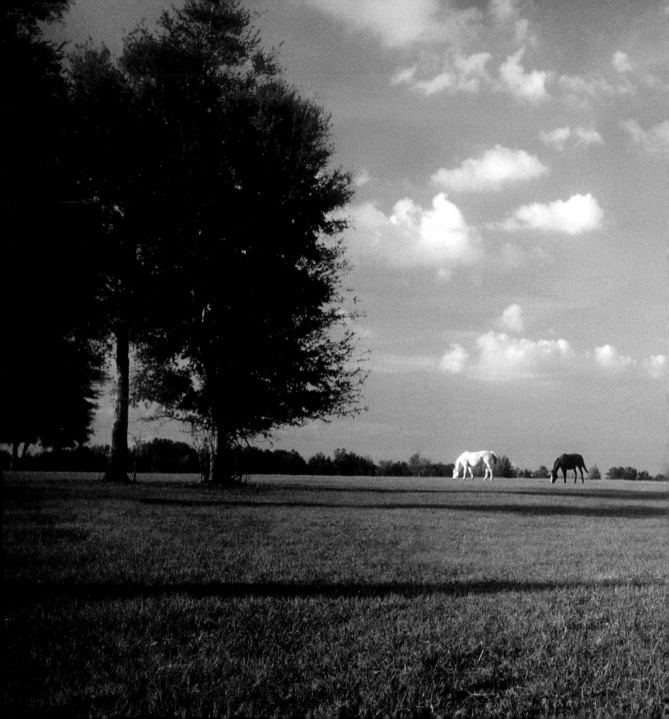

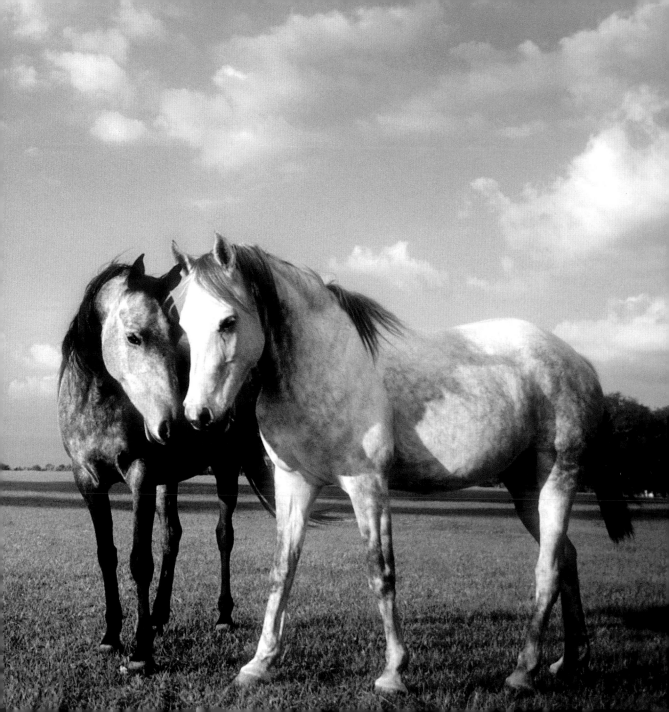

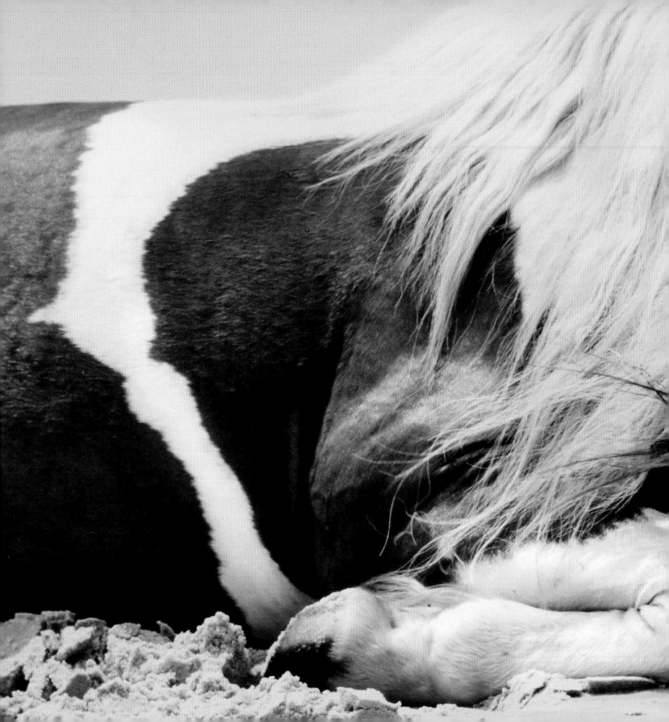

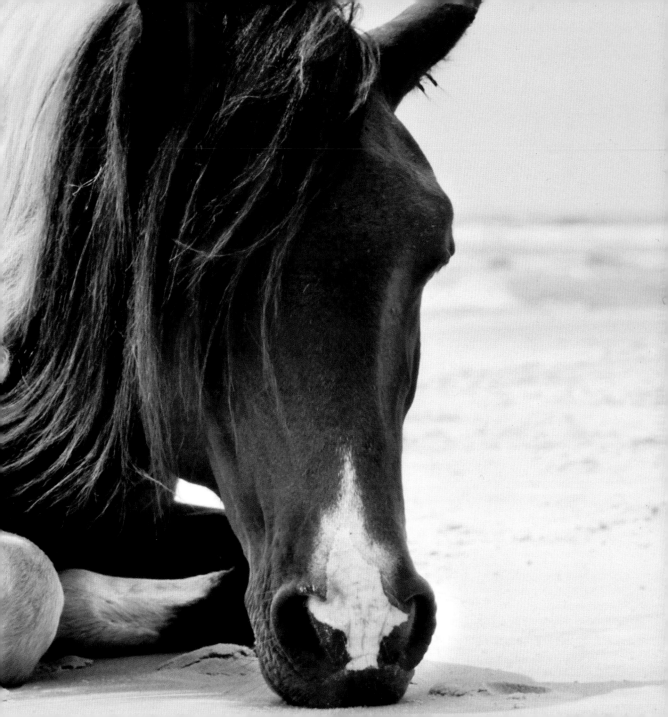

P robably no other living thing has had such an impact on our lives as the horse. Likely no other animal has exerted such an influence on the cultural and social development of man. Certainly the opening of the western frontiers of America was made possible by horses that were ridden and packed under saddle and those that worked in harness.

ANDY RUSSELL, *TRAILS OF A WILDERNESS WANDERER*

PAGES 130-131:
A Chincoteague pony stallion lying on the beach on the Assateague Island in Virginia. Most of these ponies resemble the Welsh or Arabian. The ponies have a distinctive look. Their broad forehead has a slightly dished short face with large nostrils. They come in all colors and their average size is between 12 and 13 hands.

OPPOSITE:
A herd of weanling horses run in the early morning fog. The process of weaning the younger horses from their mothers is helped along by putting them in herds together.

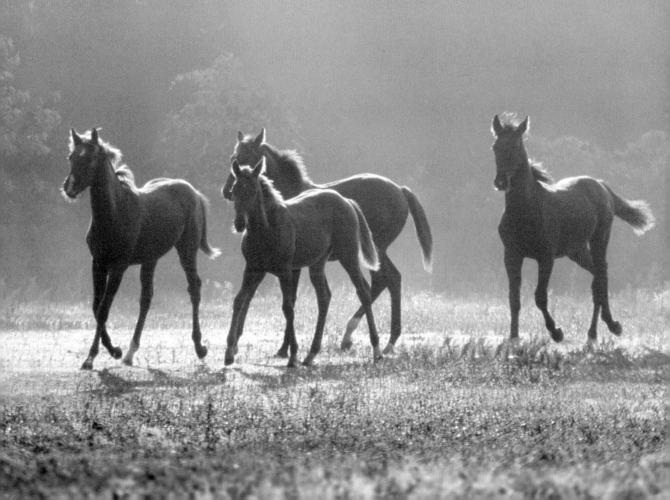

A nd when he looked at his father, the longing in his eyes was for that—for a colt of his own. "If I had a colt, I'd make it the most wonderful horse in the world. I'd have it with me all the time, eating and sleeping, the way the Arabs do in the book Dad's got on the kitchen shelf." He stroked Cigarette's nose with the unconscious gesture of an automaton. "I'd get a tent and sleep in it myself, and I'd have the colt beside me, and it would have to learn to live just the way I do; and I'd feed it so well it would grow bigger than any other horse on the ranch; and it would be the fastest; and I'd school it so it would follow me wherever I went, like a dog—" At this he paused, struck through and through with bliss at the thought of arousing such devotion in a horse that it would follow him.

MARY O'HARA, *MY FRIEND FLICKA*

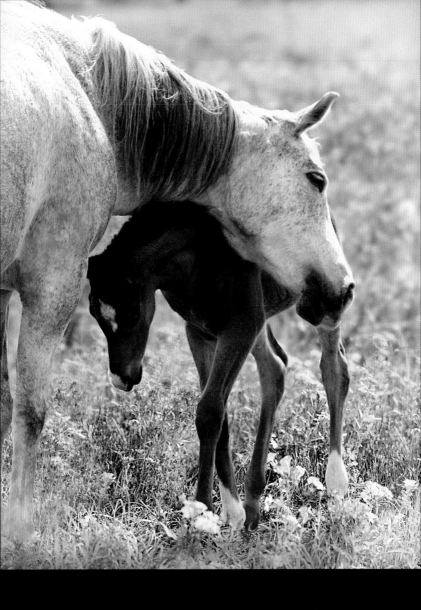

An Arabian mare tenderly rubs her foal as they stand in a field of wild phlox.

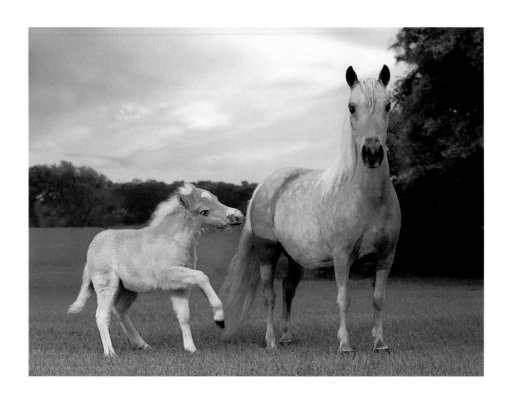

A Palomino miniature mare and foal show off their golden color with their dark eyes and white mane and tail. Miniatures are small horses that are used in many ways including carriage pulling, miniature competitions, or as pets.

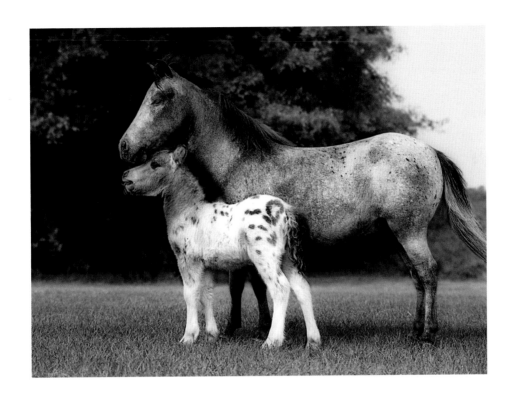

This miniature horse mare tenderly touches her foal. It is said that the first true miniatures came from Europe as early as the 1600s. They were often seen as pets for European nobility.

H e opened the door, and Vronsky went into the horse-box, dimly lighted by one little window. In the horse-box stood a dark bay mare, with a muzzle on, picking at the fresh straw with her hoofs. Looking round him in the twilight of the horse-box, Vronsky unconsciously took in once more in a comprehensive glance all the points of his favorite mare. Frou-Frou was a beast of medium size, not altogether free from reproach, from a breeder's point of view. She was small-boned all over; though her chest was extremely prominent in front, it was narrow. Her hind-quarters were a little drooping, and in her forelegs, and still more in her hind legs, there was a noticeable curvature. The muscles of both hind and forelegs were not very thick; but across her shoulders the mare was exceptionally broad, a peculiarity specially striking now that she was lean from training. The bones of her legs below the knees looked no thicker than a finger from in front, but were extraordinarily thick seen from the side. She looked altogether, except across the shoulders, as it were pinched in at the sides and pressed out in depth. But she had in the highest degree the quality that makes all defects forgotten: that quality was *blood*, the blood *that tells*, as the English expression has it. The muscles stood up sharply under the network of sinews, covered with the delicate, mobile skin, as soft as satin, and they were hard as bone. Her clean-cut head, with prominent, bright, spirited eyes, broadened out at the open nostrils, that showed the red blood in the cartilage within. About all her figure, and especially her head, there was a certain expression of energy, and, at the same time, of softness. She was one of those creatures, which seem only not to speak because the mechanism of their mouth does not allow them to.

LEO TOLSTOY, *ANNA KARENINA*

A poignant portrait of an Arabian mare bonding with her foal.
Arabians are often referred to as "hot-blooded" and are considered one
of the most beautiful breeds of horses. These horses are quick to learn.

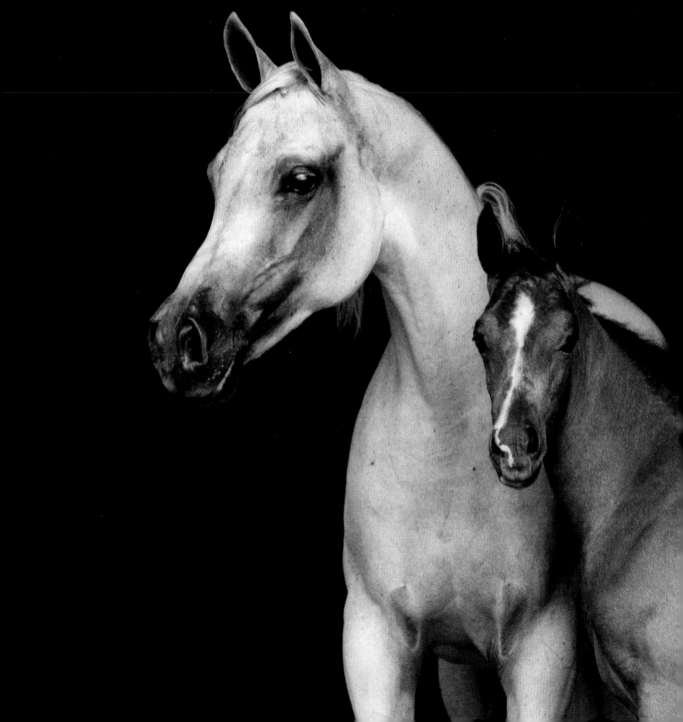

A pony is a childhood dream,

a horse is an adulthood treasure.

REBECCA CARROLL

*A newborn Appaloosa stands and nurses for the first time. It's important
for the health of a newborn foal to stand and nurse as soon as possible.*

140

There is no secret closer than what passes

between a man and his horse.

R. S. SURTEES

The Black Stallion, *1979*
Young Alec Ramsey (Kelly Reno) and the Black Stallion (Cass-Olé) swim in the deserted
island waters in the film adaptation of Walter Farley's 1941 young-adult novel.

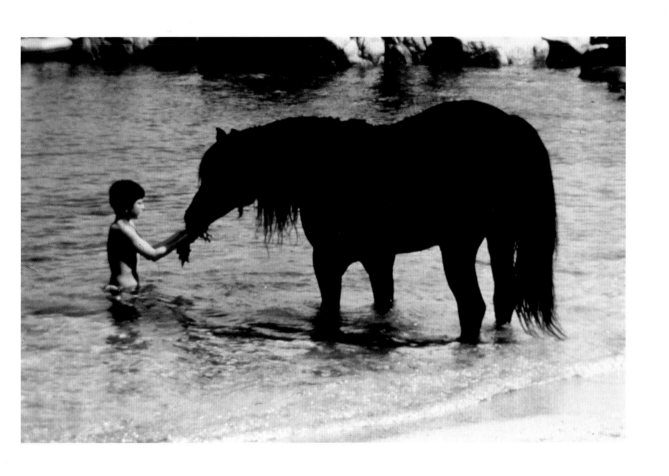

Tennis Anyone?

My first pony, Truffles, had an enormous buck in her, and I believe she truly loved launching me. Why else would it happen every single time I got on? The seventh summer of my life was full of bruises and tears. In fact, I would start crying as soon as I mounted; knowing that it was just a matter of time before I'd end up in the dirt. Once I fell and got back on, I was okay, because I knew she'd only dump me once per lesson.

I thought Truffles and I had worked out a livable solution, but my trainer was sick of the tears. She requested a "sit-down" with my mom and me, where she laid down the law. I was to stop crying every time my seat hit the saddle, or I would have to take up tennis. Just as my eyes started brimming with tears at the thought that I'd have to give up riding, my trainer's two-year-old son, McLain Ward, climbed up on the picnic table where we were sitting, dropped his pants, and peed on some nearby bushes. We all started howling with laughter. The talk was over, as was any suggestion that I stop riding—which was probably a very good thing; I've never been very good at tennis.

SHANETTE BARTH, NEW YORK CITY AND BRIDGEHAMPTON, NEW YORK

EXECUTIVE DIRECTOR, HAMPTON CLASSIC HORSE SHOW, INC.

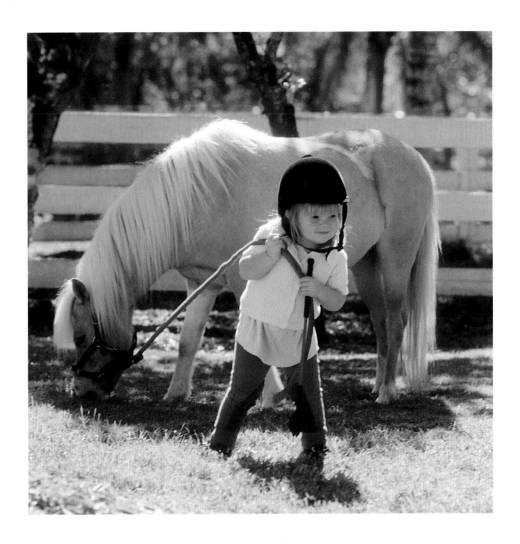

Two-year-old Haley Jerkins tugs on her grazing pony Misty.

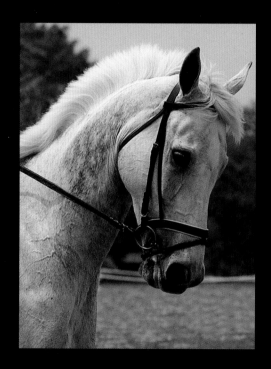

A Thoroughbred competes in dressage at Rubicon Farm in Lucketts, Virginia in June 2005. Dressage is often referred to as ballet on horseback because of the beauty and elegance of the dancing horse. The Thoroughbred is a breed of horse known for their agility and stamina.

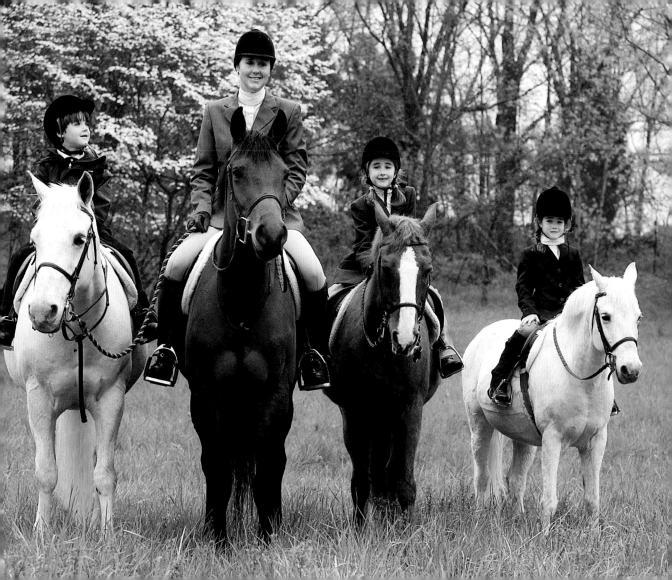

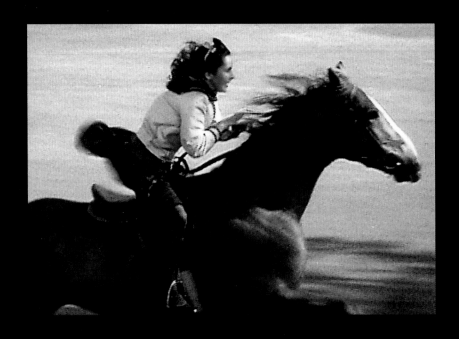

Horses and children, I often think, have a lot of the

good sense there is in the world.

JOSEPHINE DEMOTT ROBINSON

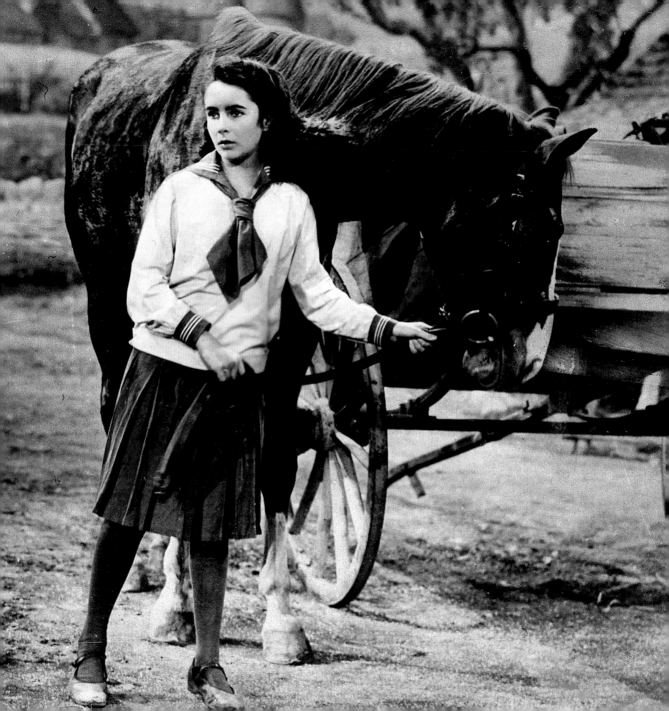

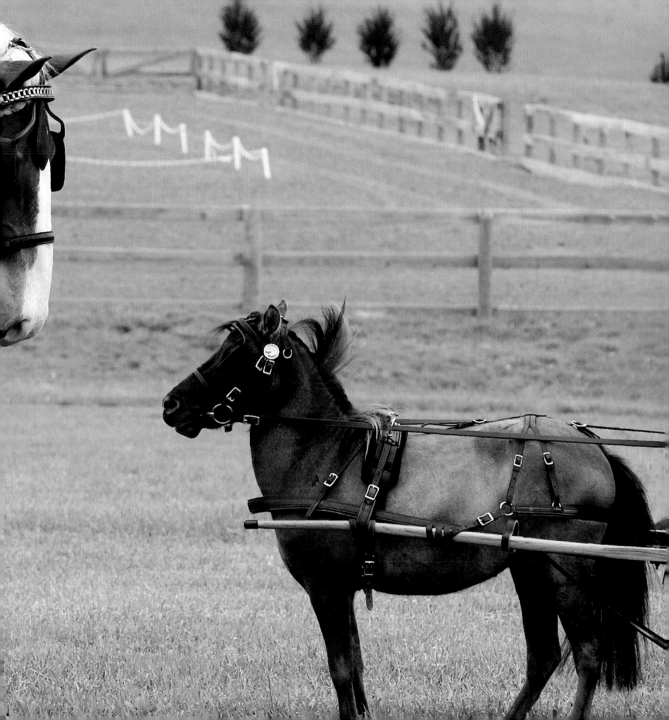

THE HORSES IN MY LIFE

I received my first horse at age two from close family friends. Like me, she was also called "Susie." After I learned to ride Susie, we purchased my first pony, Thursday.

Thursday had come from a local pony breeder, Betty Grey, who taught all of her ponies to drive. I had never driven a cart before, and boy, did I have a lot to learn! The highlight of the year was taking Thursday to the local horse show at Martins Dairy Farm. I was really excited to be able to ride her in the show and to also drive her in the driving class.

Thursday never really liked windy days. This particular show day was extremely windy, and Thursday was not up to the task. We placed third in the walk trot class early in the day. When the time came for the driving class, Thursday had had enough of the wind. While I was trying to harness her, she spooked and took off running, harness flopping around everywhere. Luckily, she wasn't hooked to the cart! It took six of us to finally capture Thursday. I was able to finish harnessing her for the class and hook her up to the cart. We didn't get a ribbon that day, but we still had a good time.

SUSIE WEBB, MARYLAND

EXECUTIVE DIRECTOR, WASHINGTON INTERNATIONAL HORSE SHOW

A miniature horse competes in a carriage show at Morven Park Equestrian Center in Leesburg, Virginia, in June 2005. Because of their small size, miniature horses make great companions. They are often purchased for pets or to help people with disabilities. For children or a person with a disability, miniatures are easier to handle and care for.

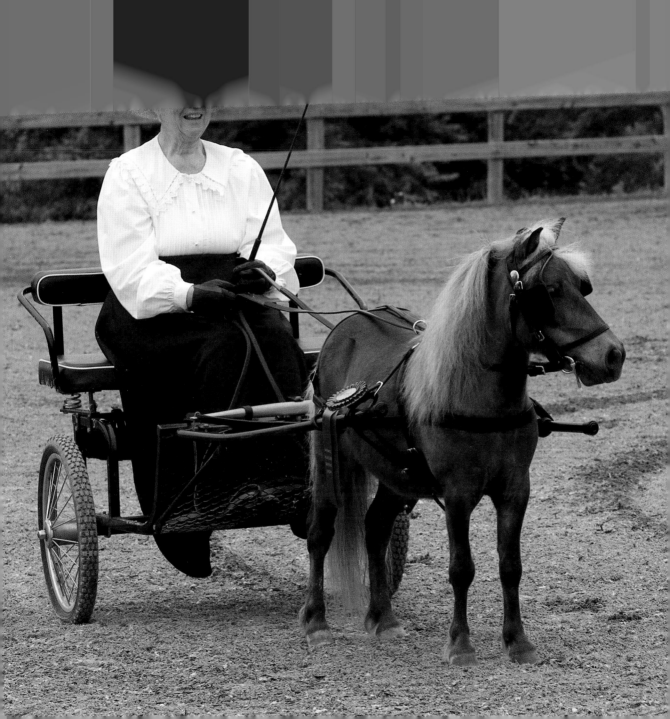

Blending Business with Pleasure

I was introduced to the equestrian world as a child spending summers on Martha's Vineyard. My first pony lived in my front yard. I continued to ride until leaving for college, then starting a business and family forced the hiatus to continue. When my younger daughter was born almost 14 years ago, I bought a home across the road from a horse farm. One of my first projects was to get my older daughter, who was six at the time, to take riding lessons. Before I knew it, I was riding again. Then came the saddle, the trunk, the horse, the horse farm, and more horses, and my passion was finally fulfilled.

I started and continue to run one of the country's largest mortgage brokerage firms, but I have always found time to ride and be with my daughters. In fact, I have sponsored many horse shows and equestrian events as a way to meld my business life with my passion for riding—and to be with my children at the same time. It doesn't matter where the horse show is; I am always at peace when I am riding one of my horses. Riding is not only great therapy, but it is also a great teacher. No two rides are the same, and the sport provides lifelong learning experiences for participants of all ages. Riding has taught me a tremendous amount about respect, partnership, and sportsmanship—all key ingredients to both a successful ride and a fulfilling career.

MELISSA COHN, NEW YORK CITY

FOUNDER AND PRESIDENT, THE MANHATTAN MORTGAGE COMPANY

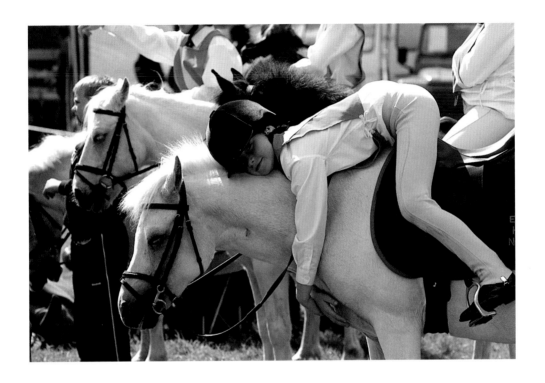

ABOVE:

It's time for this youngster to relax during a mounted games competition at the 2005 Pony Club
Championships in England. The Pony Club is an international voluntary organization for
youth interested in ponies and riding. It is the largest association of riders in the world.

PAGE 156-157:

A working horse is let off his lead for a morning bath in Kampong Trach, Cambodia.

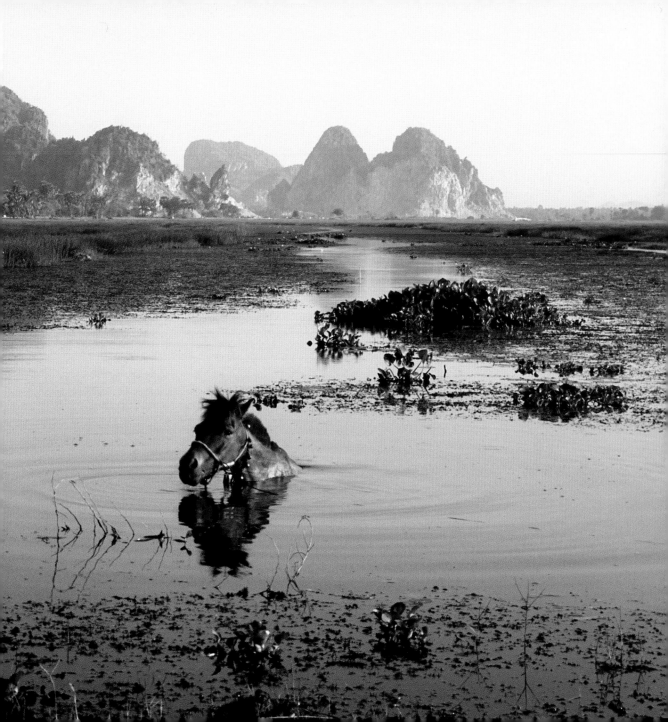

For secrets uttered softly into pricked and troubled ears,

these men were known as Whisperers.

NICHOLAS EVANS, *THE HORSE WHISPERER*

The Horse Whisperer, *1998*
Tom Booker (Robert Redford) coaxes a nervous client into submission.
Horse whisperers use their own techniques to communicate with horses on
a level understood by the horse.

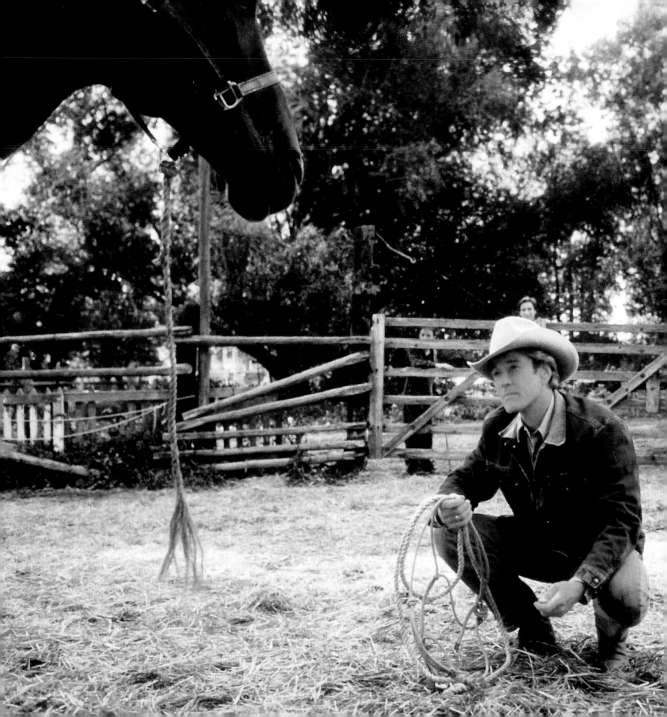

He's the kind of horse with

a far-away look. He'll sure take

a man through some awful

places and sometimes only

one comes out.

W.S. JAMES

RIGHT:
The Horse Whisperer, *1998*
Robert Redford as the rugged and intuitive Tom
Booker with one of his edgy co-stars on the set of the
film adaptation of the 1996 Nicholas Evans novel.

PAGES 162-163:
There are more than fifty miles of trails in Central
Park, New York, as there were a hundred years ago,
but not quite as many horses.

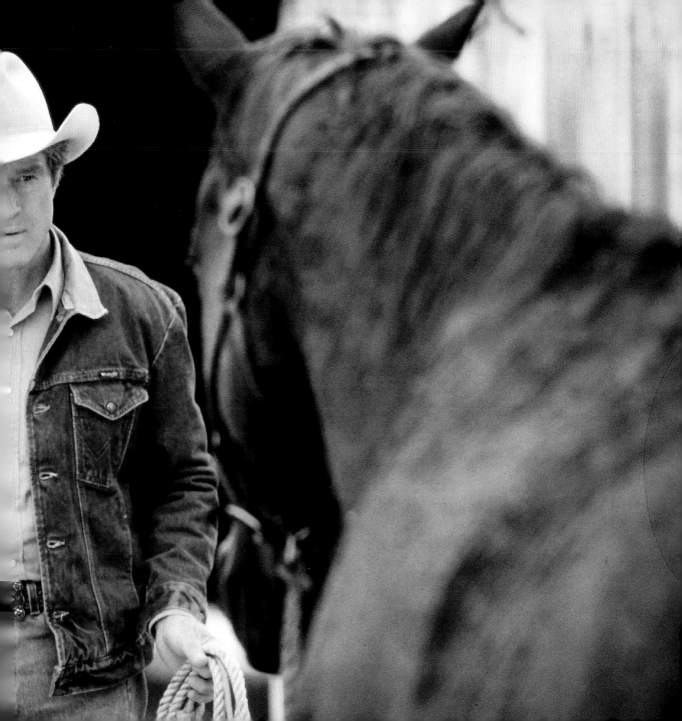

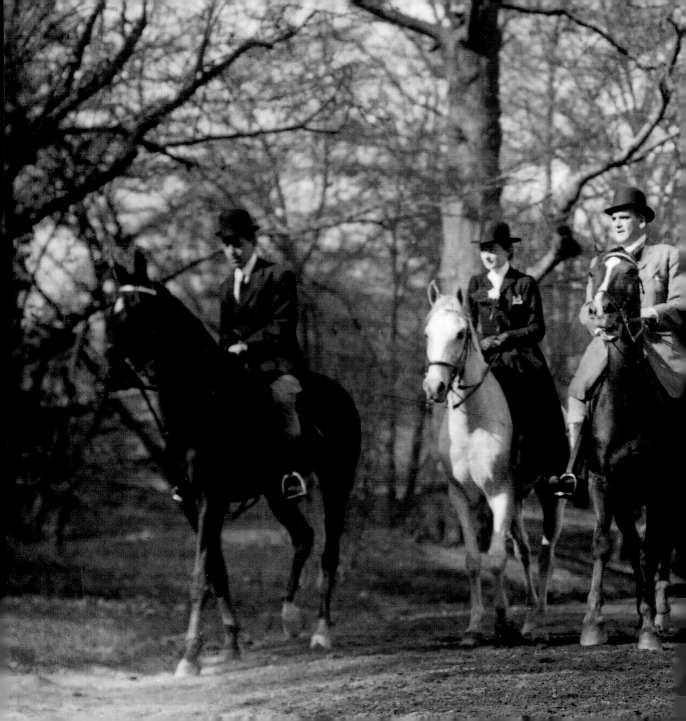

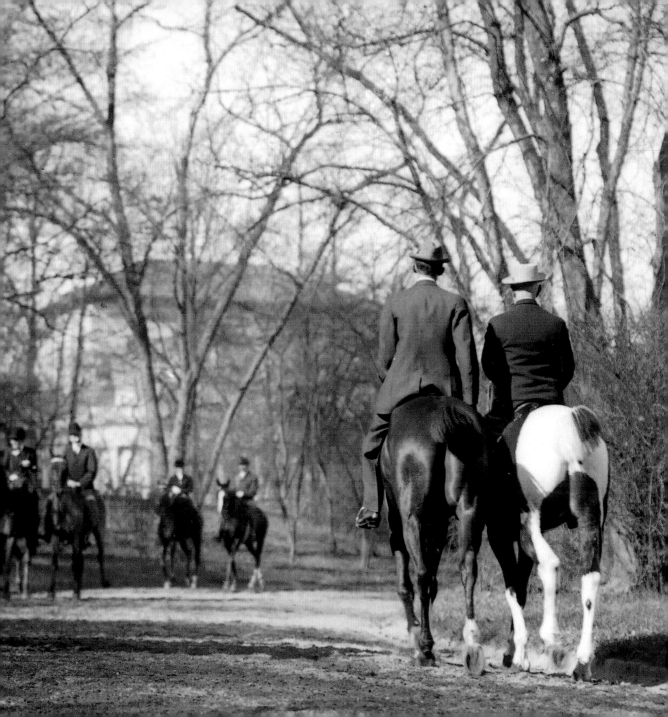

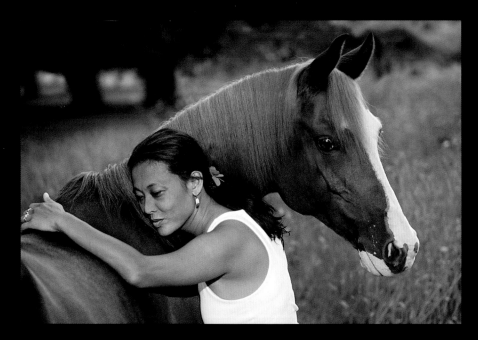

All I pay my psychiatrist is the cost of feed and hay,

and he'll listen to me any day!

ANONYMOUS

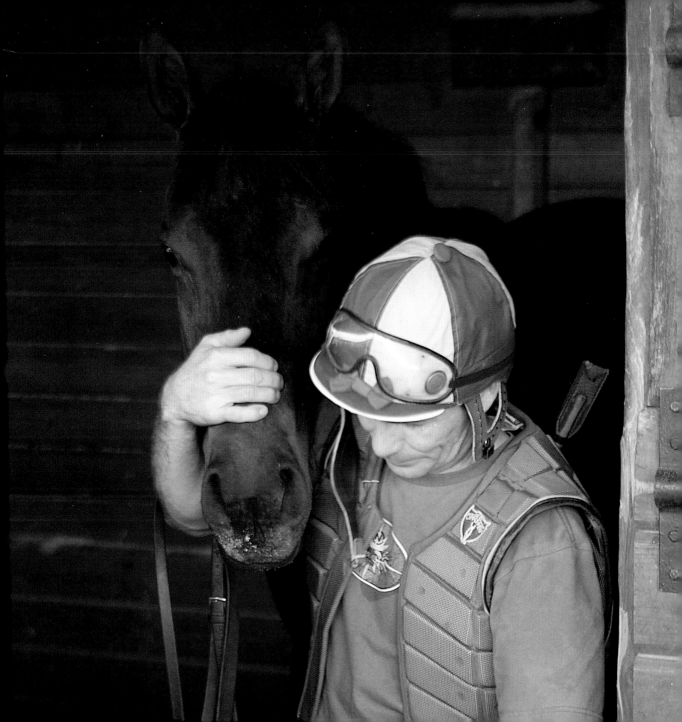

The old days now at last were dead, the last link snapped.

The American Turf had lost, and perhaps would never have

again, a single living symbol, a breathing, high-headed, fiery

horse which meant, 'Racing!' to every man of racing, and to

every wandering tourist from Portland, or San Diego or Athens,

GA. . . . For Man o' War was, if not more than a horse, then

more than a horse had ever been before.

JOE PALMER

FOLLOWING MAN O' WAR'S

DEATH AT AGE 30 ON NOVEMBER 1, 1947

Samuel D. Riddle bought Man o' War, the race horse that The New
York Times *called a "speed miracle" in 1918 for $5,000.*

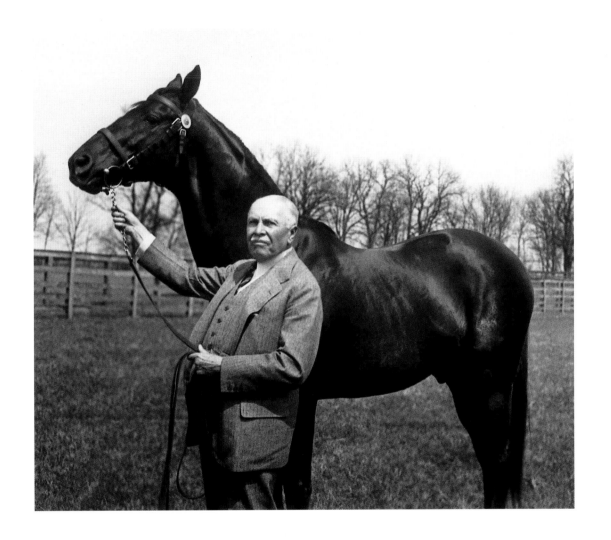

Secretariat generates a crackling tension and excitement wherever he goes. Even in the kind of gray weather that shrouds lesser animals in anonymity, Secretariat's muscular build identifies him immediately; his glowing reddish coat is a banner of health and rippling power. Magnificent enough at rest . . . when he accelerates . . . he produces a breathtaking explosion that leaves novices and hardened horsemen alike convinced that, for one of those moments that seldom occur in any sport, they have witnessed genuine greatness.

PETE AXTHELM

SPORTS COLUMNIST FOR NEWSWEEK

The famed Secretariat turns the Belmont Stakes into a moment of national celebration. He won the Triple Crown in 1973. No other horse has ever been able to match his abilities on the racecourse.

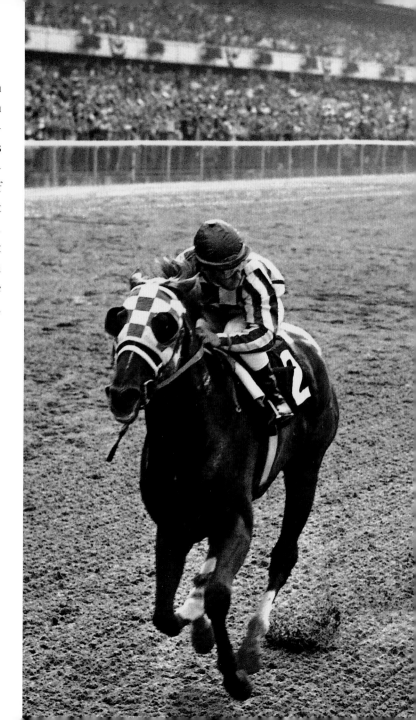

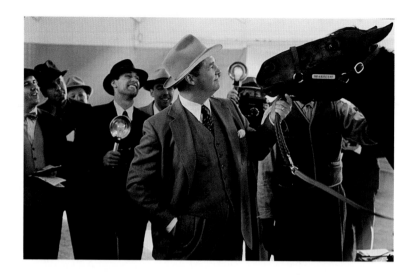

In the midst of all the whirling noise of that supreme moment, Pollard felt peaceful. Seabiscuit reached and pushed and Pollard folded and unfolded over is shoulders and they breathed together. A thought pressed into Pollard's mind: *We are alone*.

Twelve straining Thoroughbreds; Howard and Smith in the grandstand; Agnes in the surging crowd; Woolf behind Pollard, on Heelfly; Marcela up on the water wagon with her eyes squeezed shut; the leaping, shouting reporters in the press box; Pollard family crowded around the radio in a neighhbor's house in Edmonton; tens of thousands of roaring spectators and millions of radio listeners painting this race in their imaginations: All this fell away. The world narrowed to a man and his horse, running.

LAURA HILLENBRAND, *SEABISCUIT: AN AMERICAN LEGEND*

Seabiscuit, 2003. Charles Howard (Jeff Bridges) poses before the press with his triumphant Thoroughbred, Seabiscuit, in the film adaptation of Laura Hillenbrand's 2001 novel.

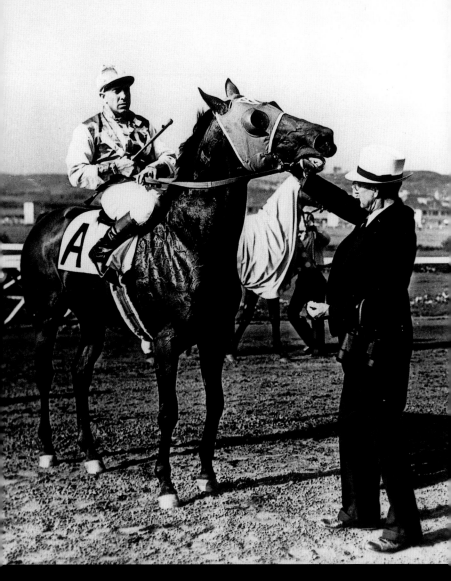

George Woolf (the Iceman) atop Seabiscuit in 1938 following a match race victory over Ligaroti at Del Mar. The Biscuit is held by his legendary trainer, Tom Smith.

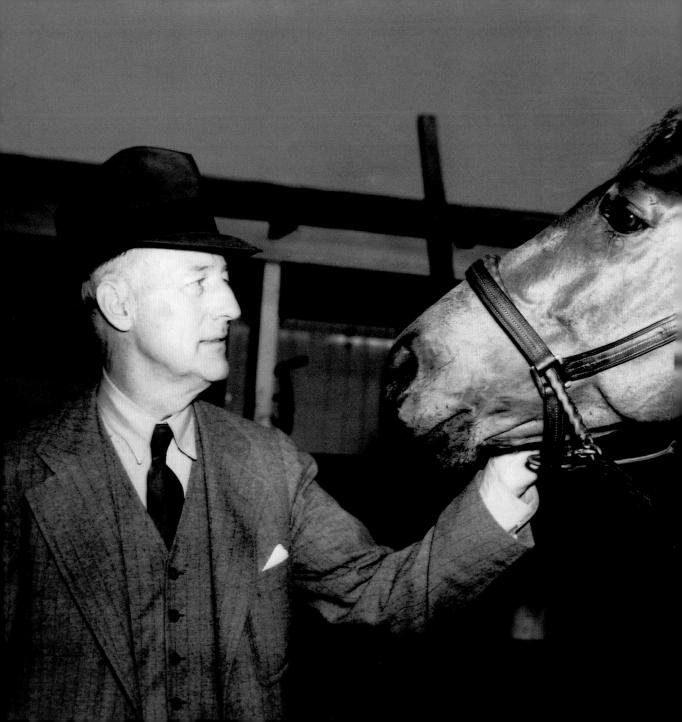

Charles S. Howard, Seabiscuit's owner, holds the
horse following his final victory in the Santa Anita
Handicap, March 2, 1940.

Secretariat wasn't just winning. He was performing like an original, making it all up as he went along. And everything was moving so fast, so unexpectedly, that I was having trouble keeping a perspective on it. Not three months before, after less than a year of working as a turf writer, I had started driving to the racetrack to see this one horse. For weeks I was often the only visitor there, and on many afternoons it was just Sweat, the horse and me in the fine dust with the pregnant stable cat. And then came the Derby and the Preakness, and two weeks later the colt was on the cover of *Time, Sports Illustrated* and *Newsweek,* and he was a staple of the morning and evening news. Secretariat suddenly transcended horse racing and became a cultural phenomenon, a sort of undeclared national holiday from the tortures of Watergate and the Vietnam War.

WILLIAM NACK, *PURE HEART*

PAGES 176-177:
The exercise riders help these young Thoroughbreds work through the energized stamina they have bundled inside them waiting to get out. Thoroughbreds are bred to go the distance, which is why they make such great racehorses.

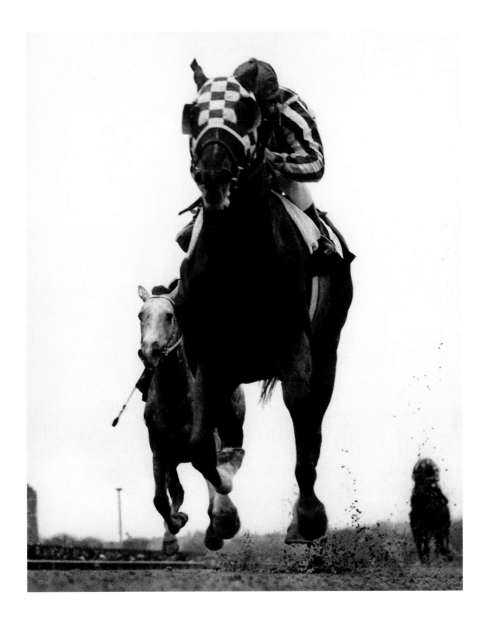

Secretariat, ridden by Ron Turcotte at Aqueduct, about to win a three-length victory and the $55,000 Gotham Stakes over Champagne Charlie in second and Flush in third. Jamaica, New York, 1973.

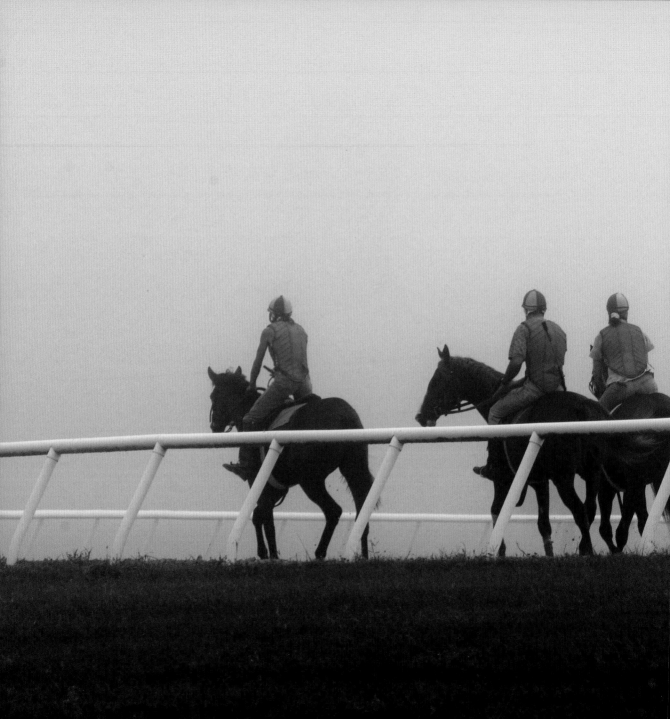

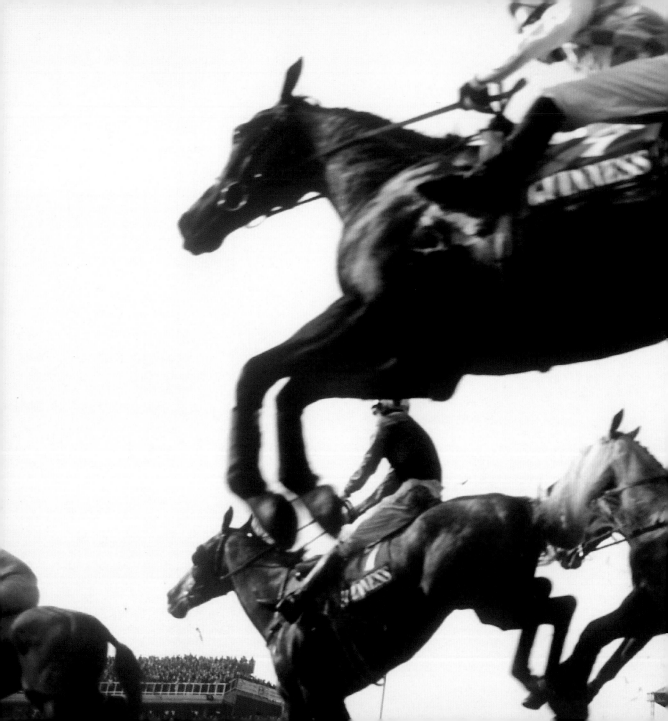

I am a ParaEquestrian (rider with a disability) born and raised in Zimbabwe and now living in Dallas, Texas, where I ride at Equest Therapeutic Horsemanship. I compete often in Paralympic competitions. This one time, I was scheduled to ride an International Paralympic Level Dressage Test in an A-recognized dressage show in Sacramento, California. At that time, when we competed we always rode on borrowed horses, which can sometimes be a challenge, since these horses must accept our disabilities. For instance, some people might have to use two crops because they don't have the use of their legs. In my case, I need a horse that responds to my weight, because I am paralyzed on the left side and cannot use my left leg and hand. Unfortunately, they could not find a horse that would accept my disability, until someone came up with the idea of using Major, a more than 16-hand Belgian draft horse weighing more than 1,800 pounds. I decided to give it a try. Since I am only 5 feet tall and 105 pounds, I was a peanut on this guy. To add to the challenge, the arena size was very small for a draft horse—only 20 by 40 meters.

Much to my surprise, Major was a sweetheart. At one point I lost my balance and started to drift to the left side, and because of my disability I was not able to push myself back. I hung off his left side for the rest of the ride. Major wasn't even fazed. He did perfect circles (his full-time job was as a vaulting horse). During my ride, those looking on chuckled and said that at least it wasn't a waste that I came to California, because I got to ride. Then the scores came out, and much to their dismay, I ended up with the top scores and the high-score rider of the day. Afterwards, my coach said that that was one of the gutsiest moves we'd ever done.

DEB LEWIN, TEXAS AND ZIMBABWE (FORMERLY RHODESIA)
PARAEQUESTRIAN

PAGES 178-179:
Jumping a steeplechase fence during the National Hunt racing at the Cheltenham Festival in England. A steeplechase race takes place over a turf course with fences or obstacles the horses must jump while racing at great speeds.

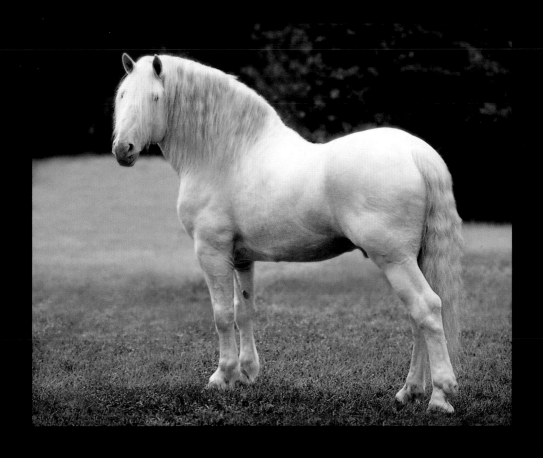

*A powerful and rare American White Draft Horse stallion. Draft horses are
also referred to as draught or harness horses. The foundation sire of the American White Draft Horse was
Old King. His snow-white color has continued to dominate the breed.*

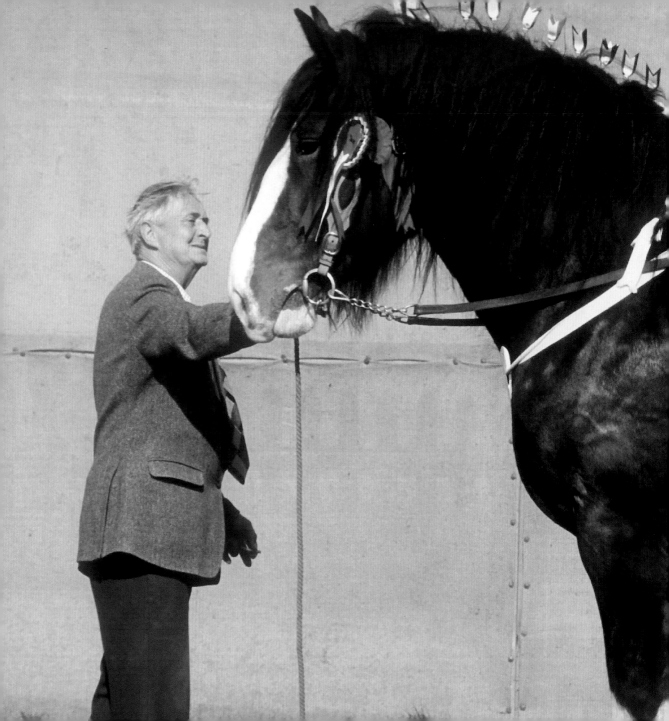

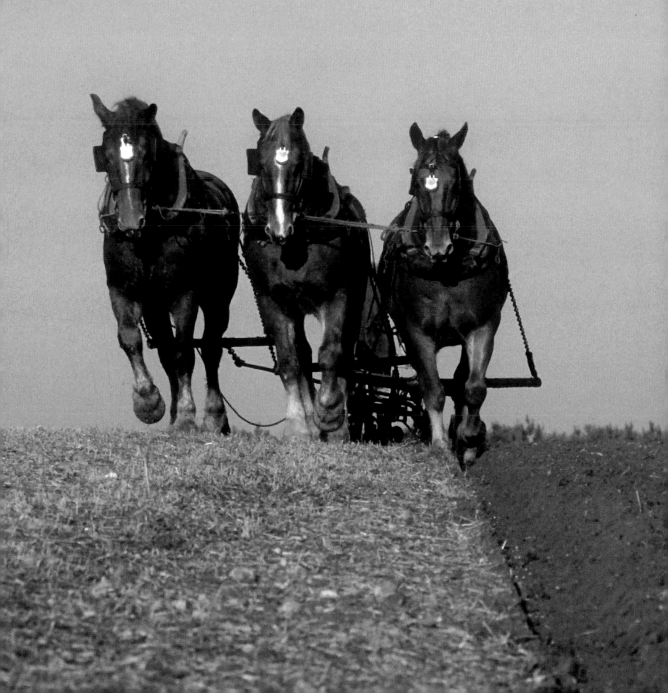

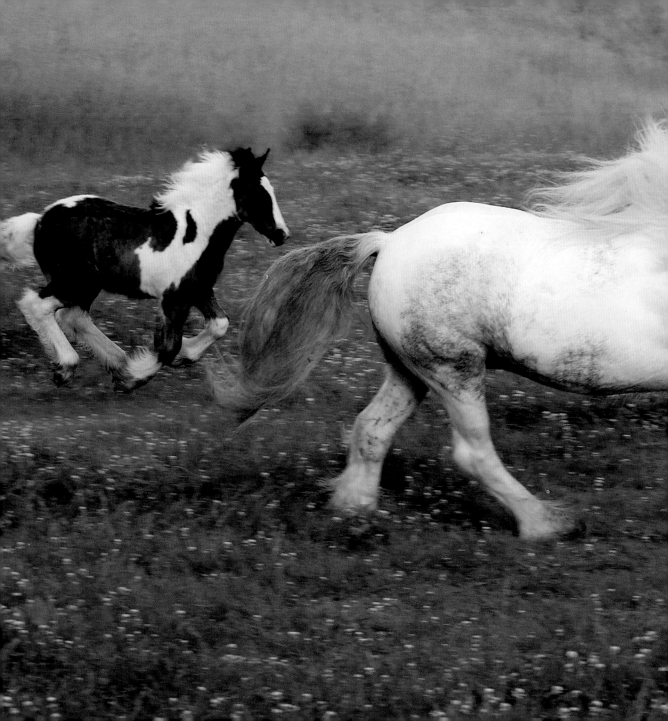

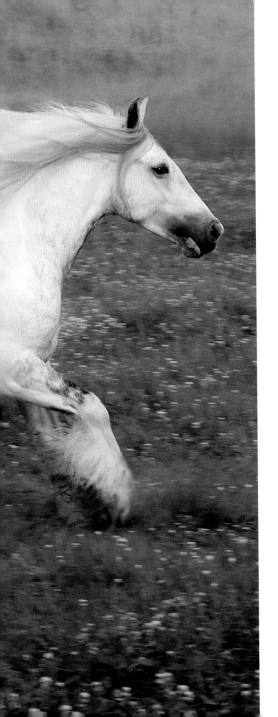

O for a horse with wings!

WILLIAM SHAKESPEARE, *CYMBELINE*

A Gypsy Vanner mare and foal run across a tall grass meadow.
Gypsy Vanner horses come in all colors and are relatively small
draft horses, usually around 15 hands tall.

South Daytona Beach, Florida.
A Gypsy Vanner stallion trots along the ocean shore at sunset.

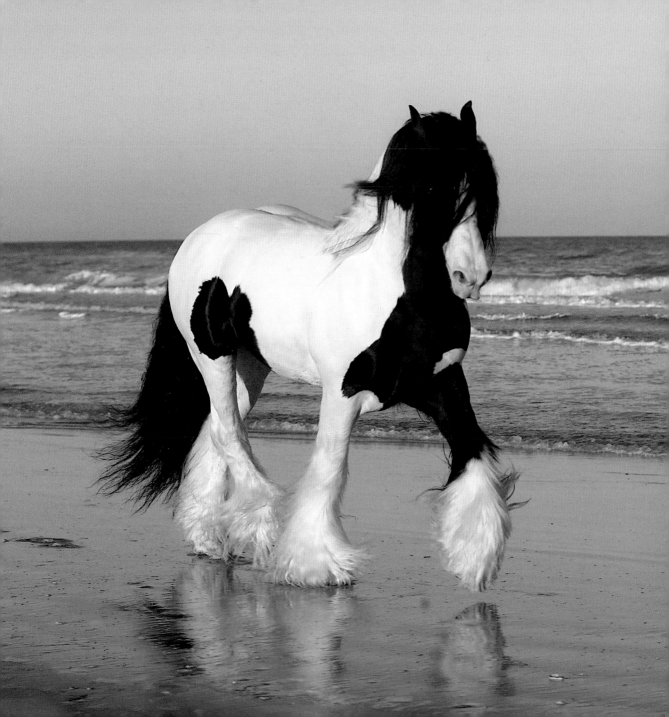

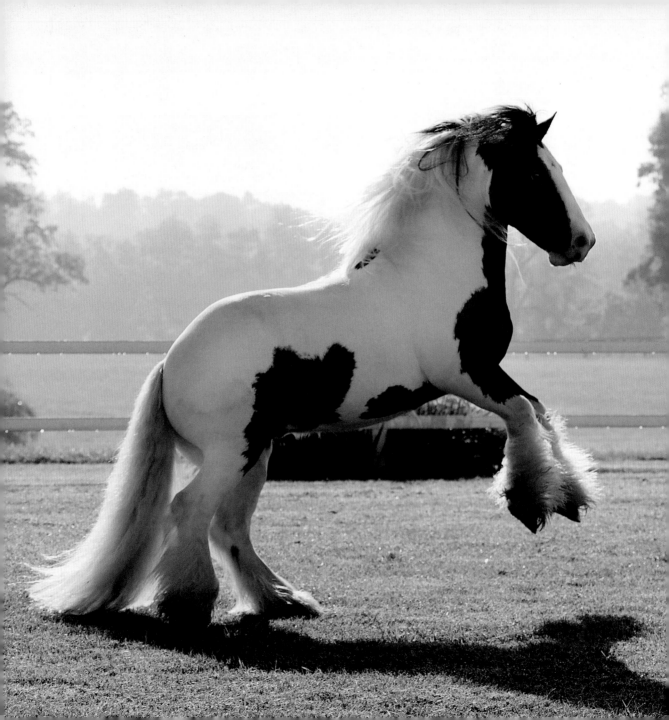

And God took a handful of southerly wind,

blew His breath over it and created the horse.

BEDOUIN LEGEND

Lash, a Gypsy Vanner stallion, rears.

KID GREY: ONE WINTER EVENING

One winter evening in Michigan, when I was about 13 years old, I was riding my mare "Kid Grey" by myself in an indoor arena. We were practicing hand galloping and halting, a test frequently asked for in those days. I pulled her up too sharply just as she hit a slick spot in the footing, and she fell over backwards on me. She got up, but I could not. I had lost the feeling in my legs and could not move them. My mare stood over me quietly and sniffed at me as if to see if I was all right. I spoke softly to her, saying "whoa," as I reached up to grab hold of the stirrup iron and hoist myself upright. With one arm slung over the saddle and my weight leaning up against her, she quietly walked to the IN gate with me hobbling alongside. She seemed to know something was wrong. While I sat on the mounting block until the tingling in my legs subsided, she stood there patiently waiting and watching me. That mare was not the fanciest of show horses, but that night she was worth her weight in gold.

CHRYSTINE JONES TAUBER, NEW JERSEY

VICE PRESIDENT UNITED STATES HUNTER JUMPER ASSOCIATION

Wendy Lewis (USA) and Rampant Lion on the cross-country course at the 2005 Rolex Kentucky Three-Day Event, where they finished ninth overall. Olympic medalist Kim Severson (2004 Athens Greece) won the event on Winsome Adante. Lexington's Kentucky Horse Park will be the site of the 2010 World Equestrian Games.

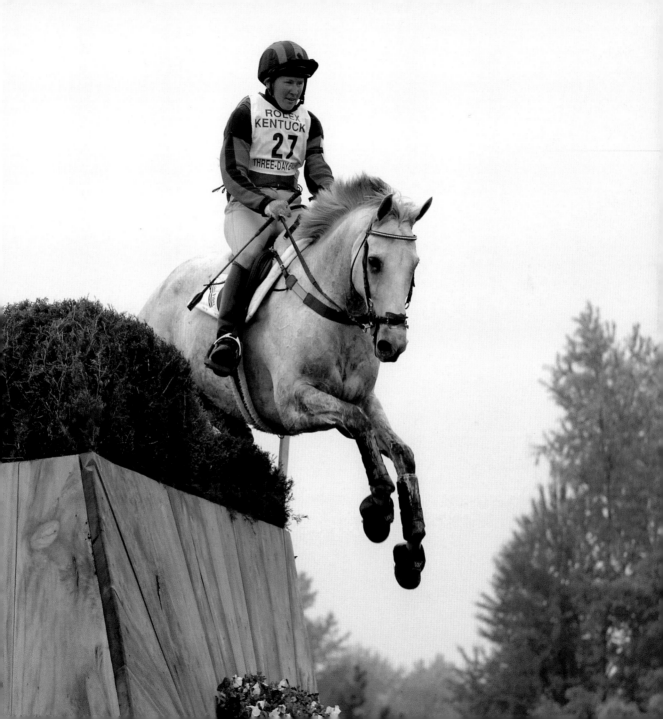

To me, horses and

freedom are synonymous.

VERYL GOODNIGHT

Olympic veteran Ginny Leng sloughing through the drink at the 1990 Griffin Badminton Horse Trials, one of the most famous eventing sites in the world. Many Olympic veterans tested their skills over the Badminton cross-country courses.

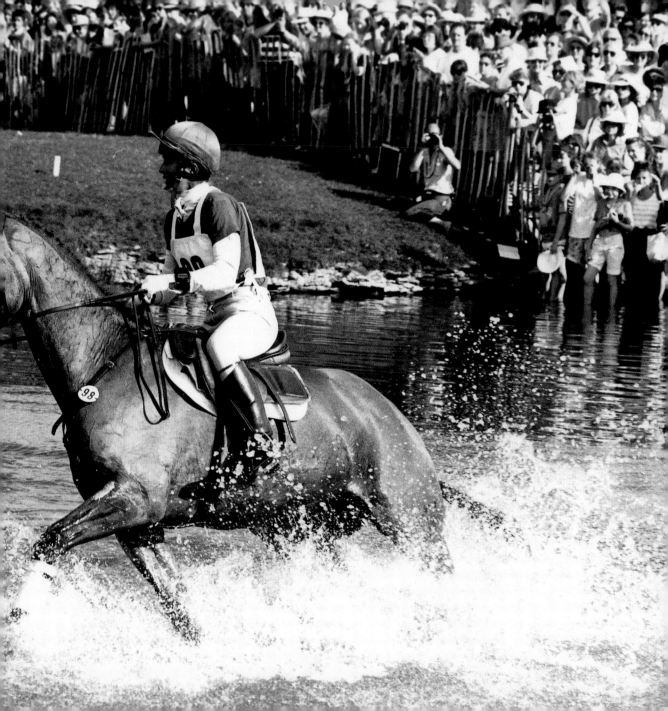

W hat a long night is this! I will not change my horse with any that treads but on four pasterns. *Ça, ha!* He bounds from the earth as if his entrails were hairs: *le cheval volant,* the Pegasus, *qui a les narines de feu!* When I bestride him, I soar, I am a hawk: he trots the air; the earth sings when he touches it; the basest horn of his hoof is more musical than the pipe of Hermes.

WILLIAM SHAKESPEARE, *HENRY V*

Close-up of an event horse jumping a cross-country fence in England. The cross-country phase is only one aspect of the three-day event. This is the phase that tests the endurance of the horse.

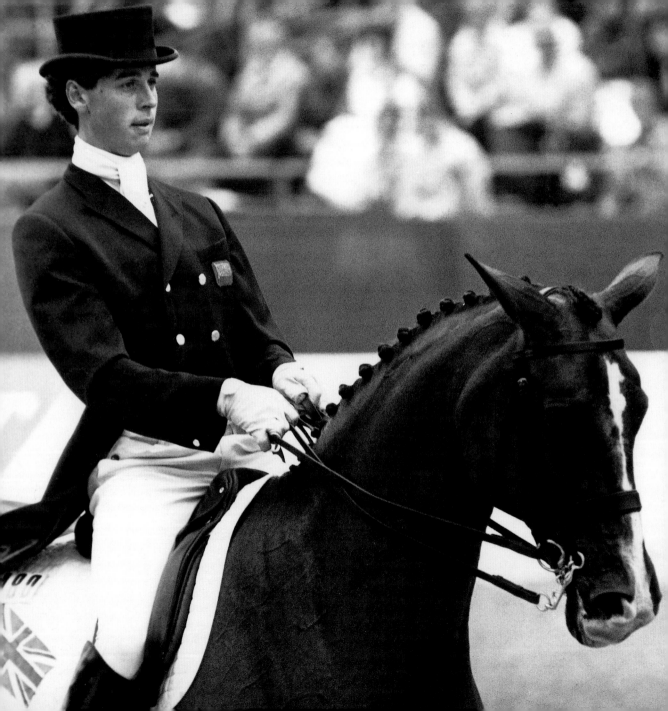

In its strict meaning, "dressage" is simply the training of the horse. In use, though, dressage has become the art and intensely competitive sport of training in the classical movements. Like figure skating, dressage emphasizes the power and beauty of motion, and competitors in the sport are judged on accuracy and the élan with which they perform prescribed movements. The movements the horse and rider are asked to perform depend on the horse's stage of development. At the lower levels, the tests demonstrate simple movements with long intervals of modulation between different gaits and maneuvers. The higher the test level, the more difficult the coordination asked of the horse and the more rapid the transitions between movements.

HOLLY MENINO, *FORWARD MOTION*

Olympic veteran Carl Hester aboard Rubelit Von Unkenruf in the 1991 European Dressage Championships. Dressage is a French word that means training. At the highest level, dressage movements include the piaffe or trot in place. During wartime the piaffe was used to keep the horse focused, warm, and in motion so that it would be ready to move forward at a moment's notice.

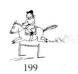

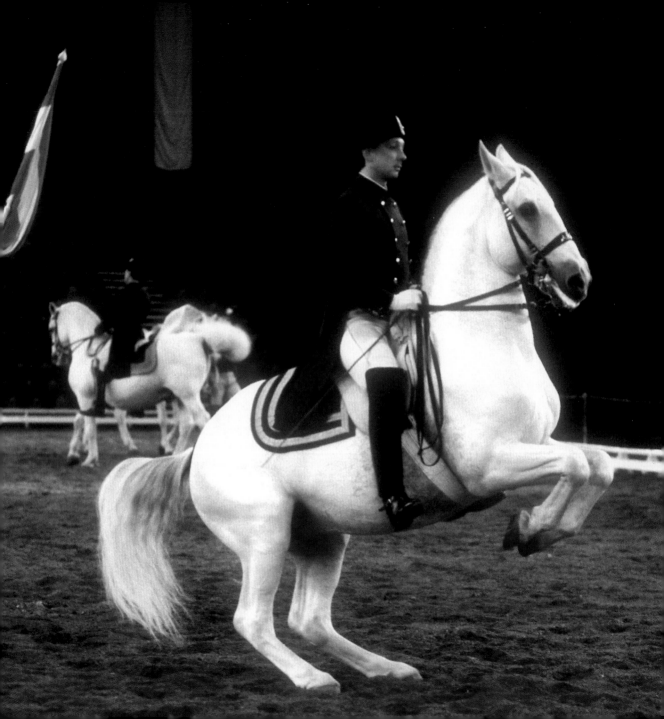

Whether one believes that Haute Ecole is the acme of fine horsemanship, or whether one is of the school of thought that it is so artificial as to be completely useless, does not change the fact that the interpretation of the will of the rider by the horse (and his desire to comply instantly with that will) approaches the uncanny. The "High School" rider and his mount were as near one as it is possible for man and beast to be. They did not perform for glory or gain as does the Arabian on his war mare, the polo player, or the jockey; horse and man devoted their entire lives to perfecting what they considered a fine art for the sheer love of that art.

CARL RASWAN, *DRINKERS OF THE WIND*

A Lipizzaner stallion from Vienna's Spanish Riding School during a display in the United Kingdom. The Spanish Riding School was formed in 1572. The Lipizzaners are known for their "airs above the ground," a variety of leaps and maneuvers which have their origins in the military.

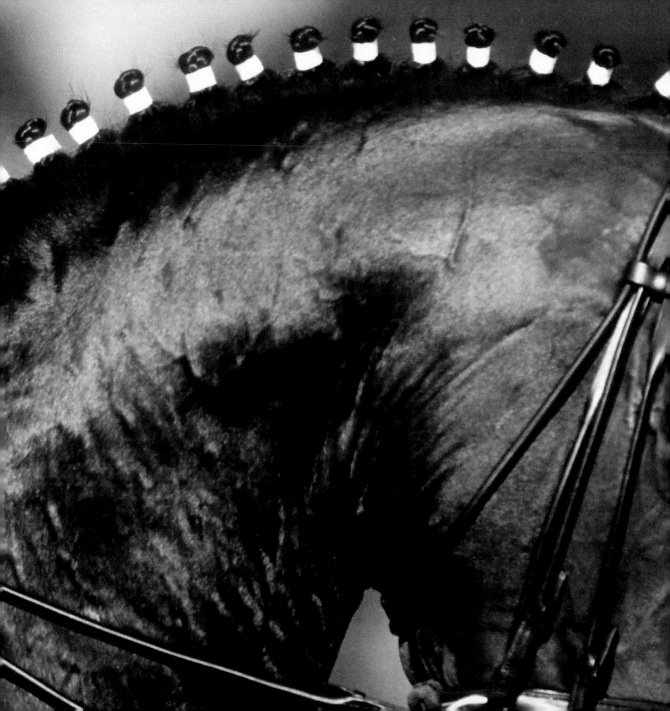

ABOVE:

A Warmblood in a dressage test, Lexington, Kentucky. The communication between horse and rider is silent but clear. The rider uses his or her legs to convey messages to the horse. These signals are often invisible to those watching, but the end result is one of beauty and majesty as the horse seems to go through the various elegant dressage moves with no effort.

PAGES 202-203:

A close-up on the powerful and charismatic dressage stallion, Donnersong, adorned with a plaited mane, during a competition in the United Kingdom. In 2003, Donnersong was voted as the top British-bred dressage horse.

A dressage mare waits to go into the ring in Arizona. Before entering the ring, there are some moments of anticipation as the rider never knows quite how the horse will react to the surroundings at any particular show. At the same time, the horse is alert to what is happening and tries to figure out as much as possible by viewing and listening to what is around him.

Gently, gently, but strong and steady, I coax the new life into the glow of the stable lamp, and the mare strains with all she has. I renew my grip, hand over hand, waiting for her muscles to surge with my pull. The nose—the head, the whole head—at last the foal itself, slips into my arms, and the silence that follows is sharp as the crack of a Dutchman's whip—and as short.

'Walihie!' says Toombo.

Otieno smears sweat from under his eyes; Coquette sighs the last pain out of her.

I let the shining bag rest on the pad of trampled grass less than an instant, then break it, giving full freedom to the wobbly little head.

I watch the soft, mouse-coloured nostrils suck at their first taste of air. With care, I slip the whole bag away, tie the cord and cut it with the knife Otieno hands me. The old life of the mare and the new life of the foal for the last time run together in a quick christening of blood, and as I bathe the wound with disinfectant, I see that he is a colt.

He is a strong colt, hot in my hands and full of the tremor of living.

BERYL MARKHAM, *WAS THERE A HORSE WITH WINGS?*

It's time for this orphan Shire draft foal's afternoon bath. With hose in hand,
this woman showers the cute foal.

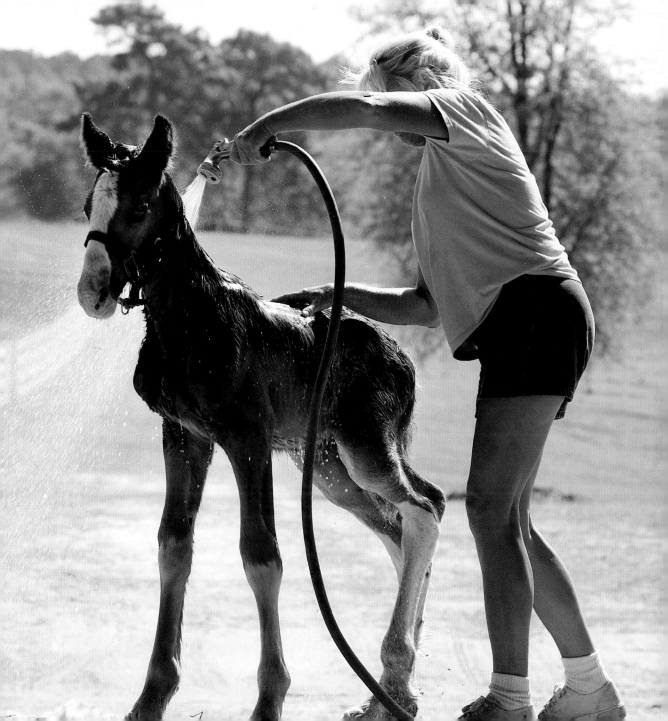

Look back on our struggle for freedom,

Trace our present day strength to its source,

And you'll find that man's pathway to glory,

Is strewn with the bones of a horse.

ANONYMOUS

Seabiscuit, *2003*
Grooms wrestle with an untrained Seabiscuit as
Tom Smith (Chris Cooper) looks on.

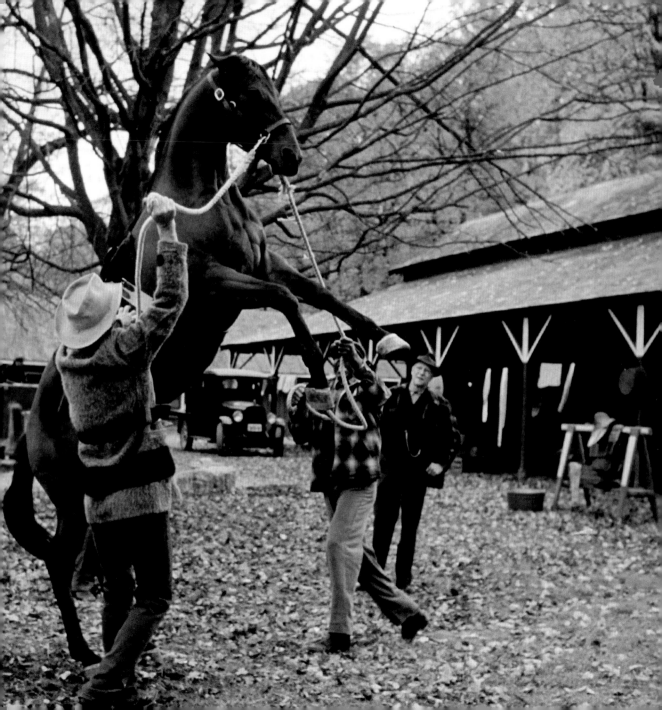

Most all of you boys have rode hosses like that.
He wasn't too thin but he never got fat.
The old breed that had a moustache on the lip;
He was high at the wethers and low at the hip,
His ears always up, he had wicked bright eyes
And don't you furgit he was plenty cow wise.

His ears and his fets and his pasterns was black
And a stripe of the same run the length of his back.
Cold mornin's he'd buck, and he allus would kick,
No hoss fer a kid or a man that was sick.
But Lord what a bundle of muscle and bone;
A hoss fer a cowboy, that little blue roan.

FROM *THAT LITTLE BLUE ROAN* BY BRUCE KISKADDON

As dusk settles in over the countryside, the outline of man and
Arabian stallion are profiled.

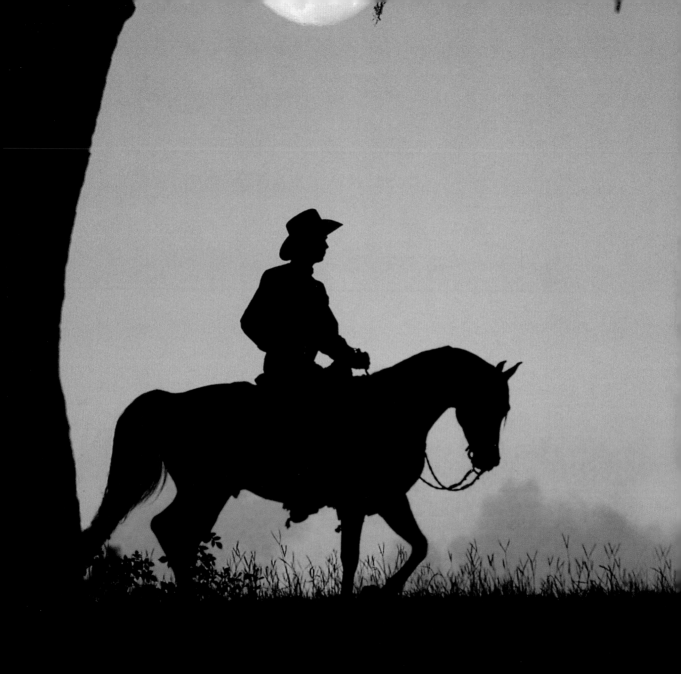

Thou shall be for Man a source of happiness and wealth;

thy back shall be a seat of honor, and thy belly of riches.

THE KORAN

OPPOSITE:
Roy Rogers, often referred to as the King of Cowboys, with his famous horse Trigger ("the smartest horse in the world"), were stars of movies and television. Rogers appeared in more than one hundred movies in his career.

OVERLEAF:
A woman performs one of the "airs above the ground" as her Lipizzaner stallion exhibits a capriole at Herrmann's Royal Lipizzaner Show in Sarasota, Florida. In this movement, the horse rears up and then strikes out with its hind legs. It is a true test of power and agility

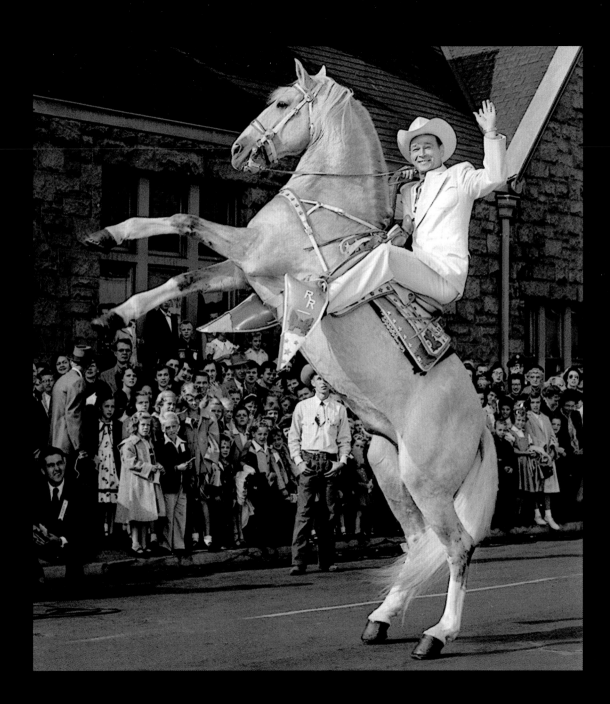

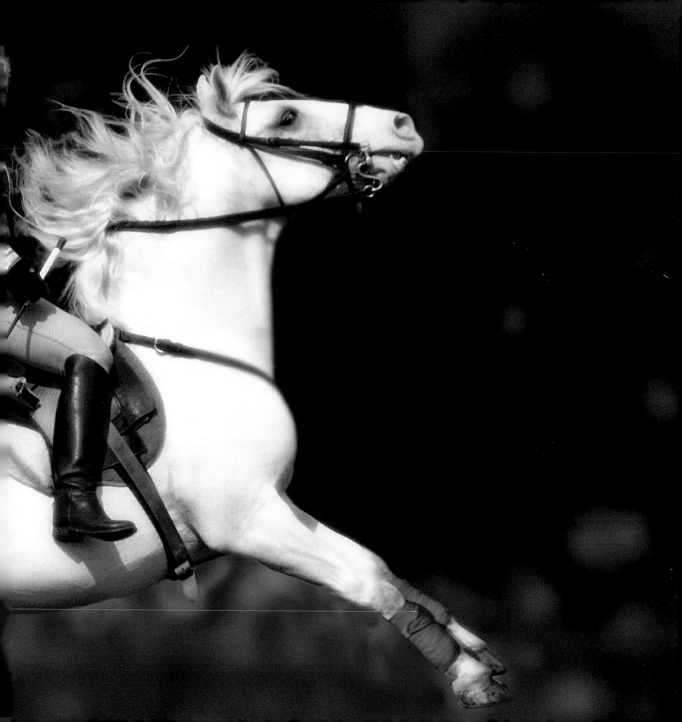

Men are generally more concerned of the breeding of

their horses than of their children.

WILLIAM PENN

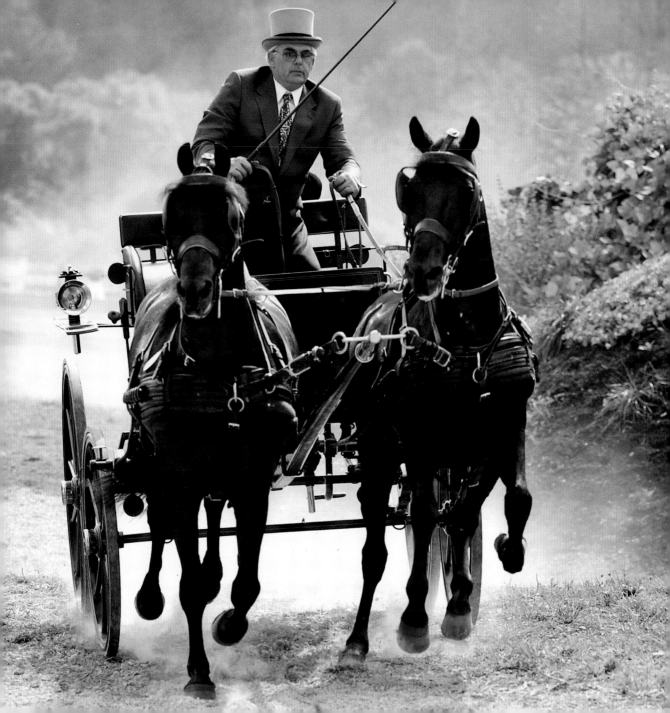

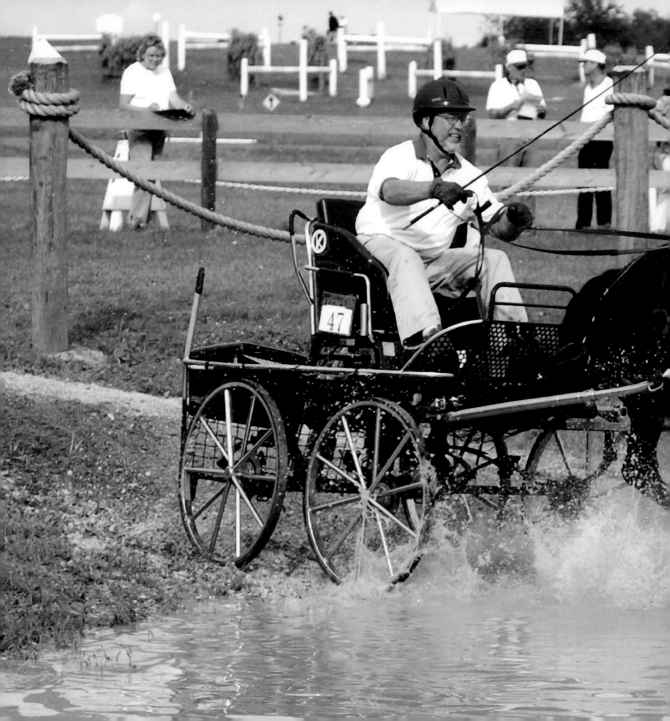

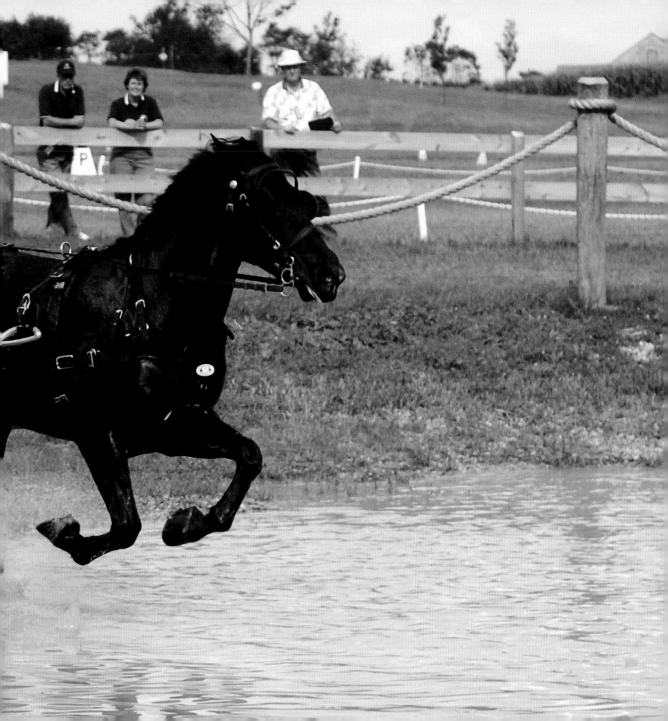

Hard it is to teach the old horse to amble anew.

EDMUND SPENCER

Two geldings, Jack Weaver's and Darrow Long's driving pair of Niki, a Polish Warmblood, and Ribas KWPN at the 2004 Laurels of Land Hope International Combined Driving Event in West Grove, Pennsylvania.

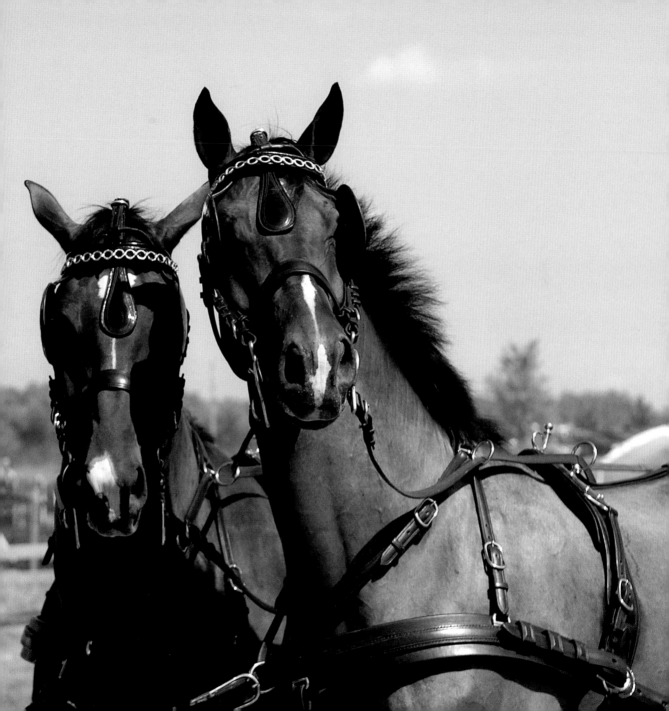

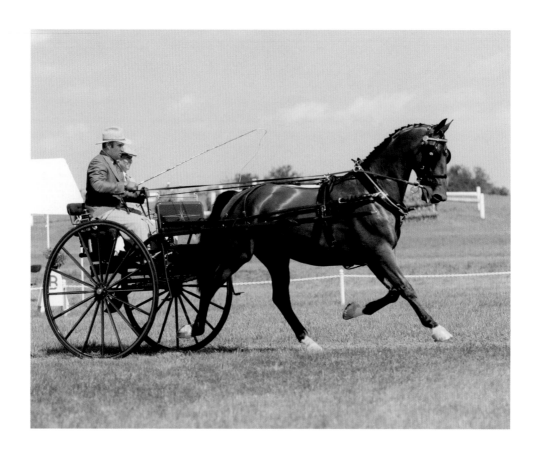

Scott Adcox of Mendenhall, Pennsylvania, as he negotiates the trail with Wayne and Majorie Graftons' Dutch Warmblood gelding Nelson. The Dutch Warmblood is a sport horse breed often used in competition or for recreation.

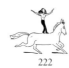

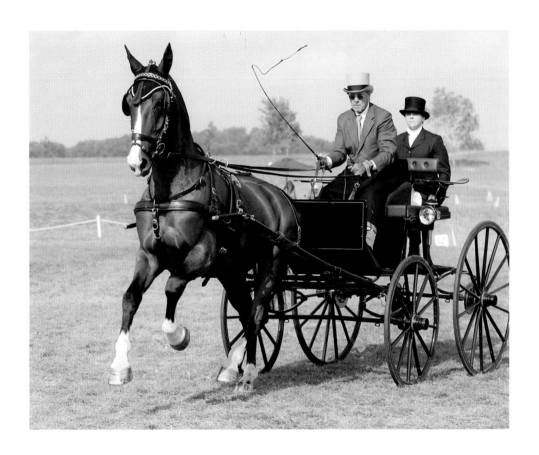

Kent Brownridge and Liberty Gelderlander at the Laurels of Land Hope International
Combined Driving Event in West Grove, Pennsylvania. Combined driving is very much
like the sport of Eventing, except with a horse pulling a carriage. It includes three parts—
a dressage phase, cross-country marathon, and obstacle or cones phase.

The Fox and the Horse

I was trail riding one day on a friend's horse that I had spent many years training. Although I adored "Panache," he could be a handful. He was a 17-hand Thoroughbred who had raced until an injury sidelined him. His owners nursed him back to health. I was always on my guard because he had a buck that often caused us to part ways, and when he took off at a gallop I had to use every ounce of strength to stop him. Well, one day we were casually walking along, and out of the corner of my eye I spotted a red fox coming our way. It was the middle of the day, and I wondered why a fox would be so bold. Then I started to worry that he was going to scare Panache. But I figured, he had to be more scared of us. For a moment I got distracted, but then quickly turned around to check if the fox was still in sight. To my surprise, not only was he in sight, but he was pulling on my horse's tail. Panache couldn't have cared less, but this was one time I let him bolt at top speed.

To this day, I still have the picture in my mind of that flaming red fox tugging on the tail of my horse as if he was our mascot.

DIANA DE ROSA, NEW YORK

JOURNALIST (WRITER AND PHOTOGRAPHER)

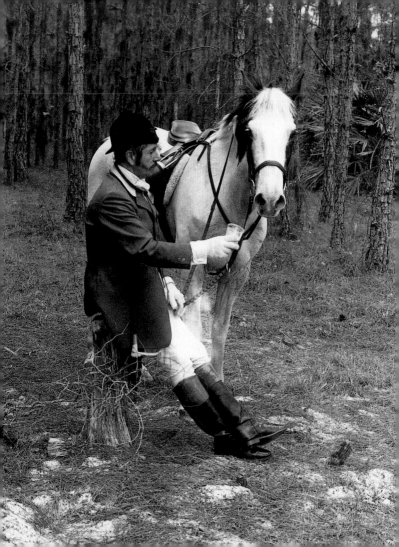

...ng a horse, we borrow freedom.

HELEN THOMSON

...foxhunting takes place all over the world. Here Ken ...ife, and their mounts take a moment to mingle with ...ds before heading out for more chasing across the Florida countryside in Palm Beach.

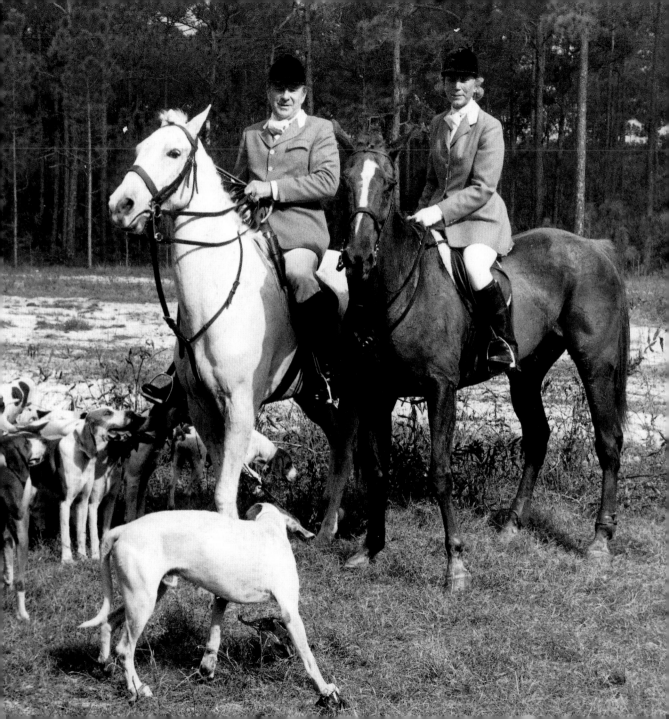

MANFRED

Of all the school horses I've ridden over the past three decades at Fox Hill Farms in Pleasantville, New York, the one with the most remarkable personality was Manfred. A bay with a Rastafarian mane and demonic expression, "Fred" had a predilection to pace rather than trot. That didn't sit very well with instructors who were trying to teach students to post; a simple but sharp "Manfred!" from an instructor, however, could galvanize the horse to switch from the lateral to the diagonal.

The greatest challenge to anyone who thought he or she could ride was to get Manfred to canter on his right lead. No matter with which aids he was asked or how he was bent, Fred went through all manner of contortions to avoid that lead. He would take it, but only after the rider persisted and persisted, to such teasing as, "Gee, I thought you could ride," from other riders or onlookers who were wise to Fred's shenanigans.

Unless, however, Fred knew that playing that particular game wasn't sporting. I recall one morning when, after Fred and I went around and around with the "right lead game" for what seemed like hours, I returned to the ring to watch a group of youngsters learn the fine art of cantering. Midway in a line of horses traveling clockwise was Fred, his rider's legs barely extending below the saddle flap. "Okay, kids, let's canter. Canter!" the instructor requested. And with that, Manfred—now the consummate teacher of novices—struck off on his right lead.

STEVEN D. PRICE, NEW YORK CITY

EQUESTRIAN AUTHOR AND EDITOR

While in the midst of an energizing foxhunt, riders jump a post and rails fence with the Zetland Hunt in England. In foxhunting, the horse is the vehicle that allows the rider to follow and observe the hounds as they hunt the fox.

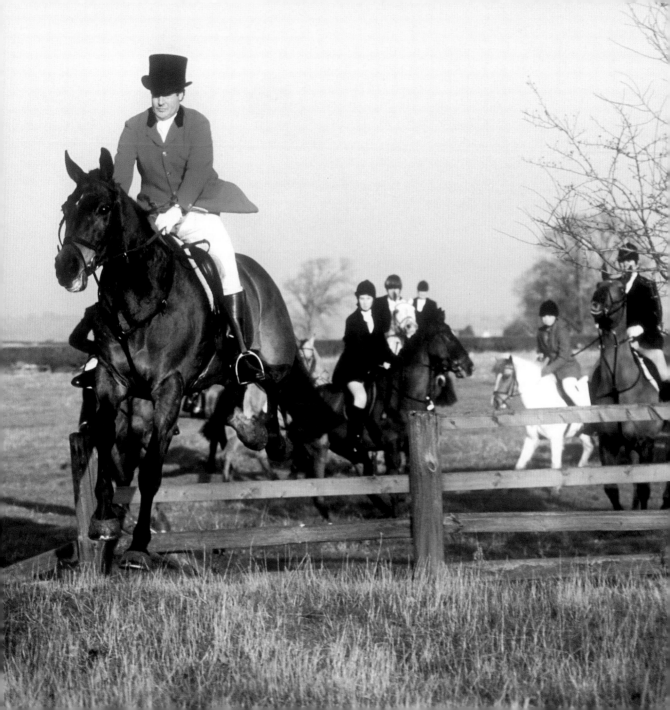

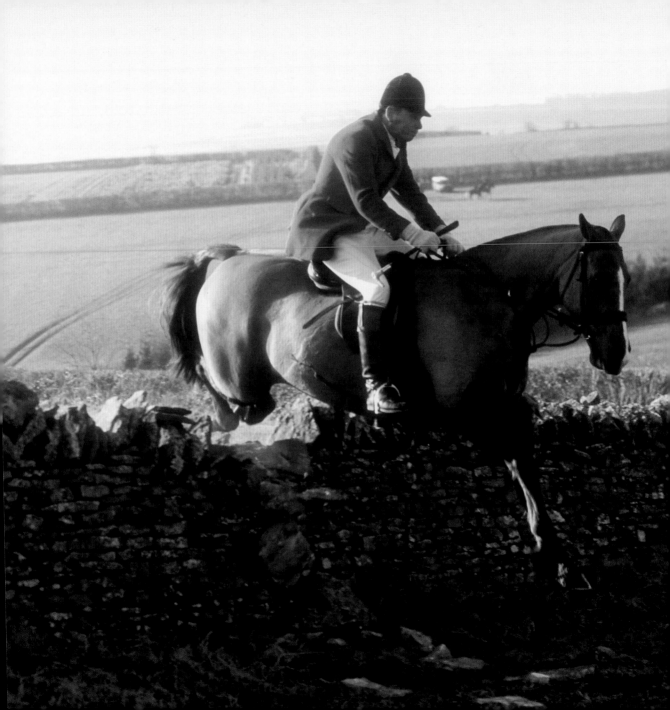

If, however, you reward him with kindness after he has done

as you wish, and punish him when he disobeys, he will be most

likely to learn to obey as he ought.

XENOPHON, *THE ART OF HORSEMANSHIP*

*This rider experiences the thrill of the chase as he negotiates a
stone wall while hunting with the Heythrop Hunt in England.
Great Britain is where foxhunting has its origins.*

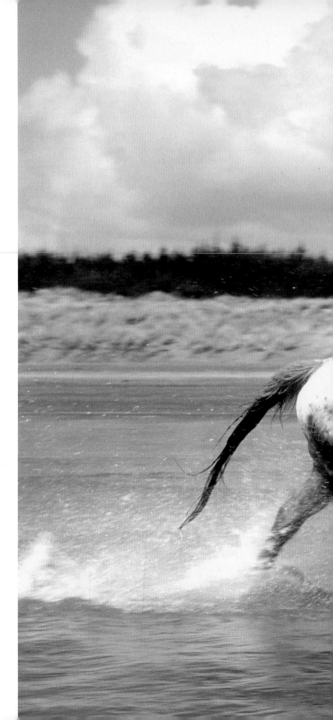

OCEAN VOYAGE

My family has a house on the ocean in a beautiful town called South Dartmouth, Massachusetts, and when I was younger I used to spend summers there. As riding became more important in my life, I found it harder and harder to divide my time between the beach and my horses. My aunt told me that when she was young she used to work race horses on the beach. It was a great way to get them fit. I decided to take this advice and develop my own training program. Early in the morning, before the crowds made it to the beach, I would get on one of my two horses bareback with a nylon halter and a rope, and I would pony, or lead, the other down the path to the beach. The best part was taking them in the ocean, where the two horses would half swim, half push from the ground. I would swim between them, holding on to one halter with each hand. Then I could go underwater and look to both sides and see their legs moving through the water. It was an incredible sight. I am sure anybody who saw this thought I was nuts! However, it was a tremendous way to get them fit, and they loved it!

PETER WYLDE, MAASTRICHT, THE NETHERLANDS

PAN AMERICAN AND WORLD EQUESTRIAN GAMES MEDALIST

OLYMPIC VETERAN

A horse and rider enjoy a chance to cool off in the sea along the 90 Mile Beach in New Zealand in 2000.

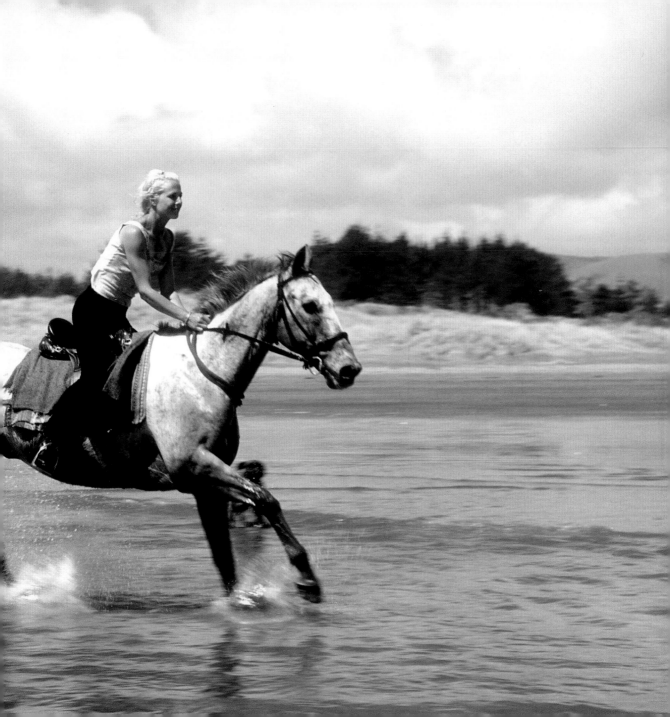

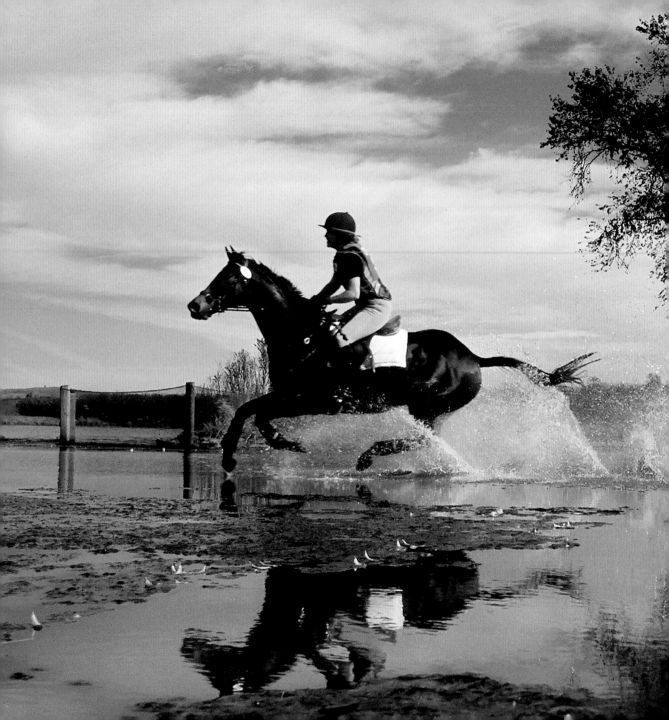

In this game there are millions

of ways to get beaten but only

one way to win—by finishing first.

BILL MOTT

*A rider competes in the cross-country phase
of a three-day event in October 2004 at the
Great Meadow Equestrian Park in
Warrenton, Virginia. "Virginia is for Horse
Lovers" is the coined phrase used to define a
state that is known for its horses.*

A gentle hand is one which feels the effect of the bit

slightly without giving too much contact.

FRANCOIS ROBICHON DE LA GUERINIERE

*The majesty of driving is witnessed in this Coaching Marathon class at the 2004 Royal
Windsor Horse Show on the grounds of the famed Windsor Castle in England.*

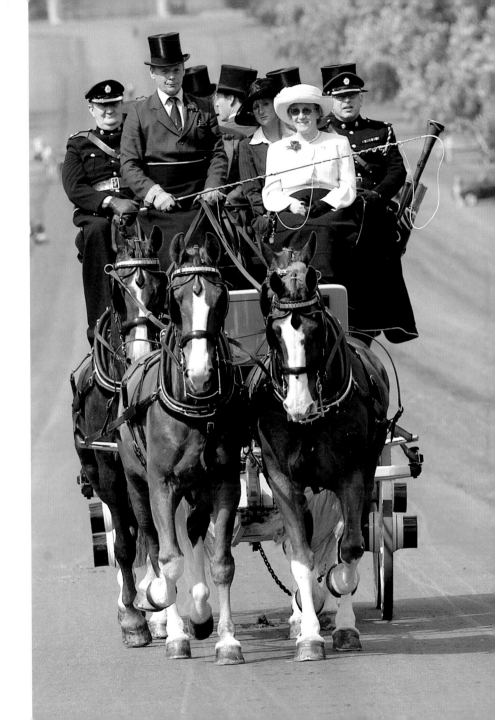

W hile Pegasus had been doing his utmost to shake Bellerophon off his back, he had flown a very long distance; and they had come within sight of a lofty mountain by the time the bit was in his mouth. Bellerophon had seen this mountain before, and knew it to be Helicon, on the summit of which was the winged horse's abode. Thither (after looking gently into his rider's face, as if asked to leave) Pegasus now flew, and, alighting, waited patiently until Bellerophon should please to dismount. The young man, accordingly, leaped from the steed's back, but still held him fast by the bridle. Meeting his eyes, however, he was so affected by the gentleness of his aspect, and by the thought of the free life which Pegasus had heretofore lived, that he could not bear to keep him a prisoner if he really desired his liberty.

Obeying this generous impulse, he slipped the enchanted bridle off the head of Pegasus, and took the bit from his mouth.

"Leave me, Pegasus!" said he. "Either leave me, or love me."

In an instant, the winged horse shot almost out of sight, soaring straight upward from the summit of Mount Helicon. Being long after sunset, it was now twilight on the mountain-top, and dusky evening over all the country round about. But Pegasus flew so high that he overtook the departed day, and was bathed in the upper radiance of the sun. Ascending higher and higher, he looked like a bright speck, and, at last could no longer be seen in the hollow waste of the sky. And Bellerophon was afraid that he should never behold him more. But, while he was lamenting his own folly, the bright speck reappeared, and drew nearer and nearer, until it descended lower than the sunshine; and behold, Pegasus had come back! After this trial there was no more fear of the winged horse making his escape. He and Bellerophon were friends, and put loving faith in one another.

That night they lay down and slept together, with Bellerophon's arm about the neck of Pegasus, not as a caution, but for kindness.

NATHANIEL HAWTHORNE, *THE WINGED HORSE*

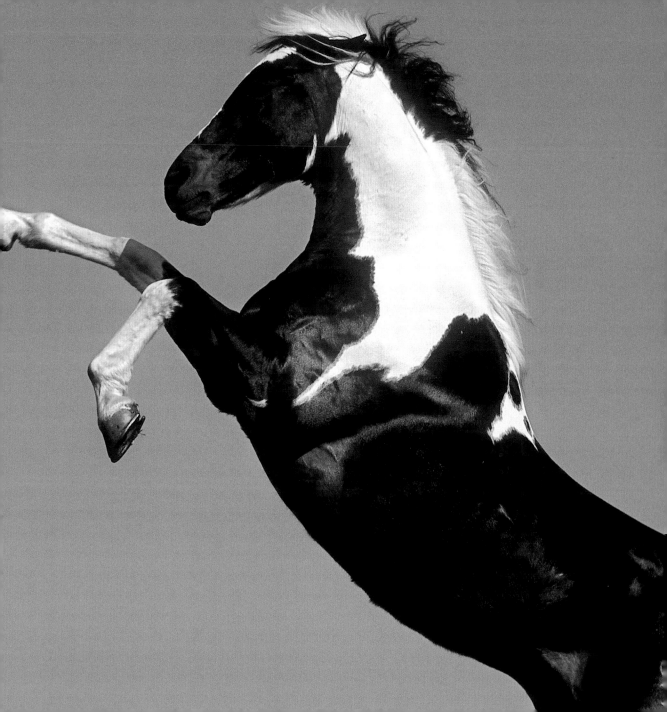

A lovely horse is always an experience…

It is an emotional experience

of the kind that is spoiled by words.

BERYL MARKHAM

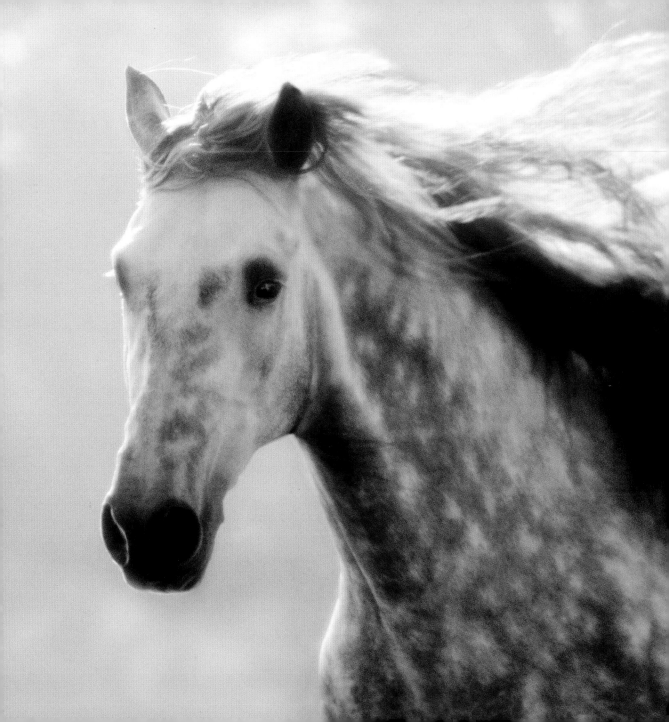

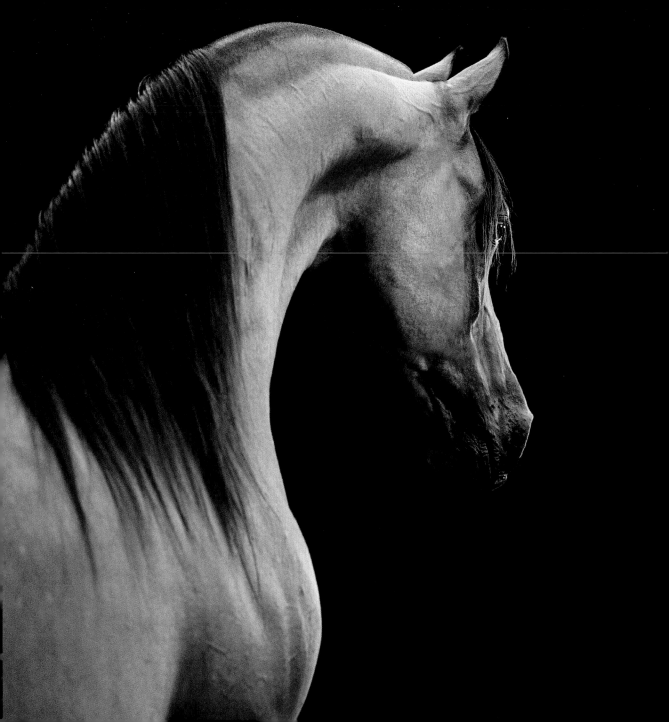

The knowledge of the nature of a horse is one

of the first foundations of the art of riding it, and every

horseman must make it his principal study.

FRANCOIS ROBICHON DE LA GUERINIERE

Portrait of an Arabian stallion, Ivanhoe Tsultan.

Spring and summer are riding on a piebald mare.

RUSSIAN PROVERB

Out for a bit of fun and frolic as these two Norwegian Fjord colts rear and play. This is one of the oldest and purest breeds of horse. It is thought that this breed is related to the primitive wild horses of Asia, the Przewalski.

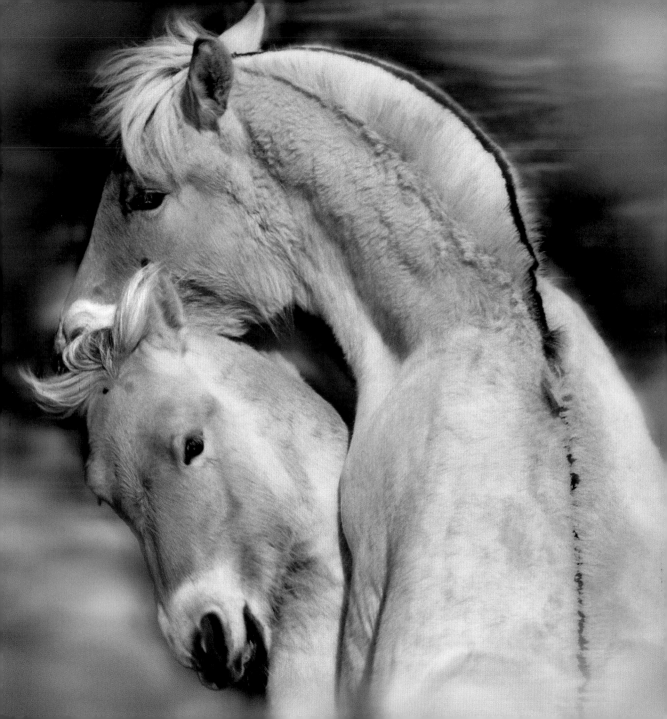

[Man o' War] did not beat, he merely annihilated. He did not run to world records, he galloped to them. He was so far superior to his contemporaries that, except for one race against John P. Grier, they could not extend him. In 1920 he dominated racing as perhaps no athlete— not Tilden or Jones or Dempsey or Louis or Nurmi or Thorpe or any human athlete—had dominated his sport.

JOE PALMER, *AMERICAN RACE HORSES*

OPPOSITE:
*A pair of Paint horse stallions having a little fun splashing through a shallow stream
in the Ocala National Forest in Florida. Historical pictures often depict a native
American Indian seated on a colorful Paint horse.*

PAGES 248-249:
After a wonderful afternoon rest, a sleepy Arabian foal rises from a nap in the grass.

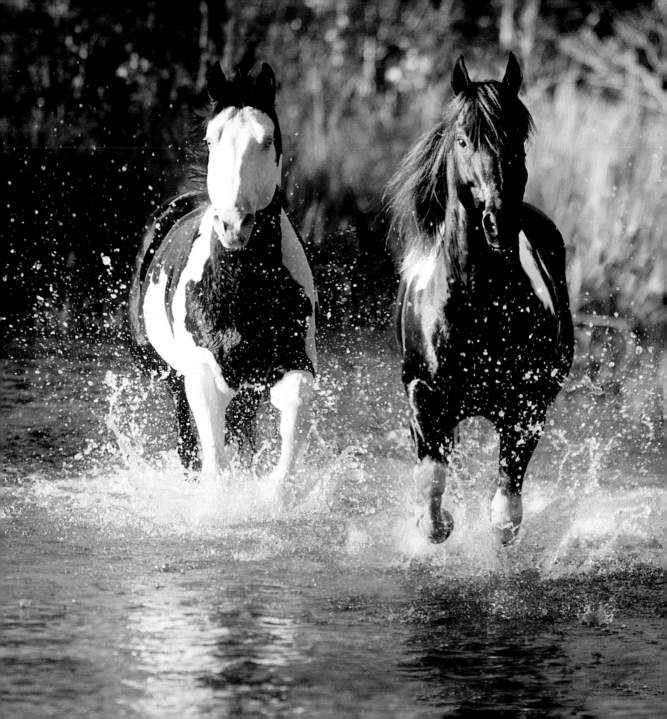

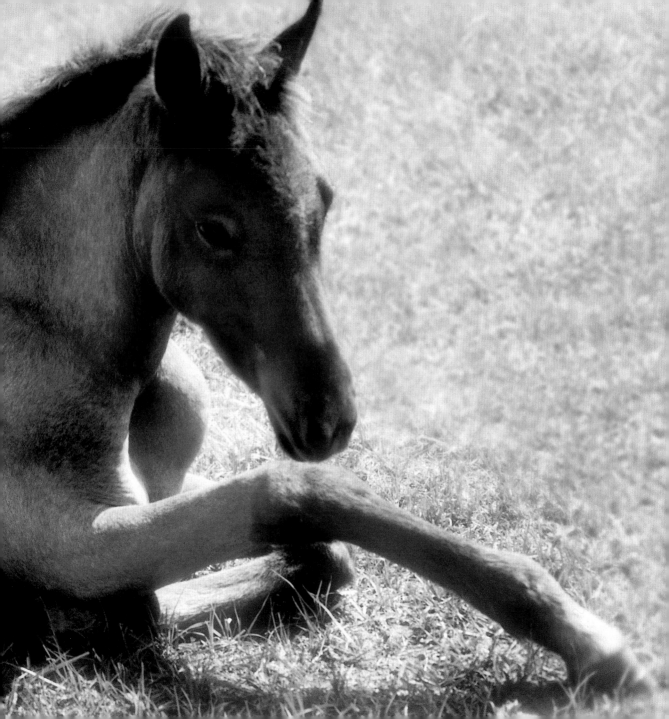

PAL

I worked a summer in college at a major livery on the edge of Rocky Mountain National Park in Estes Park, Colorado. There were a lot of memorable horses, but one in particular comes to mind: an old U-shaped palomino named "Pal." Pal was a great trail horse. He didn't get too excited about much; he didn't ever move very fast; he always stayed in line and his only vice was eating grass. Hey, what can you expect from someone whose work area doubles as a salad bar?

In fact, we didn't even bother tying Pal up at the livery. You just put him at his spot by the rail and threw the reins over his neck, and he would stand there all day. He might walk to the water tank and get a drink, but he would always go back where you put him. If it was a particularly hot day, he would sometimes wander over to a row of small pens where he could find some shade.

There were times I dreaded having Pal on a ride, but other times, when Pal was carrying a small child, I could look back at him plodding along and smile, because even if it did take a little longer, I knew that kid would get home safely. Pal, like many horses, had inside him whatever it is that allows them—among the largest and most powerful animals around—to take care of our smallest and weakest.

JON PADGHAM, TEXAS

NUTRITION SPECIALIST, D&L FARM AND HOME

A close-up shot of a Bashkir Curly mare reveals the breed's subtle curls on the face. The hair on the body is thicker and curlier and resembles a Berber rug.

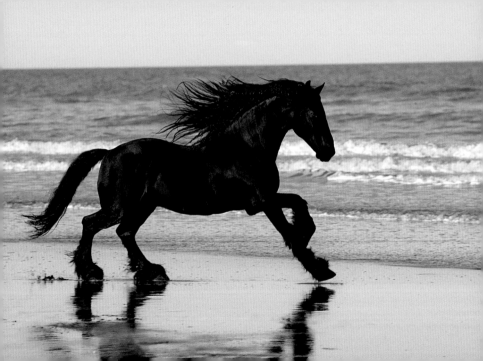

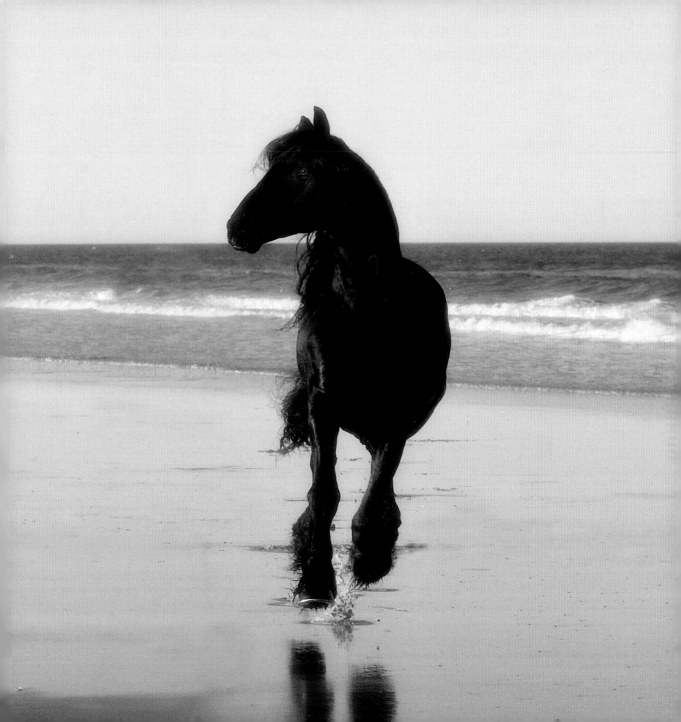

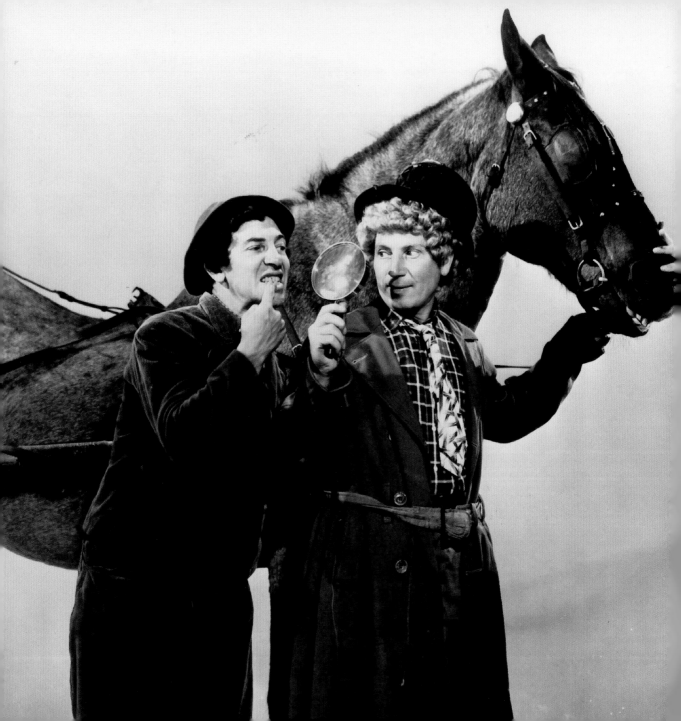

Show me your horse and

I will tell you what you are.

OLD ENGLISH SAYING

OPPOSITE:
A Day at the Races, *1937*
Chico, Harpo, and Groucho Marx star as Tony, Stuffy, and Dr. Hugo Z. Hackenbush in the 1937 film where a vet posing as a doctor and a racehorse owner try to keep a sanitarium open with the help of a misfit racehorse.

OVERLEAF:
A young woman taking a stroll with an Arabian under oak trees in Ocala, Florida.

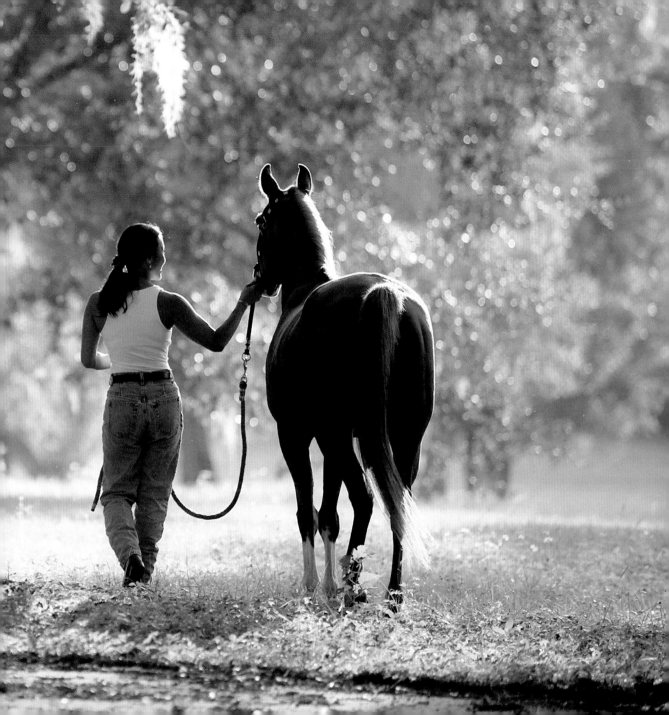

Kissed by sunlight, embraced by open fields.

The horse is the center of all beautiful things.

ANONYMOUS

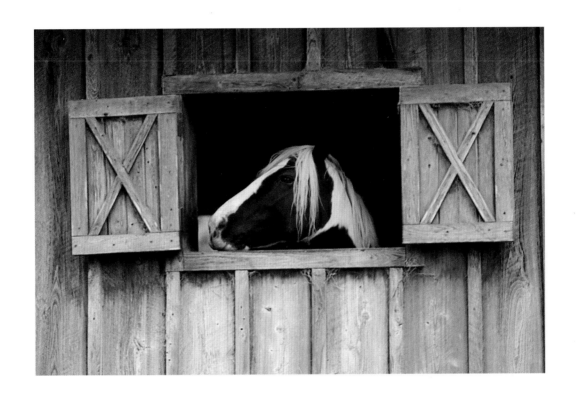

A Gypsy Vanner mare looks out in to the distance from its barn window. Gypsy Vanner horses are known for their quiet dispositions, intelligence, and long, flowing mane and tail.

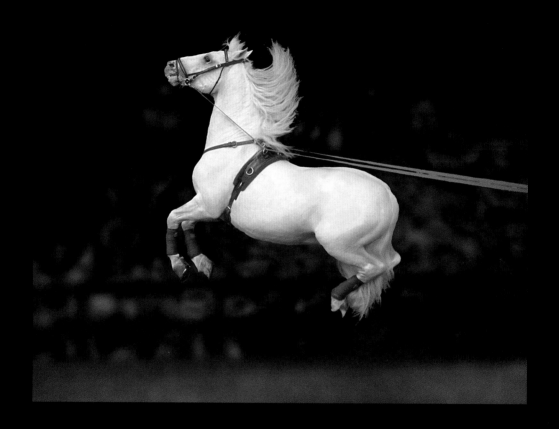

Herrmann's Royal Lipizzaner Stallion Show in Sarasota, Florida. This Lipizzaner stallion is performing a capriole, which requires both strength and agility to demonstrate this movement that is said to have been used in wartime to fight the enemy.

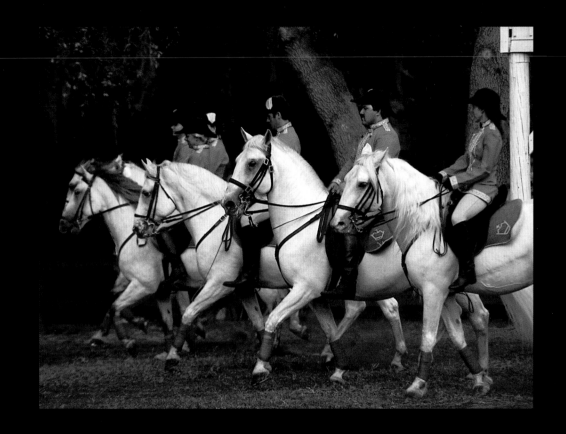

Here a group of stallions at Herrmann's Royal Lipizzaner Stallion Show in Sarasota, Florida performs a dressage drill. Dressage is a way of developing the horse through training and channeling the horse's strength, agility, balance, and suppleness with the goal of maximizing its potential.

Popping the Poop

A story that I was told from when my grandmother owned a riding school:

An instructor was giving an intermediate lesson to a group of adults. One of the adults was riding "Beau," who was a very large, round, lazy horse. The student was having a particularly hard time getting Beau to move. So the instructor suggested using the crop on the horse. The student objected for fear of hurting the horse. The instructor insisted, because she would never get Beau to trot otherwise, as Beau was the type of horse who tested all who rode him. Finally, after much protesting, the woman decided that the instructor was correct and she was never going to get a trot unless she used the crop. The student took the crop and lightly tapped the horse behind her leg, and the horse abruptly stopped and pooped. The student cried, "Oh my goodness, look what I have done, I have beat the crap out of this poor horse!" With that she vowed never to use a crop again. We all had a good laugh.

BETH SACCARDI (15), NEW YORK
HORSE ENTHUSIAST AND TRAIL RIDER

Young riders perform old-fashioned jumps over a steeplechase course, circa 1920.

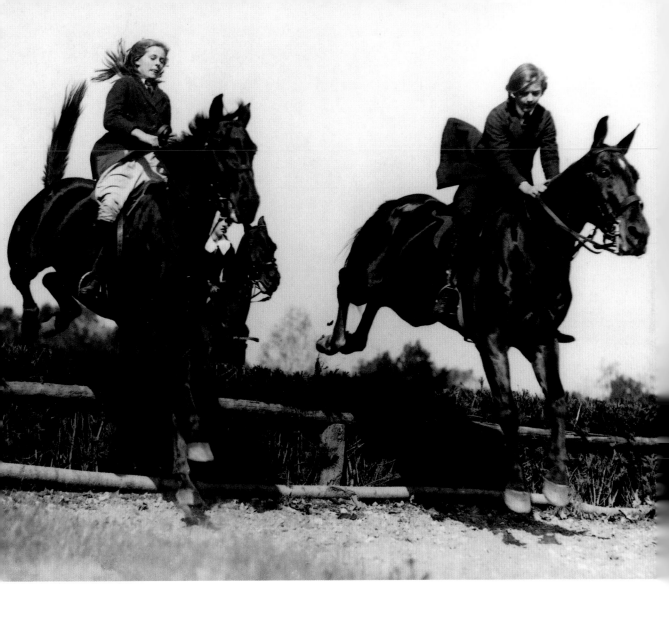

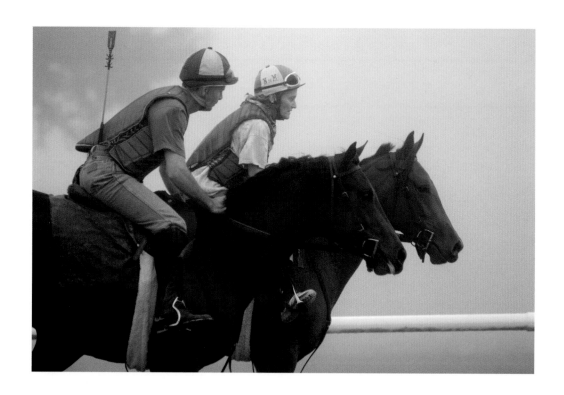

The morning is when exercise riders take to the track with their young Thoroughbreds
for an early morning workout, even when there is a foggy mist covering the track.

A racetrack exists as a world apart, rich in its own mysteries and subject to laws of its own devising. When you walk through the turnstiles at Santa Anita Park, near Pasadena, you could be going back in time to an era of Hollywood glory and entering a grand Art Deco hotel of the thirties. There are curved mirrors and etched glass, imported Mexican tiles and semiformal gardens where punters sit reading the *Racing Form* in a sea of flowering bougainvillea, as if they were waiting for a bellhop to grab their luggage, or a cigarette girl to deliver some smokes. The chance of bumping into a retired movie star in the private turf club is extremely high, as is the opportunity to soak up the last fading essence of Southern California class.

BILL BARICH, *THE SPORTING LIFE*

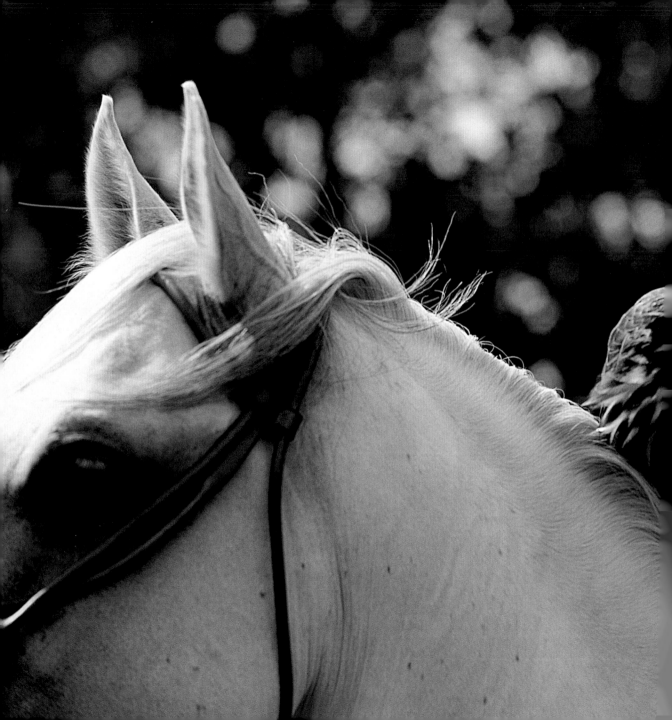

A hawk on a Lipizzaner horse in Le Lude, France.

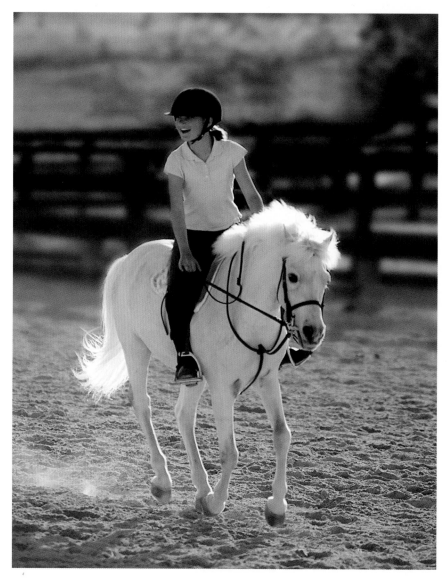

Jazzy and Misty: Our First Ponies

A young girl enjoys herself in an arena as she rides around on a pony and they learn and bond together. Ponies can be a handful, but learning how to ride a pony will one day prepare her to ride a horse.

It was a cold, brisk morning. I was on a trip to Florida on April vacation with my mom, my sister, and my riding instructor. We had just pulled up to a small barn in Ocala, Florida, to try a Quarter Horse pony named "Jazzy" (short for Smoky's Tasmanian Jazz). I nearly tripped, I was so excited. I had been searching for a pony for a year. Finally, the moment arrived and around the corner came this small, adorable pony.

We said our hellos and then we went to the arena to see this pony go. I watched in amazement and knew at that instant this pony was the one. Finally, it was my turn. My mother yelled to me, "Is she comfortable?" and I replied, "Of course! It feels amazing up here!" I lied, because she wasn't very comfortable but I loved this pony from first touch. Then I squeezed her into a canter and we went around and around. To jump this pony felt like no other.

Jazzy was to be my ultimate birthday present. About a month later we headed to the barn to meet the enormous truck that held my new pony. I will never forget the day she came: It was June 4, 2002, at 8:30 in the morning. Jazzy and I made an incredible team. It didn't matter whether it was pony club, hunter shows, or just having fun. I have outgrown her, but she is still mine and is pregnant too!

PAIGE HENDRICKSON (12), MASSACHUSETTS

No hour of life is wasted

that is spent in the saddle.

WINSTON CHURCHILL

A trainer gives his Arabian stallion a chance to show off as it lifts onto its hind feet and goes up in the air into a rear at Nodorama Farms in Ocala, Florida.

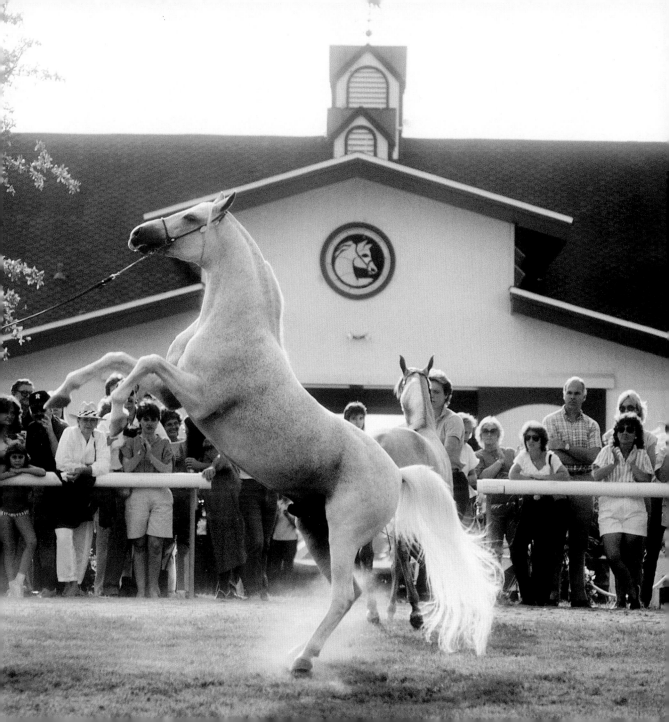

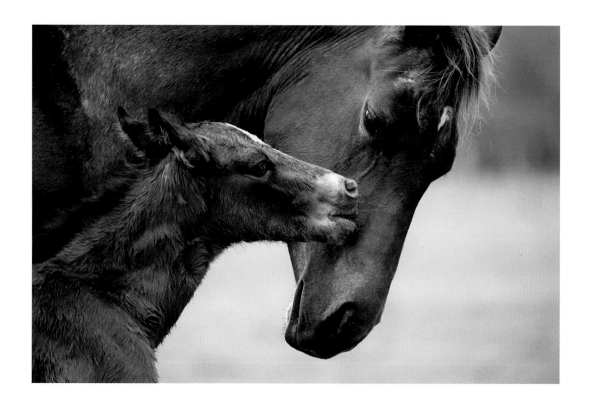

A newborn Appaloosa bonds with its mother. The Appaloosa is a unique breed that is generally recognized by its colorful coat patterns. Appaloosas are also noted for their mottled skin, white sclera, and striped hooves.

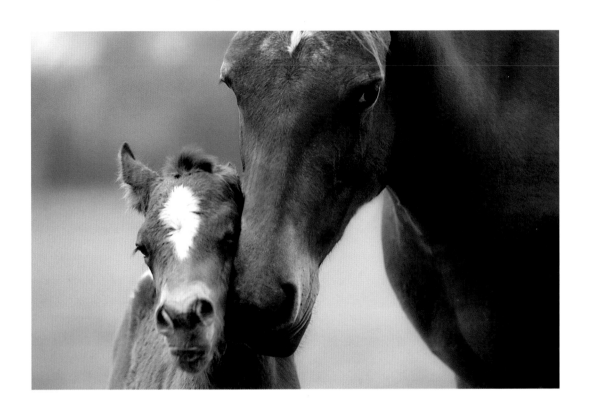

A precious moment between an Appaloosa mare and her just-born foal. Who knows what this foal will do, as Appaloosas are seen in many competitive disciplines and also make great trail horses.

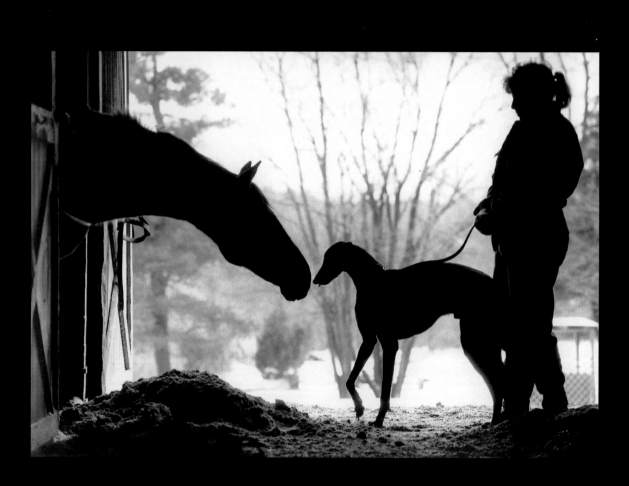

With much in common, a retired racehorse and a retired and adopted
greyhound come together from different worlds.

Ride Like Eddie

It was in late spring 1966, and at the young age of 18, I was on my first show jumping tour in Europe as a member of the United States Equestrian Team. It was an honor; it was thrilling, but also quite daunting. We were at the CSI Cologne in Germany, and I was riding in my first international Grand Prix on the final Sunday. During the week I listened to coach Bertalan DeNemethy's every word and followed his instructions and advice. In preparation for the Grand Prix, I was riding Mr. and Mrs. Patrick Butler's Irish-bred mare "Fru" in a time first jump-off class. I was clear in the first round, and since the mare could be a little "hot," I was advised to ride a nice, quiet, clear round in the jump-off. The mare was jumping very well that day and it was tempting to go fast and take a few short turns, but I did not. Several other competitors had faults in the jump-off, and I jumped a lovely clear round.

When I came out, Bert said to me I should have gone faster, I could have won the class. I am sure I had a totally bewildered look on my face as I thought I had followed his orders. The captain of our team, the legendary Bill Steinkraus, observed this and drew me to the side. He said "Jonesey, when we are in competition and you think you have a shot, take it. If you lose, you will get the same dressing down you just got, but if you win, you are Eddie Arcaro!" I jumped a clear round in Sunday's Grand Prix, and while standing at the IN gate for the jump-off I remembered those words and I went for it. As a result, I became the youngest rider at that time to win the Grand Prix of Cologne.

CHRYSTINE JONES TAUBER, NEW JERSEY

VICE PRESIDENT UNITED STATES HUNTER JUMPER ASSOCIATION

Horses are known to make friends with many other types of animals. Some even become their personal mascots. Here a tiny cat makes friends with a Gypsy Vanner stallion.

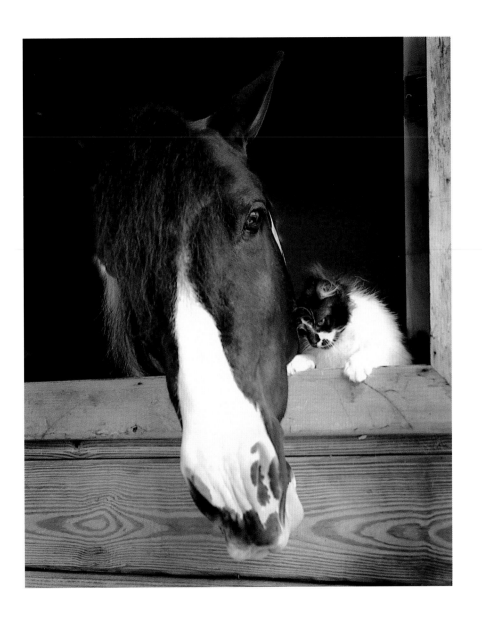

THE HORSE I RIDE

The horse I ride
Her name is Misty
She's brown and white
And she rides swiftly
I love to ride her
She's my friend
I'll never forget her
Till the end.

LYNDSAY HENDRICKSON (17), MASSACHUSETTS
MEMBER OF THE WORCHESTERSHIRE PONY CLUB
WRITTEN ABOUT THE FIRST PONY SHE RODE WHEN SHE WAS SEVEN YEARS OLD.

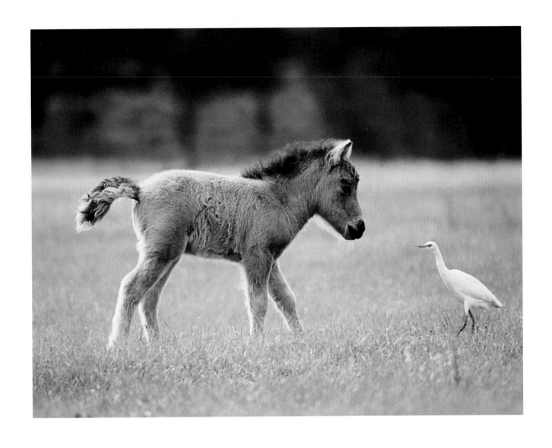

A miniature horse foal peers curiously at a cattle egret. The miniature finds the small white heron a little different from its horse friends.

Union Cavalry Orderly at Antietam, Maryland, 1862.

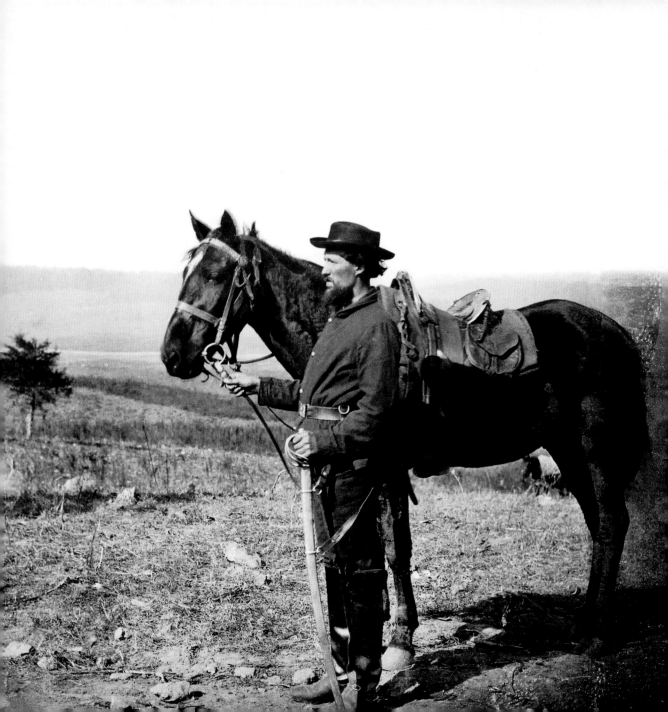

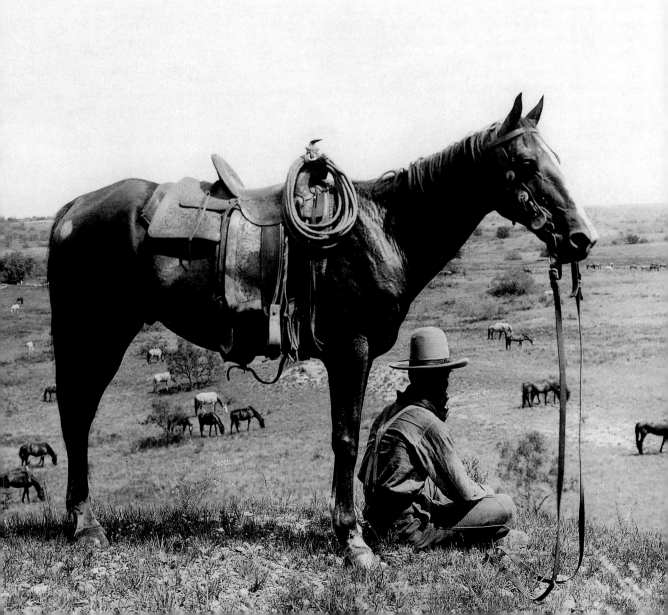

Have you ever saddled your horse
And been on your way
When the hoot owls were hootin'
At the break of day?

And rode out on the range
In the real early morn'
And felt kinda lucky
That you had been born?

Heard a meadow lark singing'
A real special tune,
With the stars fading out,
Though you can still see the moon.

Sagebrush and grass
Still sparklin' with dew,
The sky in the east is
Turning red, mixed with blue.

Your horse's shod hooves
Knock sparks from the rocks,
And you hear the strange struttin' sounds
Of them proud old sage cocks.

The lonesome wail
Of a coyote cry,
With nose pointed up
Toward the sky.

An eagle soars high,
With wings out-spread.
The sun's now coming up,
And it's sure big and red.

A red-tailed hawk screamin'
Down from the hill,
Looking for breakfast,
A rabbit to kill.

A magpie sits in a bush close by
Watching this with a watchful eye,
He'd like to enjoy a feast
With his brothers from the sky.

A horny toad struggles
To get out of your way,
A lizard glides off a rock
Like he wants to play.

Your horse shies off the trail
At the buzz of a rattle,
Then you sorta' remember
You're here to round up cattle.

FROM *EARLY MORNING ROUNDUP* BY OWEN BARTON

285

Horses make a landscape look beautiful.

ALICE WALKER

PAGE 285:
Cowboys are known for the signature cowboy hat, and often chaps become part of their garb. Here a typically attired cowboy takes a moment to pause and view Glacier Park.

OPPOSITE:
The silhouette of an Arabian foal as it meanders on the shore during an impressive sunset.

PAGES 288-289:
Miniature horses at Haven Farms in Alberta, Canada. This distinctive breed of horse is found in all parts of the world. The first true miniature horses originated in Europe.

PAGES 290-291:
These massive Clydesdales and ranch horses gallop through a snowy Wyoming field during their relaxing hours. Soon their day will start and they'll be preparing the land and taking care of the cattle once the ranch hands start their day.

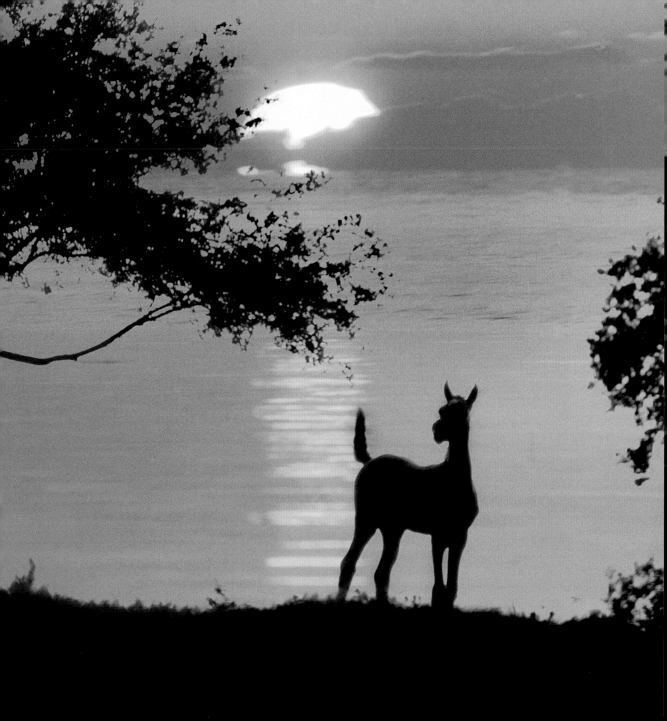

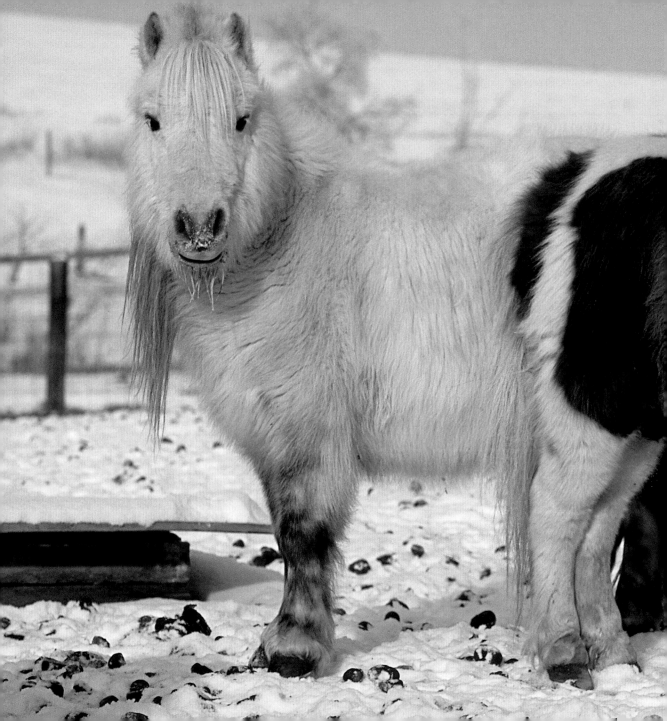

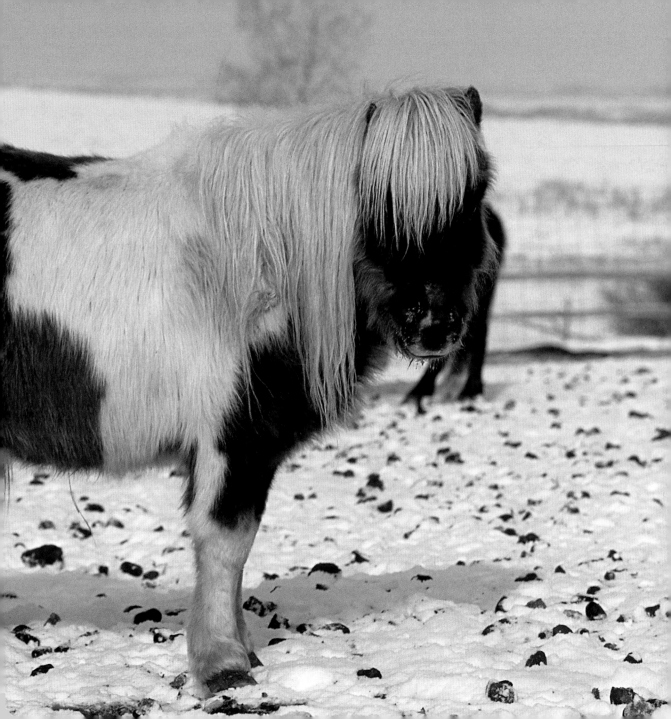

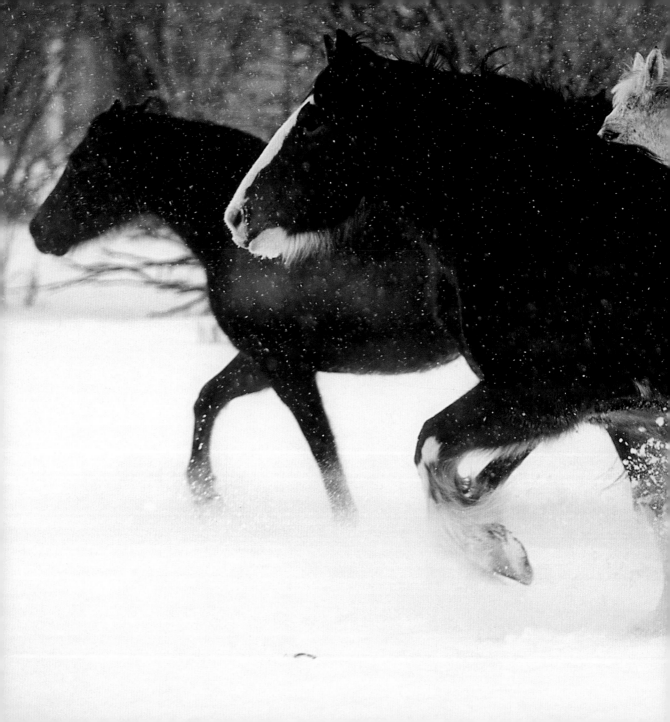

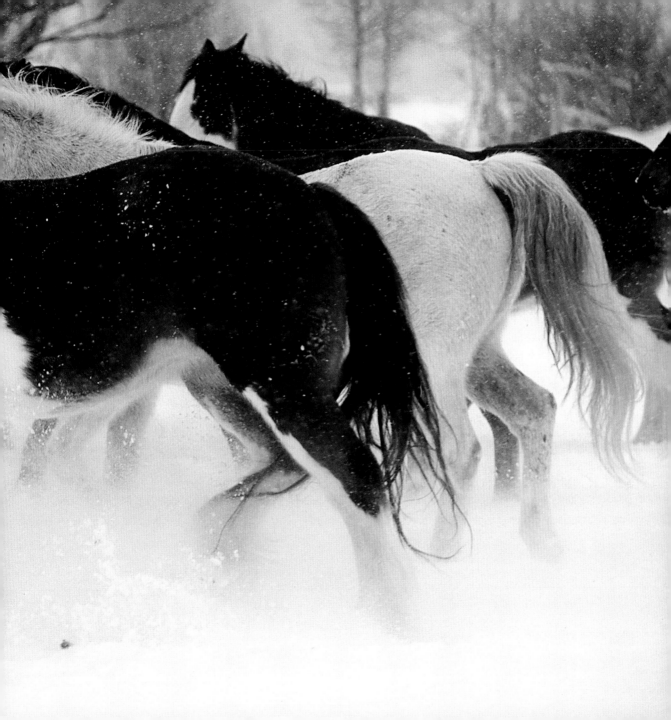

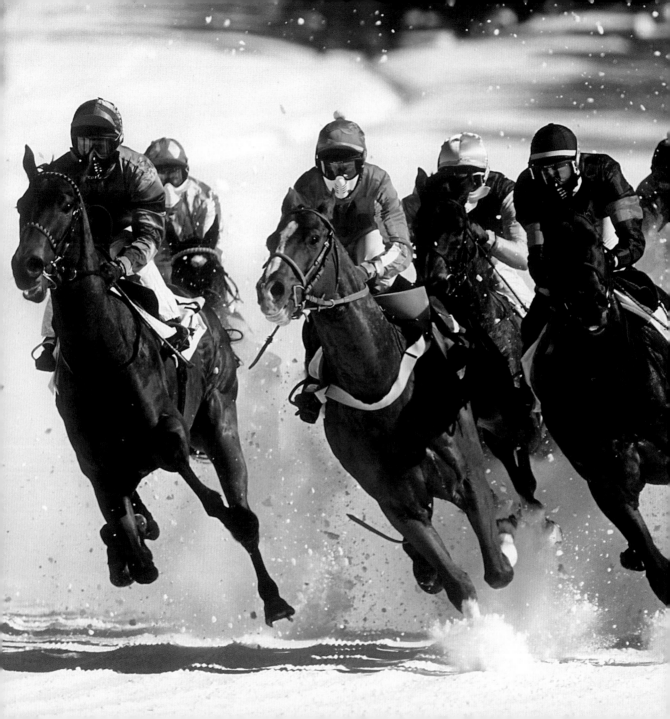

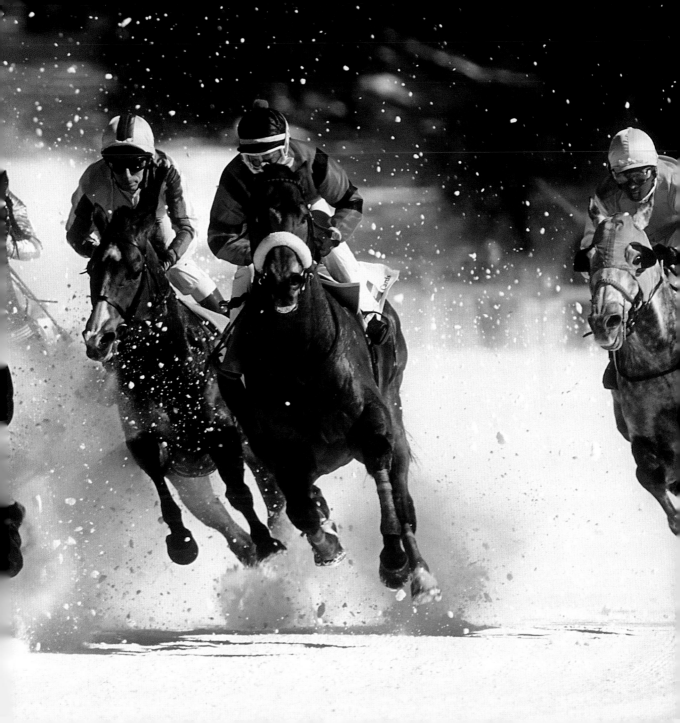

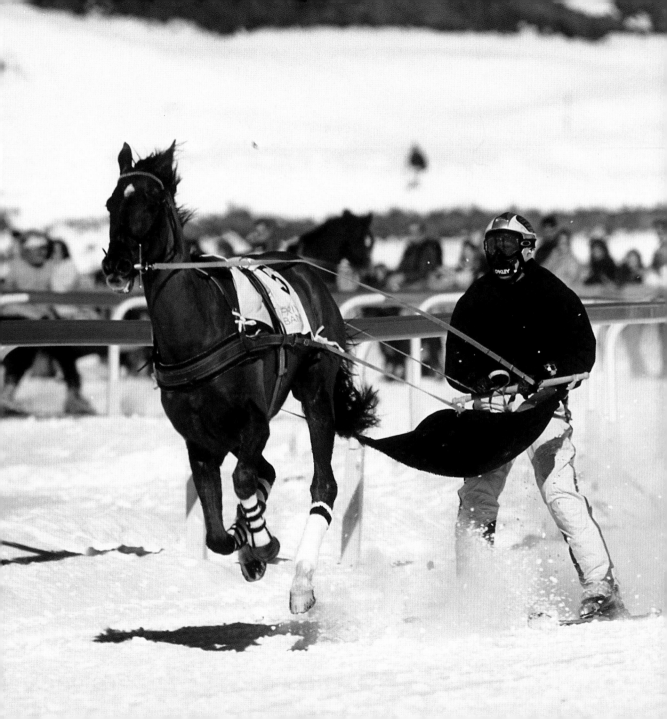

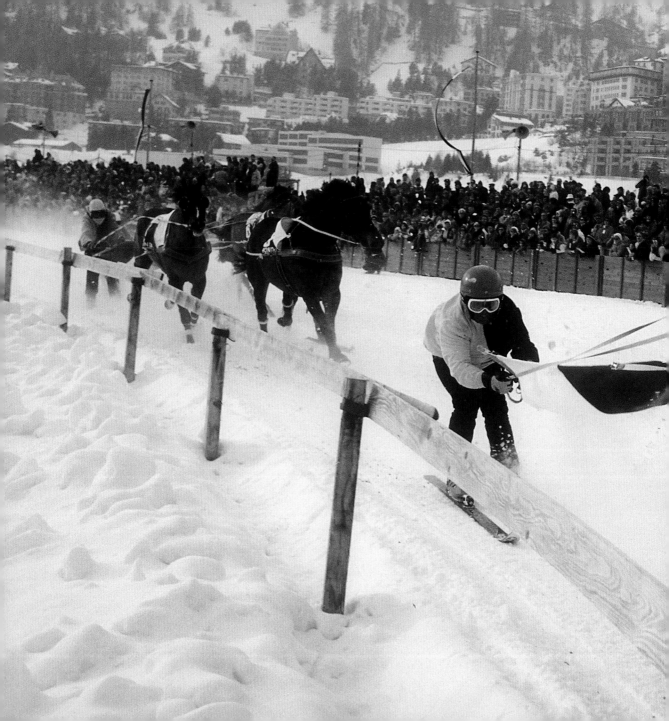

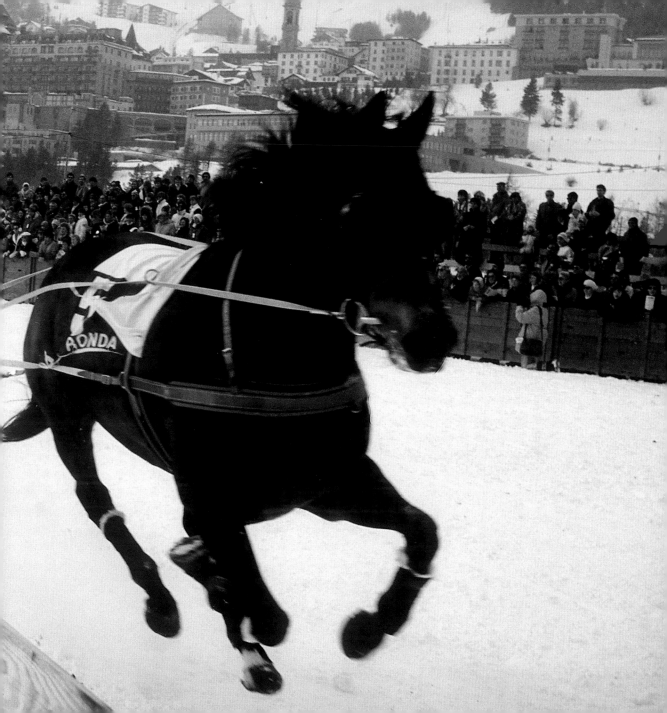

Wintertime is just as much fun for this pair of Thoroughbred mares who are enjoying a snow-covered landscape as they wander near a stream. It's a perfect place to take a sip of water to quench their thirst.

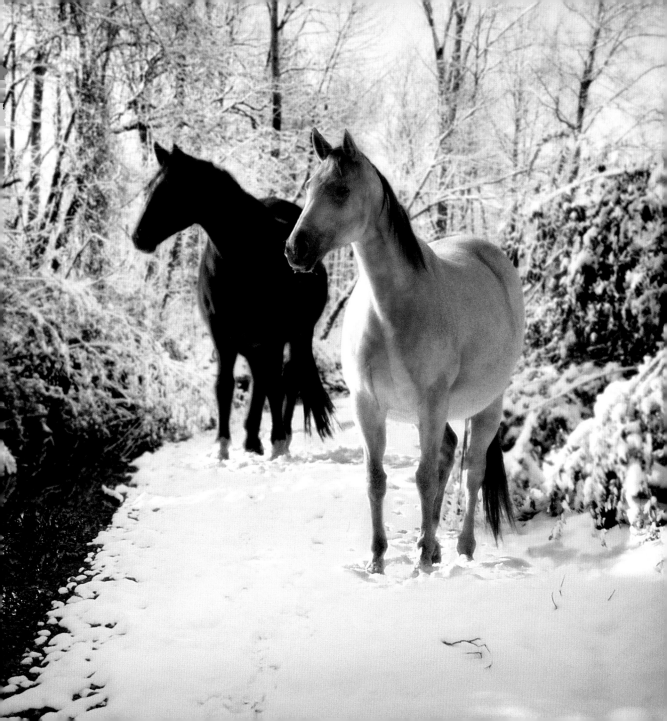

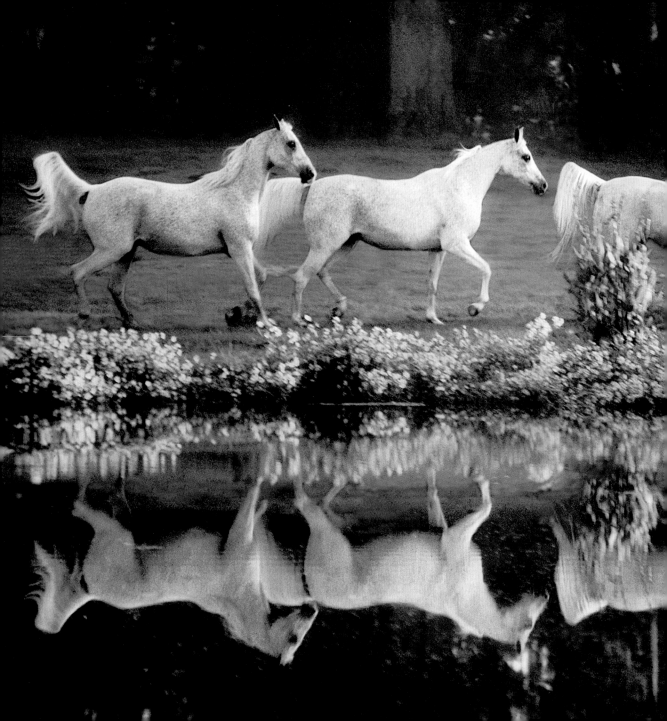

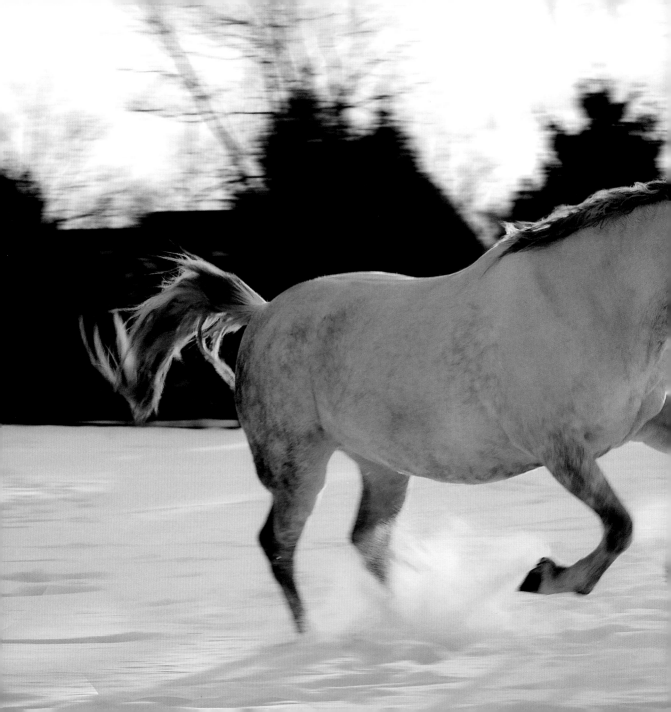

RIGHT:

Traveling together and following one another, this herd of Arabian mares and foals gallop over a rise. It's a natural instinct for the foals to stay close to their mothers. One day they will be weaned away from them, but for now they enjoy their time together.

PAGES 306-307:

A herd of Spanish mustang mares as they move through some Florida scrub. The mustang is derived from sixteenth-century Conquistadors' horses, which entered the United States through Mexico.

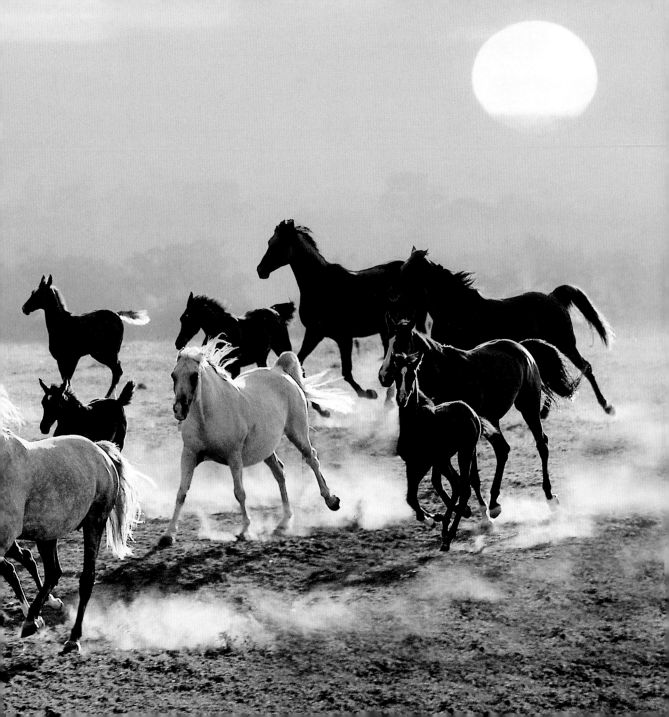

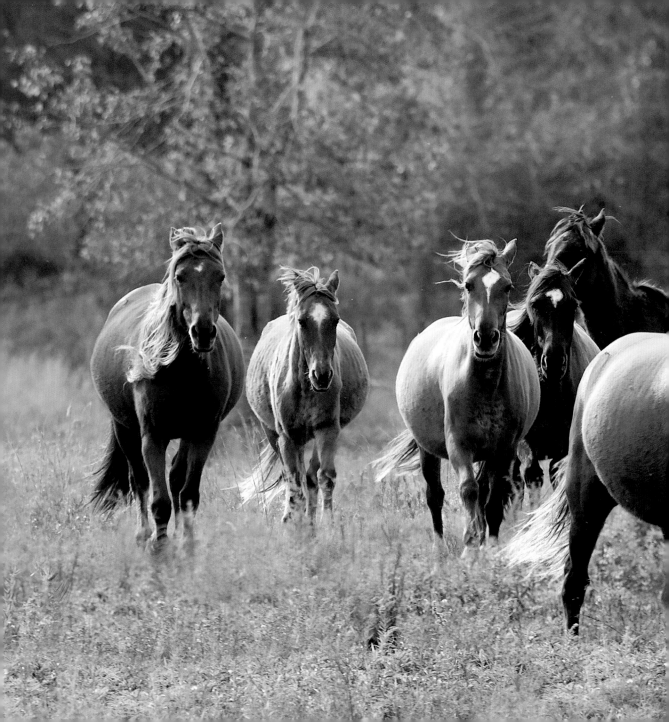

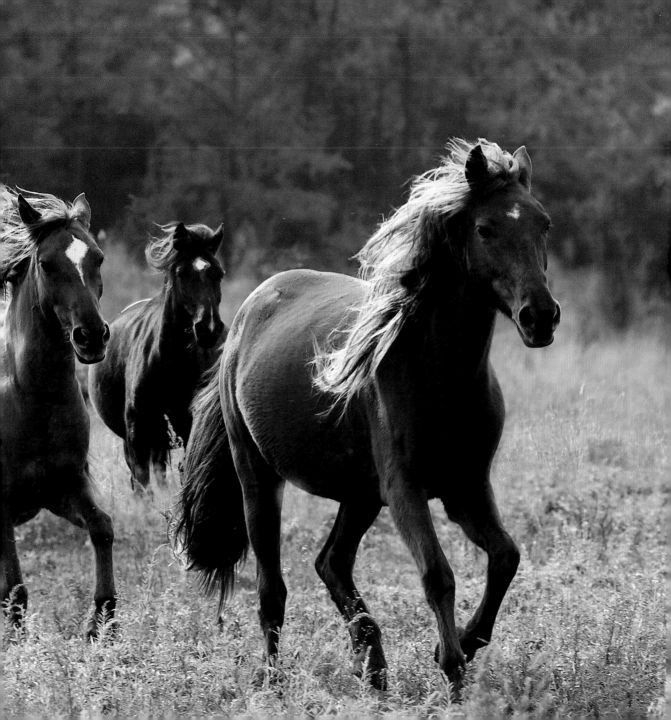

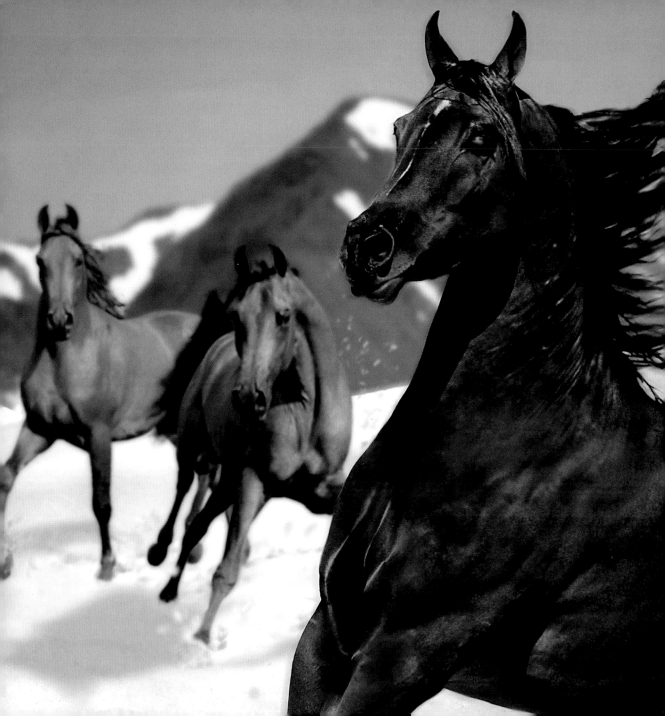

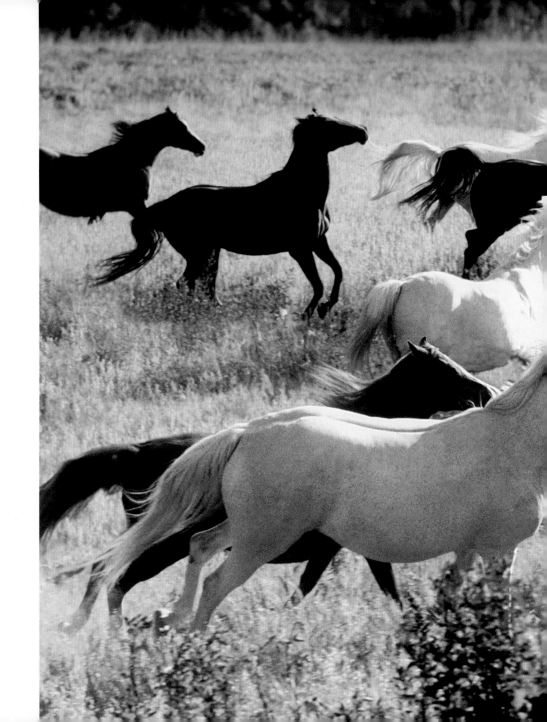

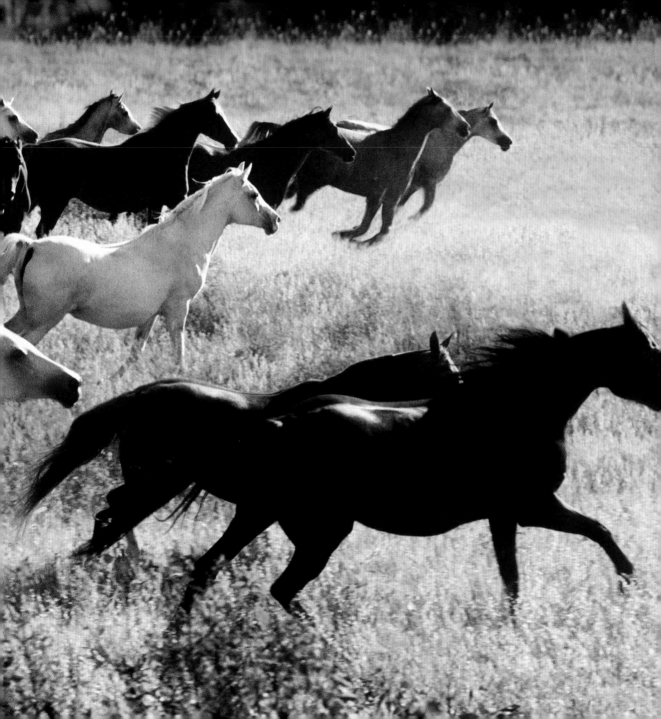

For want of a nail a shoe was lost, for want of a shoe a horse

was lost, for want of a horse a rider was lost, for want of a rider

a army was lost, for want of an army a battle was lost, for want

of a battle the war was lost, for want of the war the kingdom was lost,

and all for the want of a little horseshoe nail.

BENJAMIN FRANKLIN

A horse and rider on the beach. The sandy footing is exercise for the
horses as it is harder to run through sand, especially if it is soft.

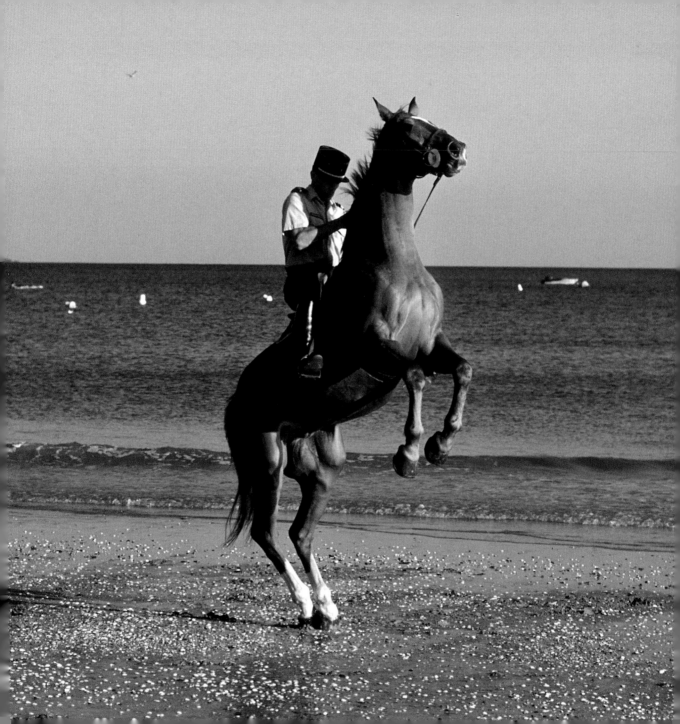

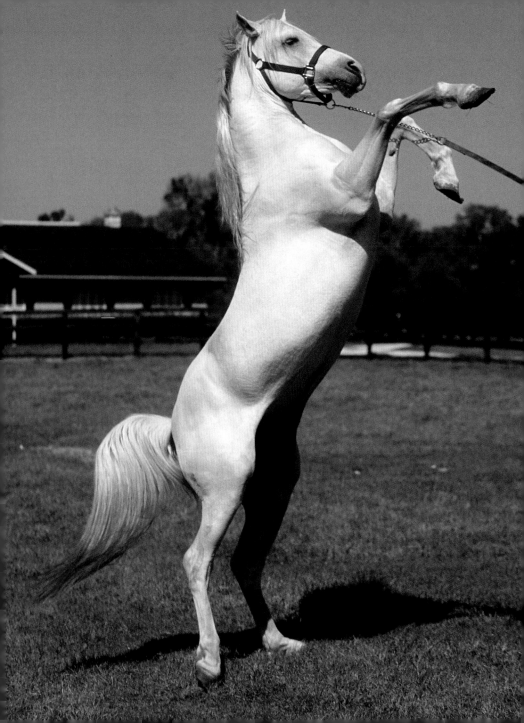

At Galway Races

There where the course is,
Delight makes all of the one mind,
The riders upon the galloping horses,
The crowd that closes in behind:
We, too, had good attendance once,
Hearers and hearteners of the work;
Aye, horsemen for companions,
Before the merchant and the clerk
Breathed on the world with timid breath.
Sing on: somewhere at some new moon,
We'll learn that sleeping is not death,
Hearing the whole earth change its tune,
Its flesh being wild, and it again
Crying aloud as the racecourse is,
And we find hearteners among men
That ride upon horses.

WILLIAM BUTLER YEATS

*A horse on a lead rearing on command by its handler. When a
horse rears, he must balance his weight on his two hind legs.
The pawing action is often seen when the horse takes this stance.*

A Paso Fino in a paddock at Young's Paso Fino Ranch in Florida. Paso Fino horses are known for their smooth gait. They exhibit a perfect four-beat rhythm. The Paso Fino is considered a hearty horse that was often used to work the farmland. The smooth gait was so comfortable that a rider could spend all day in the saddle.

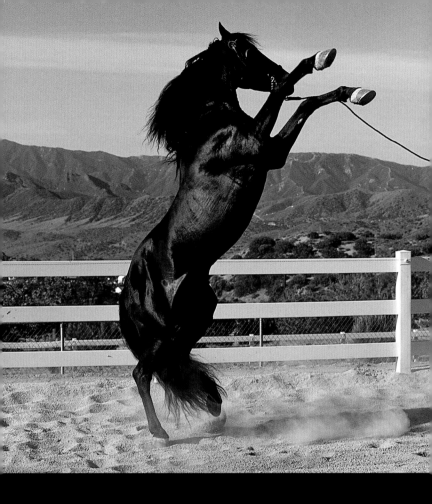

ABOVE:

Californians Susan and James Hassard's Andalusian, Rio Paraiso, a 16-plus-hand beautiful black stallion. The Andalusian horse is known for its extraordinary spirit and movement.

OPPOSITE:

Centauro II (an Azteca horse) at Ramon's Equestrian Entertainment in California displays his powerful rear. The Azteca breed was started by crossing Andalusian stallions with Quarter Horse and Criollo mares. Their early beginnings date back to the Aztec era, when the Conquistadors brought their Spanish blood horses to Mexico and turned them loose rather than take them back home on their ships.

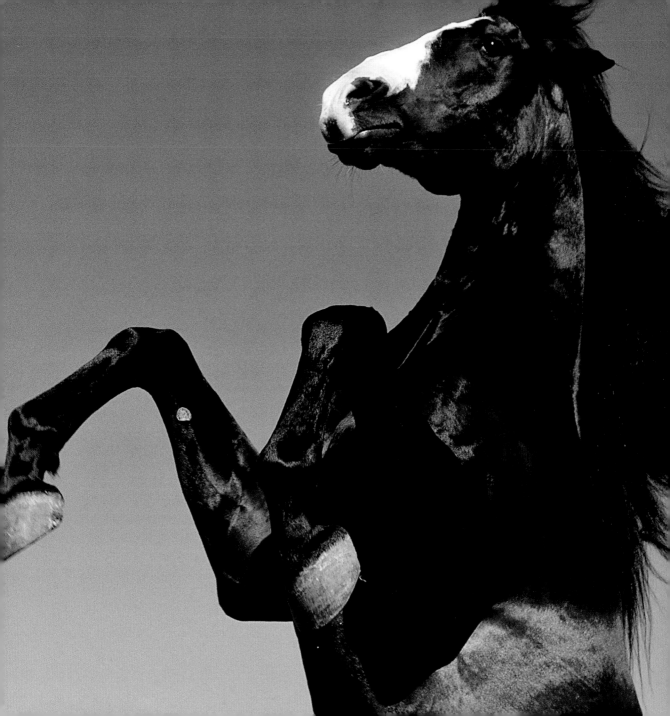

He took us through some rough country, where the ambitious horses, finding that by bending their heads they could squeeze through, forgot to seek openings high enough to admit those sitting in the saddle. We crashed through underbrush, and I, with habit torn and hands scratched, was sometimes almost lifted up, Absalom-like, by the resisting branches. Often we had no path, and the general's horse, "Vic," would start straight up steep banks after we had forded streams. It never occurred to his rider, until after the ascent was made, and a faint voice arose from the valley, that all horses would not do willingly what his thoroughbred did.

ELIZABETH B. CUSTER
WIFE OF GENERAL GEORGE CUSTER

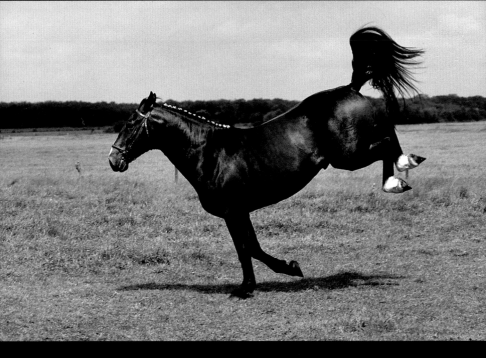

ABOVE:

Gronigen is a breed of horse that originated in the northeastern part of the Netherlands. It is a cross between the Dutch Friesian and the German Oldenburg. The breed is known to have a heavier build, able to handle the tough clay soil found in this region of Holland.

PAGES 322-323:

Gus, a powerful Clydesdale stallion, playing in his paddock at Folly Lane Farm in Florida. The Clydesdale is a heavy draft horse breed recognized for its strength, style, and versatility.

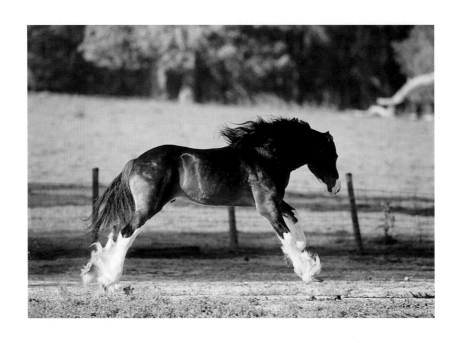

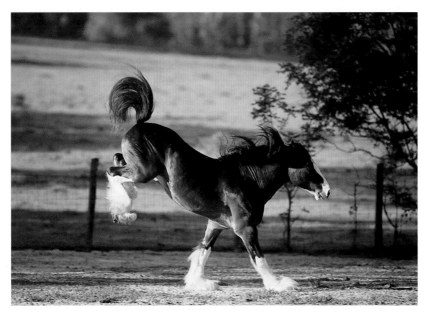

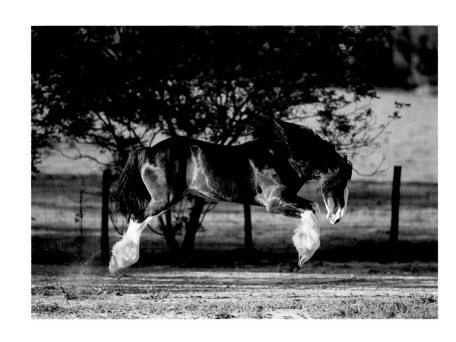

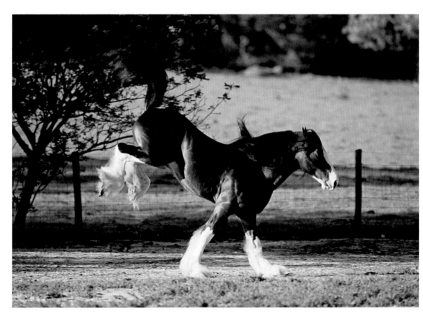

If your horse says no, you either

asked the wrong question,

or asked the question wrong.

PAT PARELLI

OPPOSITE:
A Clydesdale Draft Horse stallion with a beautiful head and expressive eyes gallops past.

PAGES 324-325:
A Tennessee Walking Horse colt kicking up his heels in the snow at a Louisville, Kentucky farm. This light horse breed had its origin in middle Tennessee. They are best known for their "running walk."

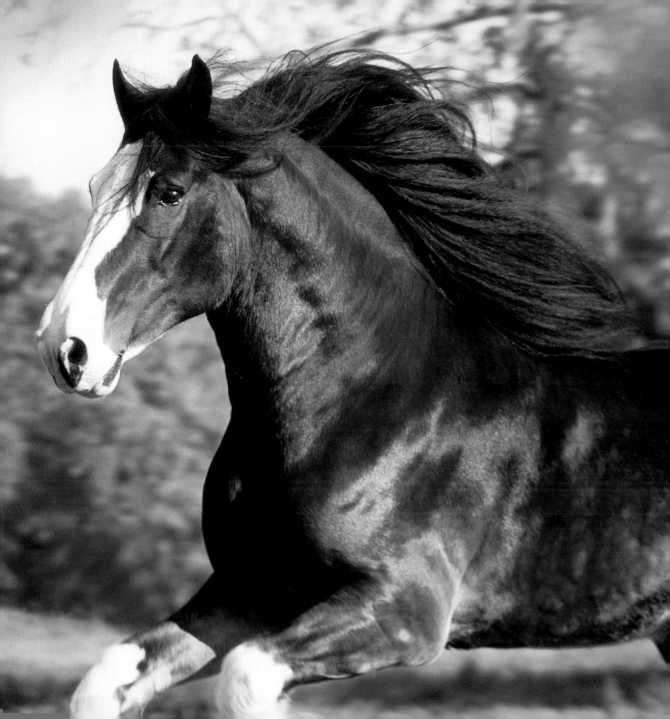

The Hooves of Horses!

Oh! witching and sweet
Is the music earth steals from the iron-shod feet;
No whisper of lover, no trilling of bird,
Can stir me as much as hooves of horses
Have stirred.

WILL H. OGILVIE

RIGHT:
When no rider is on its back, this rearing Morgan stallion feels free to have some fun.

PAGES 330-331:
An Arabian stallion gallops by a pond in Peaks of Otter, Tennessee. Stallions are generally more difficult to handle than geldings, both from the ground and on their back, but if that energy can be focused in a positive way they usually can skillfully handle any sport.

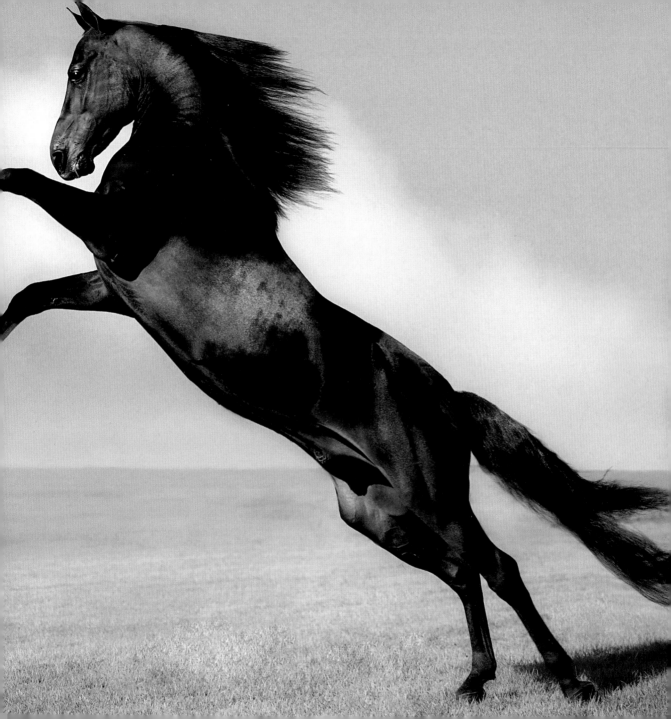

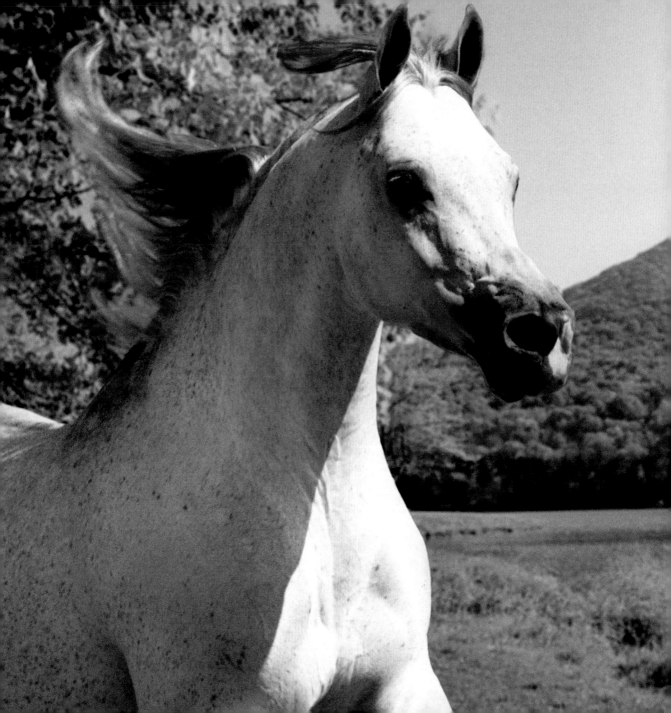

TUCKER KNOWS BEST

I was in a bad mood when I arrived at the barn that day. A frustrating day at work combined with a fight with my boyfriend left me cranky and depressed. I was glad I had my horse to help me cope.

I tacked up Tucker, my gorgeous bay Thoroughbred, and started out for a trail ride. I turned him one way, but he turned around, heading north instead. I started to turn him back, but he was determined that we would go his way. Oh well, I thought, I'm not fighting with anyone else. If he wants to head north, we'll head north.

We climbed a hill, coming out to a big open field. The sky was bathed in scarlet from the setting sun. My shoulders dropped and I relaxed a little. It was so beautiful. We headed around the perimeter of the field and I thought I heard something. Was I crazy? I was sure I could hear music.

Then I remembered. There was an outdoor concert that night on a hill near where we were. We got closer, and the music became clearer. It was Copland's "Appalachian Spring" they were playing, my all-time favorite piece of classical music. Angry? Depressed? Tucker's choice of where to go took us to beautiful views, exquisite music. I couldn't have been happier.

ANN JAMIESON, CONNECTICUT
EQUESTRIAN, HUNTER, AND HUNTER SEAT EQUITATION JUDGE

An Appaloosa filly is exuberantly kicking up her heels. It doesn't matter the color or the breed, all horses enjoy their freedom and show off whenever they can.

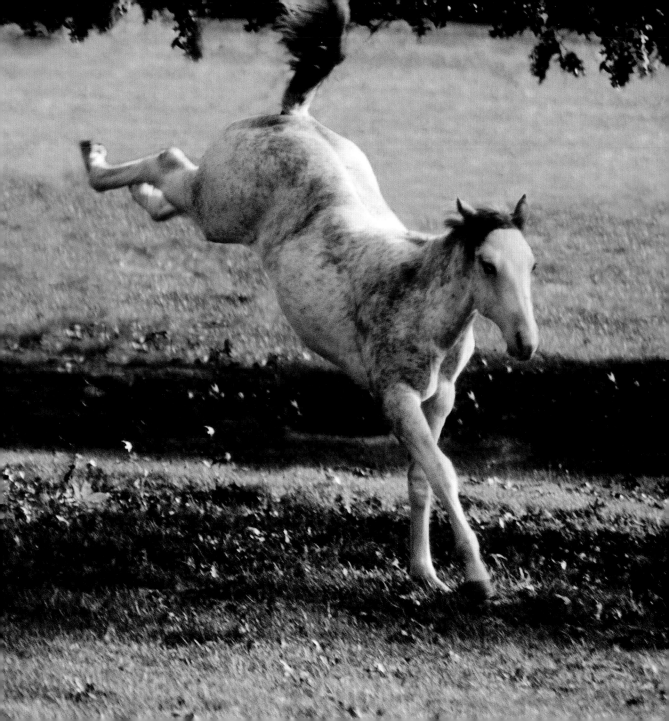

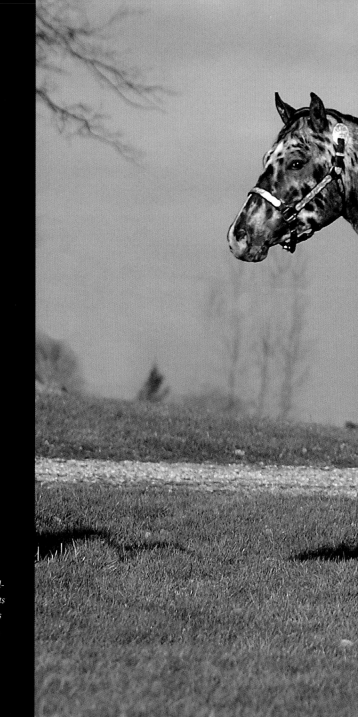

An impressive spotted Appaloosa stallion in Columbus, Ohio. A stallion is a male horse often used for breeding. It is hoped that the traits of the parents will be present in the offspring which is why a horse's history is important when selecting a stallion to mate with a mare.

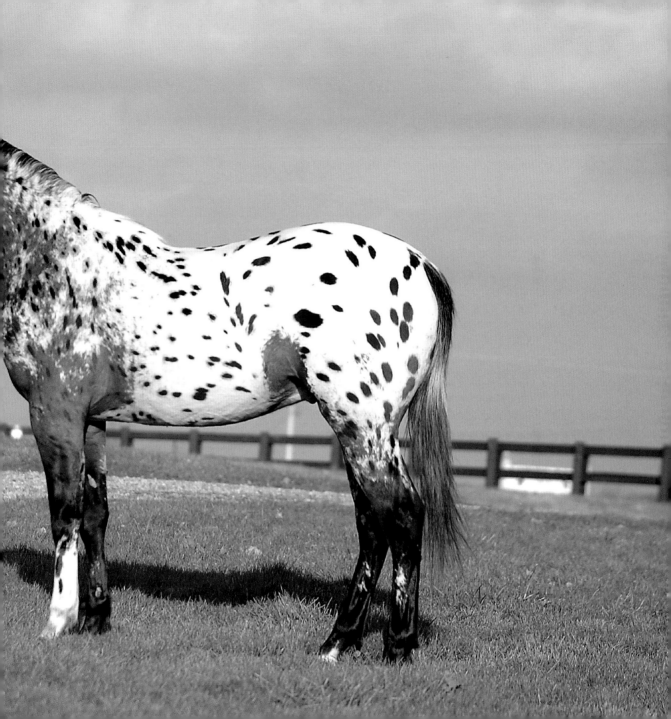

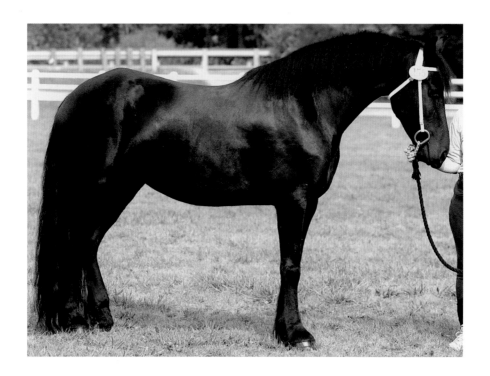

A sturdy Belgian gelding in Ohio being held by its handler. The white bridle goes well with its jet black color. The long tail, while impressive looking, is also helpful for swishing away flies in the warm weather.

SHORT-STIRRUP MAYHEM

I was seven years old and going to my very first horse show. It was a frosty, early spring morning. My old and quiet pony, Monte Carlo, was going to show me the ropes in the short-stirrup ring. My trainer arrived just in the nick of time with Monte. Quickly, I mounted him and walked straight into the ring, with no warm-up, for the "under saddle." What I didn't realize was that he was feeling quite frisky. His morning had begun with a quick lunge and a cold bath. Then he had to stand in the trailer for a couple hours' ride to the show. He was freezing!

Calmly, we walked into the ring. I was secure knowing Monte would take care of me. I had blue ribbons dancing in my head. At the walk, Monte seemed to have a lot of step. Given my first-grade mind, I did not have a clue. Next they called for the trot. When I gave my light squeeze, Monte skipped the trot and broke straight away for the gallop, passing all the other "saintly" ponies. I grabbed his mane, managed not to yelp, held on for dear life and somehow finished the class. Needless to say, there was no hack ribbon. But given all the boundless energy he still had, we nailed the over fences to lock the tri-color. This was my first horse show and first championship.

Moral of the story: Don't always be prepared!

MEGAN DAVIS (12), MARYLAND
PONY RIDER AND COMPETITOR

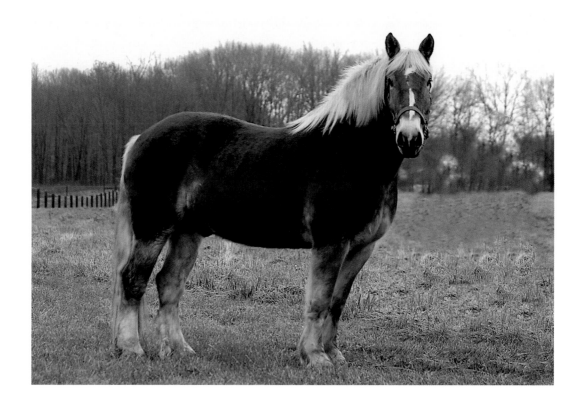

Something has caught the attention of this Belgian gelding that is enjoying some relaxation time at his Ohio home. He pauses for a moment to observe his surroundings.

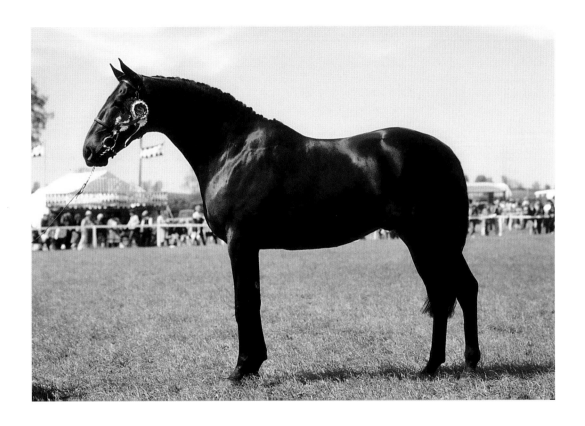

A Show Hunter in a conformation pose for an in hand showing class at the Bath & West Show, UK. Note the alert ears, the impressive head carriage and muscled neck, the well-defined shoulder and solid hindquarters; all are indications that this horse should be a powerful show jumper.

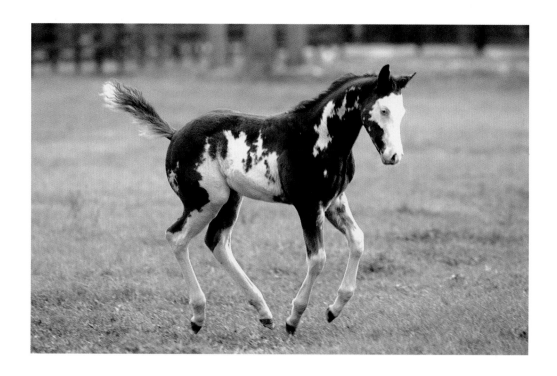

A Paint foal at CS Acres in Fort Pierce, Florida. Although Paint is the breed of the horse, it also signifies the color combination of white combined with some other color. The shapes, sizes, and patterns vary from horse to horse.

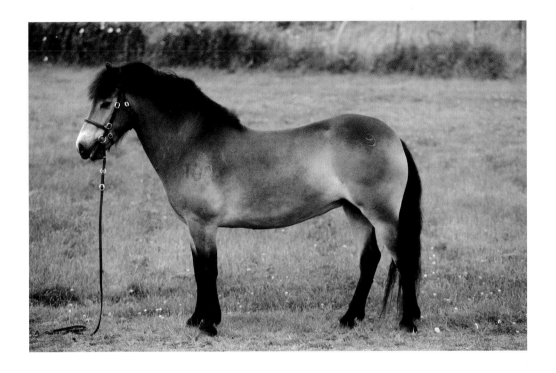

This Exmoor pony comes from England. The pony is thought to have existed in prehistoric times and probably was the pony that pulled the chariots of the Celts. The breed has remained remarkably pure. These ponies are considered to be strong, intelligent, and kind.

The Andalusian "Brilloso" finds a home at Owl's Nest Farm in Magnolia, Texas where they breed Andalusian and Lusitano horses. Brilloso is a 16-hand pure Spanish Portuguese Andalusian stallion.

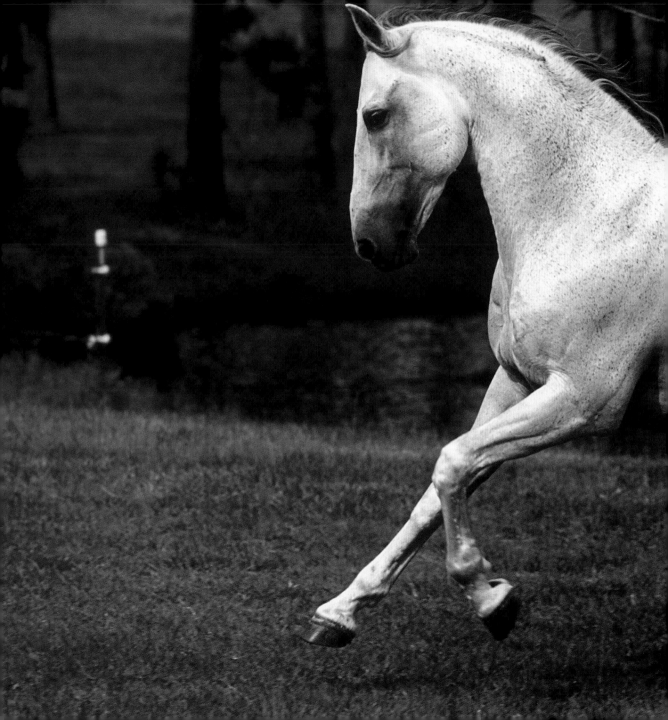

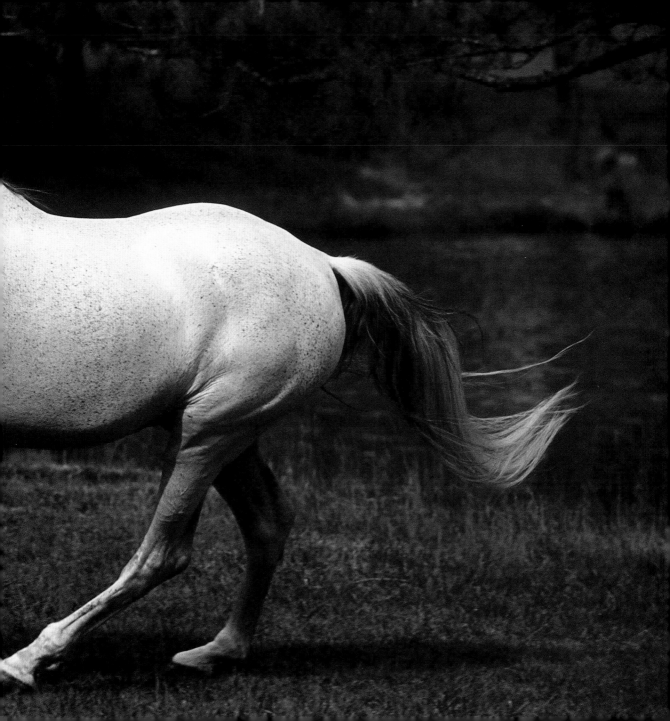

The White Horse

The youth walks up to the white horse, to put its halter on
and the horse looks at him in silence.
They are so silent, they are in another world.

D. H. LAWRENCE

OPPOSITE:
*This Bashkir Curly Cross "Twist" seen at Construct-All Inc. in Texas displays all the characteristics of the
breed. The origin of this curly hair breed is unknown and continues to remain a mystery.*

PAGES 344-345:
*Paint tobiano stallion "Ima Switch Hitter" at Painted Feather Farm in Florida. Ima Switch Hitter is known
for its tobiano gene. A tobiano may be mostly dark or white and the dark color often covers one or both
flanks. All four legs tend to be white, especially below the hocks and knees and the tail is often two colors.*

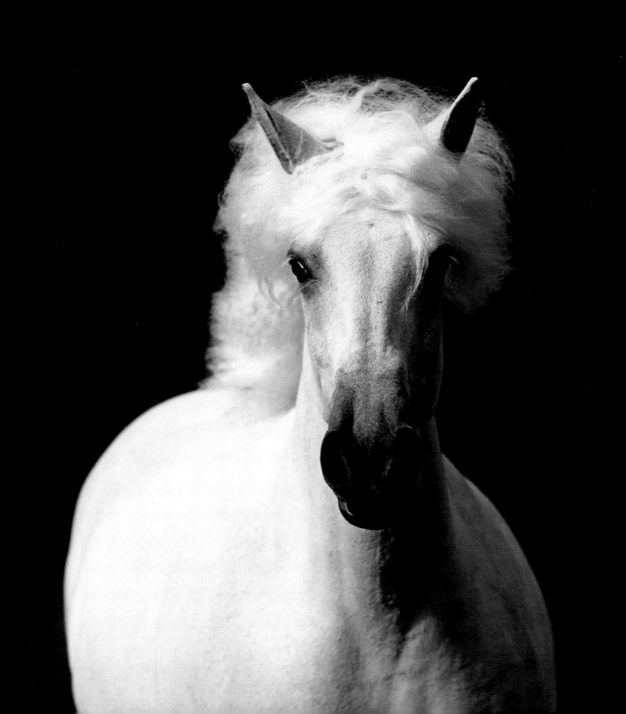

Paint foal at CS Acres in Fort Pierce, Florida.

Quarter Horse cross mule foal at Roubidoux Farm in Florida. When you breed a male donkey to a female horse the animal is called a mule, but when you breed a male horse to a female donkey it's known as a hinny. The offspring are almost always sterile.

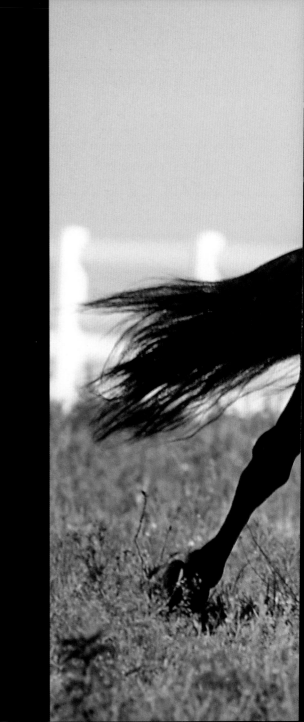

*Friesian "St. Bogart Von Jorrit" at Proud Meadows in Texas.
The Friesian horse originated in the Dutch province of Friesland,
one of twelve provinces of the Netherlands.*

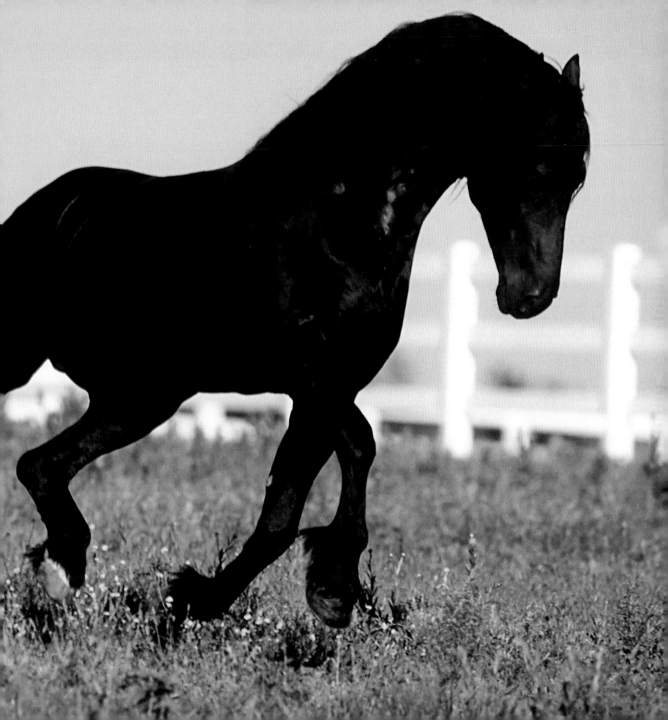

Remebering Those Fun Days

I had such great fun when I was a kid. I started foxhunting when I was about seven. We went out with a farmer pack (which is not a recognized group of hounds). I remember galloping and jumping and learning which hounds were speaking. You could tell the hounds apart by their voices. I recall being freezing cold but always having such fun.

I also was a member of the Hillendale Pony Club. My mom was the instructor/coach, and we would go to pony club rallies. You had teams and you weren't allowed to talk to anyone—not your coach or your parents. You had to do everything yourself. They would come and inspect the barns, and you had to have everything in order and immaculate. This one time, we were so excited because we had spent all morning making sure nothing was out of order and everything was perfect. When the inspector came, she discovered a hook somewhere in the stall, and we ended up with points off for that because we didn't put tape around it or something silly like that. When I look back, I realize that those are the times you never forget—that was when riding and working around horses was so much fun.

LOUISE SERIO, PENNSYLVANIA
TOP HUNTER RIDER, **2005** *MONARCH INTERNATIONAL SHOW CIRCUIT*
(PROFESSIONAL WCHR TITLE, AMONG NUMEROUS OTHER AWARDS AND CHAMPIONSHIPS)

*Quarter Horse mare "A Certain Gold Lilly" at Petty Quarter Horses Farm in Ocala, Florida.
Quarter Horses are known for their fast speeds over a quarter of a mile.*

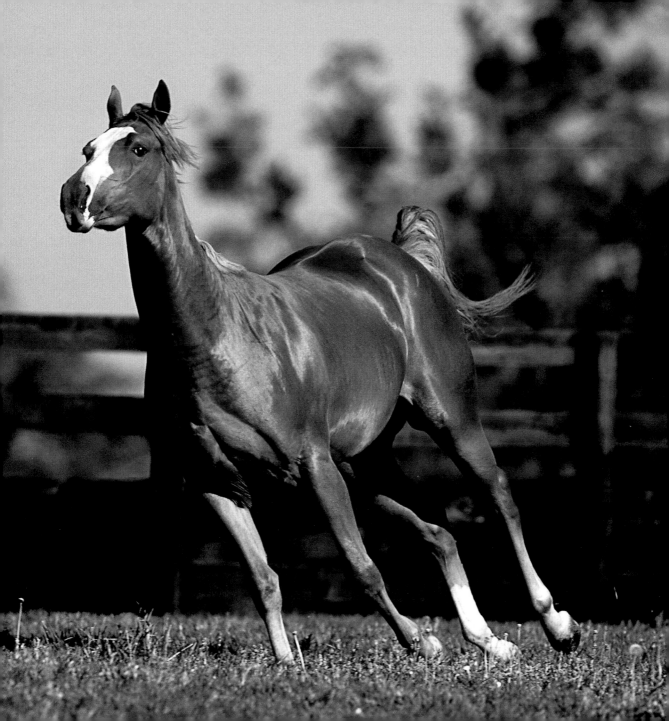

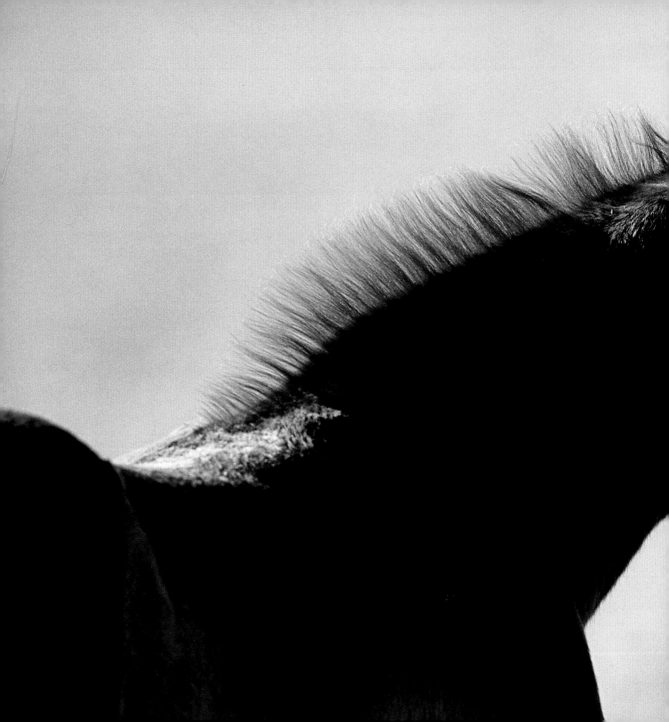

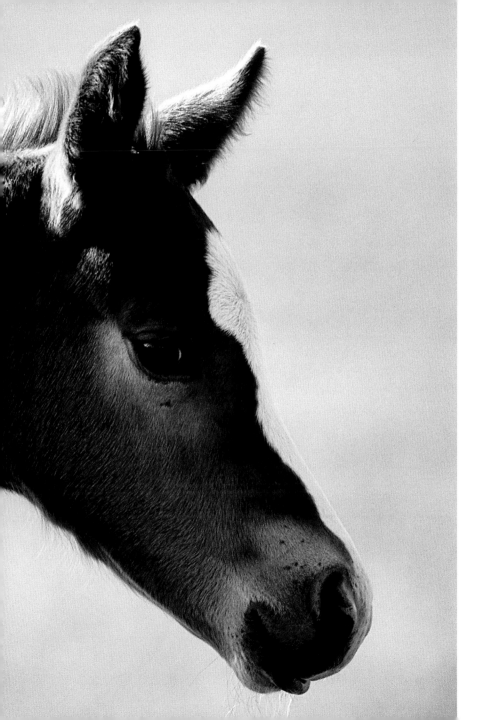

Quarter Horse foal at Petty Quarter Horses Farm in Ocala, Florida where they both breed and show Quarter Horses.

The outside of a horse is good for the inside of a man.

WINSTON CHURCHILL

PAGES 358-359:
Friesian horses are always black. They are not allowed to have any white markings on their body or legs to be considered part of the Friesian breed. They are known for their long, thick, flowing mane and tail. The Friesian has a high head carriage.

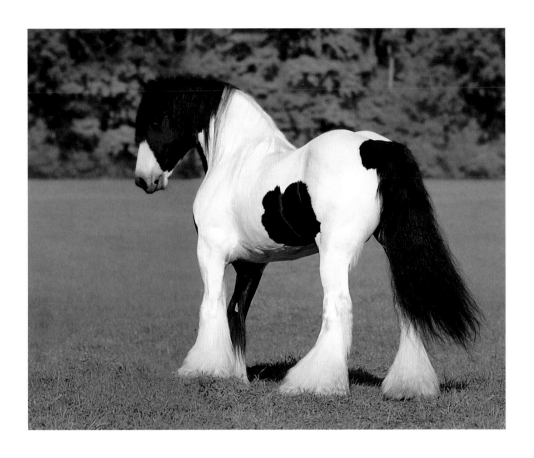

The Gypsy King, a Gypsy Vanner stallion. The Gypsy Vanner is a new breed to the United States, developed by Gypsies in Europe as gentle, hardy horses that were fancy enough to pull their elaborate caravans.

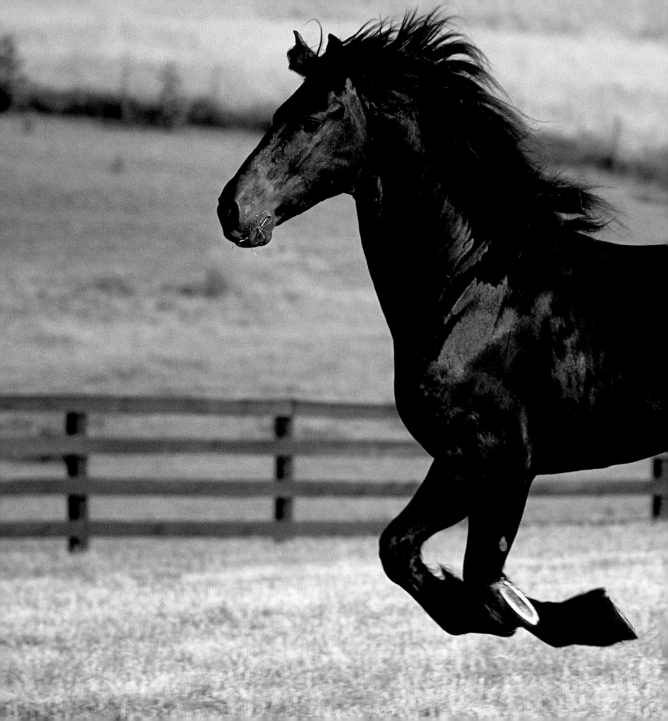

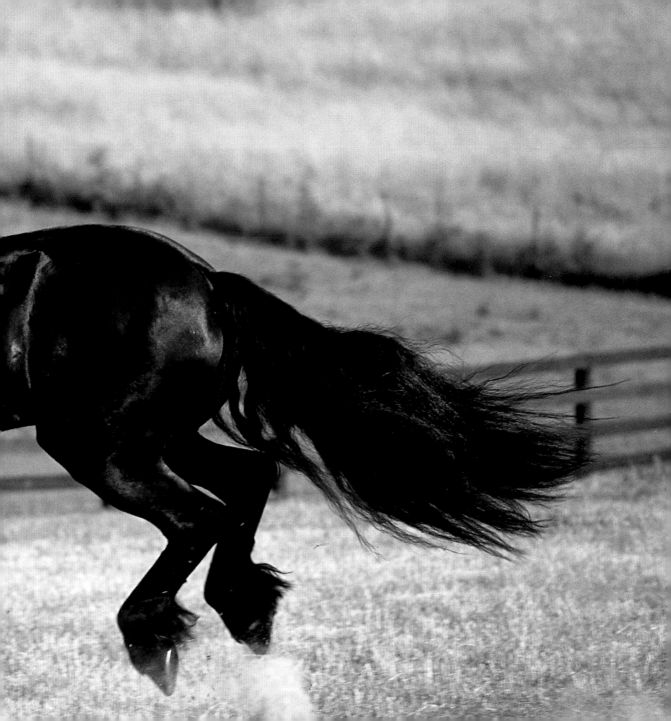

He doth nothing but talk of his horse.

WILLIAM SHAKESPEARE, *THE MERCHANT OF VENICE*

A touching moment as a Warmblood and Arabian meet. The Warmblood is wearing a bridle, while the Arabian has a halter on. They are using many of their senses (hearing, sight, feel, and smell) to assess a new-found friend.

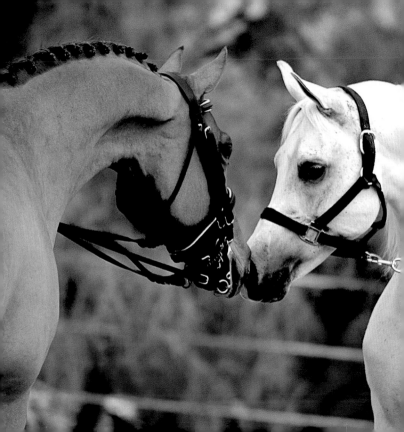

[Don Quixote] then bade the host take good care of his steed, saying

that no better piece of horseflesh munched oats in all the world

MIGUEL DE CERVANTES SAAVEDRA, *DON QUIXOTE*

OPPOSITE:
*Two Thoroughbreds sharing friendship, Columbus, Ohio. Horses love
to be close to each other and prefer having a companion.*

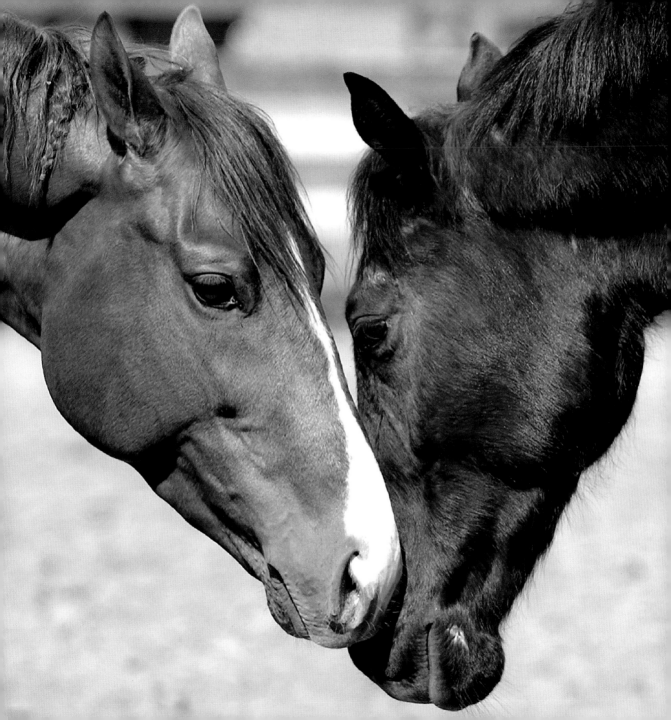

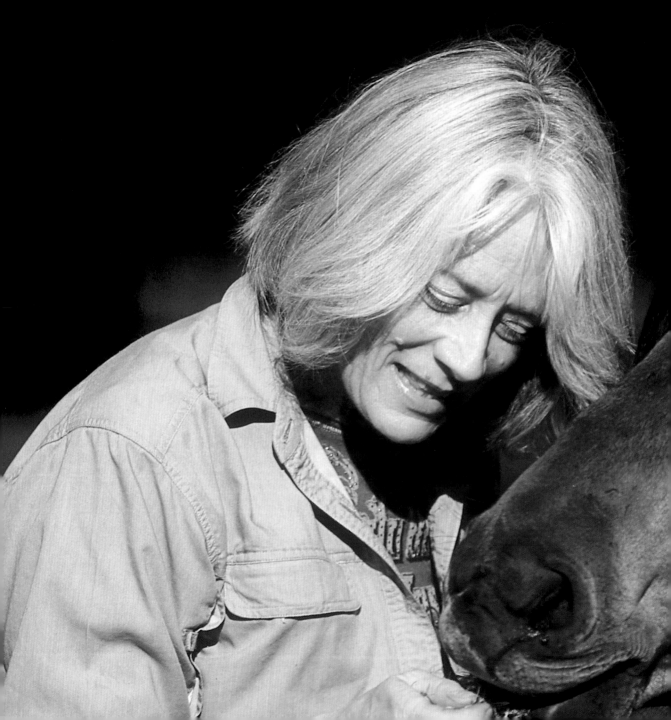

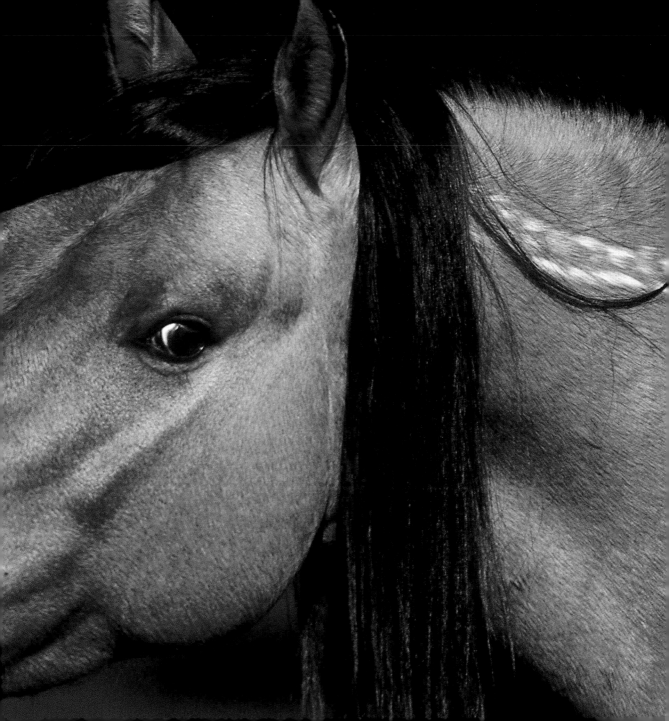

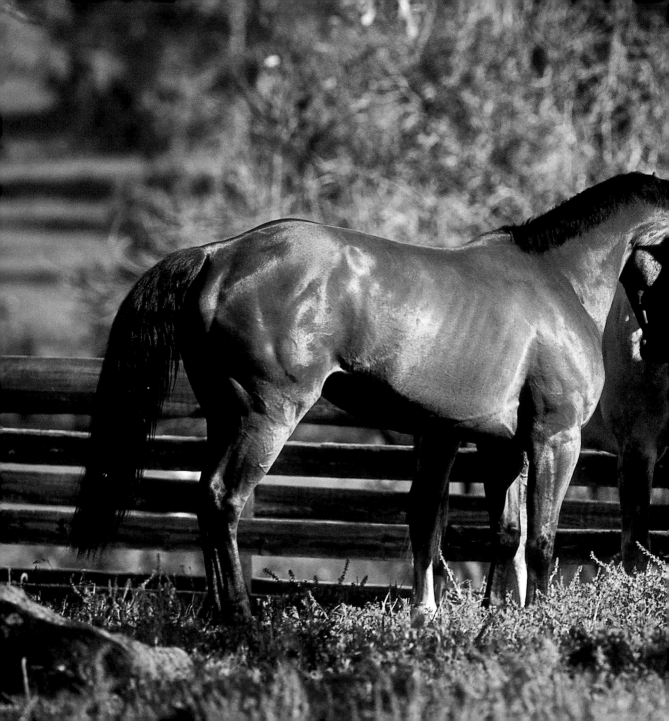

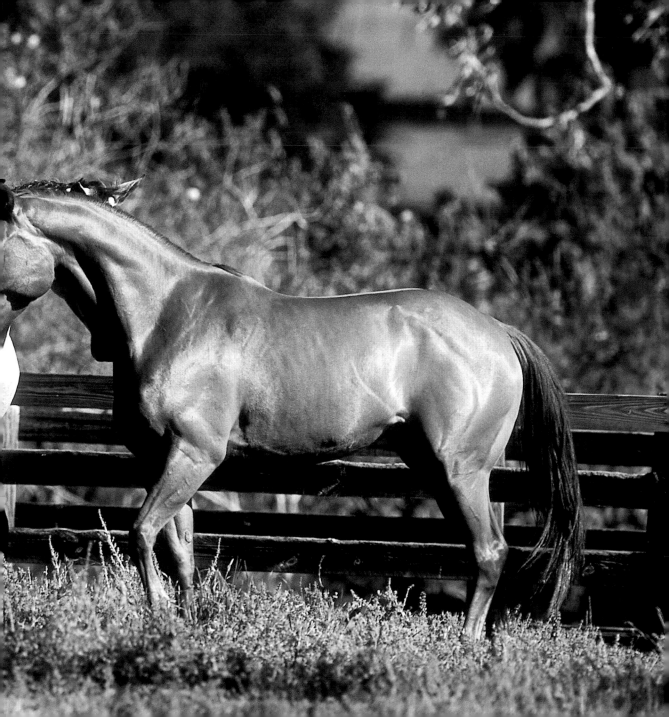

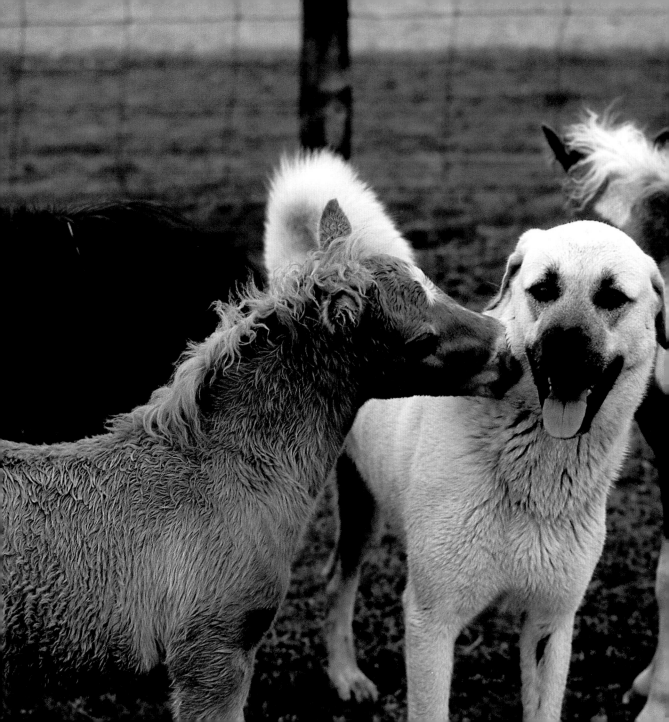

PAGES 366-367:
It is a natural instinct for most horses to stand close together as part of a herd. These Warmbloods demonstrate that togetherness in a paddock at Kingridge Stables in Ocala, Florida.

LEFT:
Horses often make friends with other types of animals. Here a miniature horse befriends a dog at Double Destiny Syndicate in Kentucky.

LOVE AT FIRST SIGHT

She was six; I was fifteen. When they led the mare out of her stall, her nostrils flared and she exhaled loud puffs of smoke into that October evening. Her coat was a rich sorrel red with just one star on her delicately chiseled head. Her wide eyes turned toward me. It was love at first sight. Kaymado had been a brood mare, had traveled across the country and bore the signs of fear and distrust. On the day Kaymado was transported to our suburban "ranch" on Long Island, it took three hours and five people to coax the stubborn Quarter Horse onto the trailer. Her exit from the trailer took seconds!

Riding Kaymado, nicknamed "Kim," was an adventure. She was quick and responded to the lightest touch of my hands. She loved trail riding, and always listened for the sound of my voice.

For a time, I had to sell my Kaymado. During those three years, I visited Kim with a heavy heart. In the cold winter of 1975, I received a phone call alerting me that Kim was for sale. Needless to say, I bolted to the stable with cash in hand and a trailer. This time, Kim walked right up the ramp. When we arrived home, she lifted her head and whinnied over and over as we trotted up the drive as if to announce to everyone, "I'm home!" And there she remained. Kim passed peacefully without any fear.

The Miniature Caspian "Ucuncu" at Texana Farms in Waller, Texas. The Caspian is an extremely rare and ancient breed, thought to be a direct ancestor of the Oriental breeds. The Caspian has a short, fine head with large eyes and nostrils and small muzzle. The breed has a well-proportioned body.

PAGES 372-373:
The Colorado Ranger traces its origins back to Constantinople. The name Colorado Ranger horse, also referred to as the Rangerbred, comes from the fact that these horses were bred on the open range in Colorado.

CAROL ARON, CALIFORNIA

TRAIL RIDER AND FORMER WESTERN HORSE OWNER

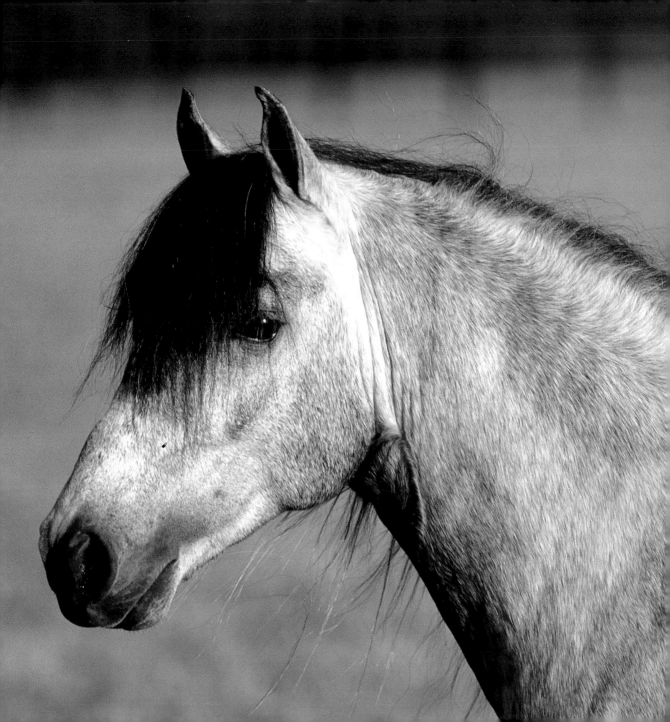

The name excited my father's curiosity and he called at the hotel to meet the gentleman who told him that he had, he thought, the finest horse in the world, and knowing General Grant's great liking for horses he had concluded, inasmuch as he would never be able to ride again, that he would like to give his horse to him; that he desired that the horse should have a good home and tender care and that the only condition that he would make in parting with him would be that the person receiving him would see that he was never ill-treated and should never fall into the hands of a person that would ill-treat him. This promise was given and General Grant accepted the horse and called him "Cincinnati." This was his battle charger until the end of the war and was kept by him until the horse died at Admiral Ammen's farm in Maryland, in 1878.

GENERAL FREDERICK DENT GRANT (1850-1912)

This horse is an image of grace and beauty and a fine example of what has captivated humans for centuries.

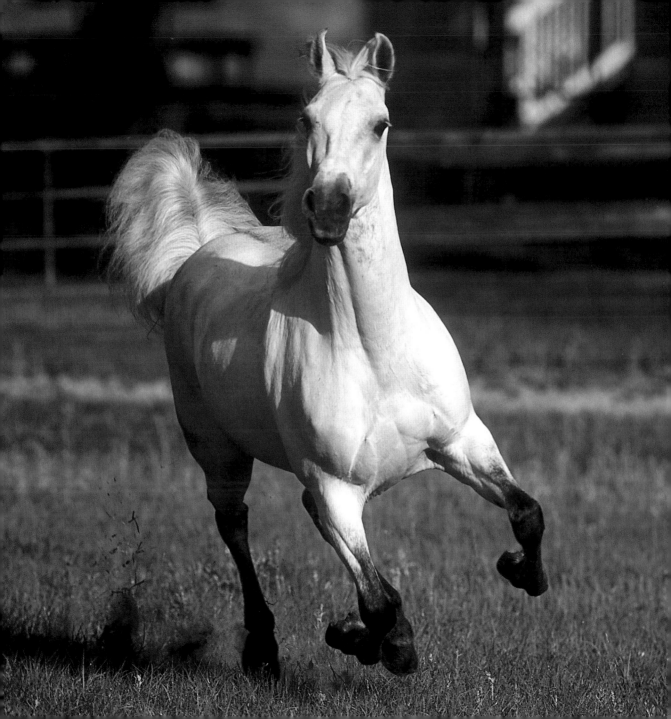

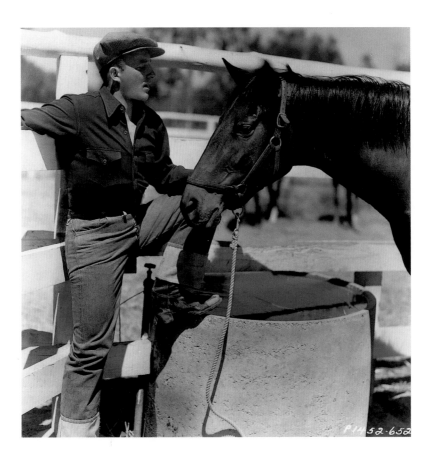

The legendary movie star Bing Crosby, seen enjoying some private time with his horse, 1940. Known mostly for his charismatic singing, this was a rare sight to catch him spending time with his horse.

The well-known actor from the Silver Screen, Clark Gable, on his horse, 1933. Considered the "king of Hollywood," Gable was the greatest male star of the 1930s.

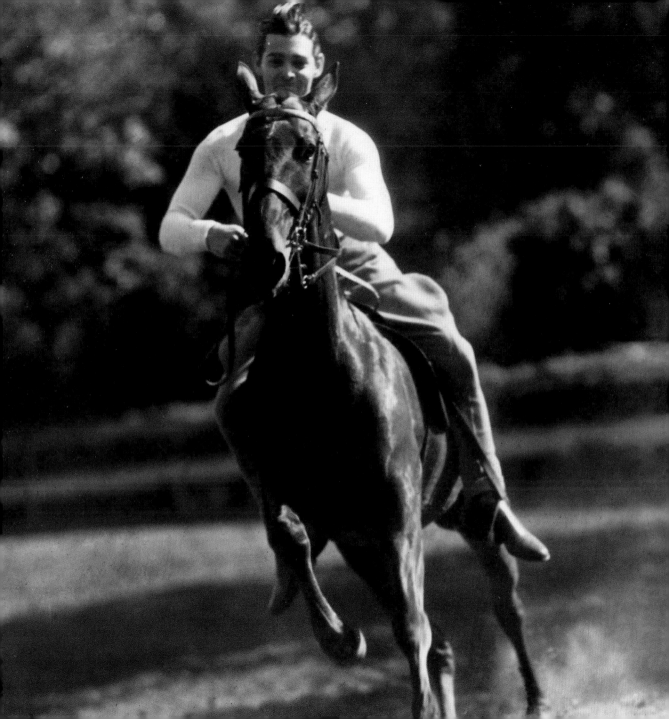

I Ride an Old Paint

When I die, take my saddle from the wall
Place it on my old pony, lead him out of his stall
Tie my bones to my saddle and turn our faces to the West
And we'll ride the prairie we love the best

TRADITIONAL COWBOY SONG

OPPOSITE:
A cowboy in the western plains of the United States.

PAGES 380-381:
Cowboy Aron Broadhead with his trick Quarter Horse at Lazy J Dude Ranch in
Wickenburg, Arizona in 2003.

Published in 2006 by Welcome Books®
6 West 18th Street, New York, NY 10011
(212) 989-3200; Fax (212) 989-3205
www.welcomebooks.com

Publisher: Lena Tabori
Project Director: Alice Wong
Designer: J.C. Suarès
Design Assistants: Naomi Irie and Kate DeWitt
Editorial Assistants: Jeffery McCord and Maren
Gregerson
Text Contributor: Diana De Rosa
Photo Researcher: Maisie Todd

Library of Congress Cataloging-in-Publication Data

The big book of horses / edited by J.C. Suarès. -- 1st
ed.
 p. cm.
 ISBN 1-59962-013-8 (hardcover)
 1. Horses--Pictorial works. 2. Photography of
horses. I. Suarès, Jean-Claude.
 SF303.B54 2006
 636.1--dc22
 2006010981

ISBN-10: 1-59962-013-8
ISBN-13: 978-1-59962-013-8

Printed in Malaysia
FIRST EDITION

10 9 8 7 6 5 4 3 2